Performance and Identity in Irish Stand-Up Comedy

THE UNIVERSITY OF
WINCHESTER

Martial Rose Library
Tel: 01962 827306

To be returned on or before the day marked above, subject to recall.

Performance and Identity in Irish Stand-Up Comedy

The Comic 'i'

Susanne Colleary
University College Dublin, Ireland

First published 2015 by
PALGRAVE MACMILLAN

Palgrave Macmillan in the UK is an imprint of Macmillan Publishers Limited, registered in England, company number 785998, of Houndmills, Basingstoke, Hampshire, RG21 6XS.

Palgrave Macmillan in the US is a division of St Martin's Press LLC, 175 Fifth Avenue, New York, NY 10010.

Palgrave is the global academic imprint of the above companies and has companies and representatives throughout the world.

Palgrave® and Macmillan® are registered trademarks in the United States, the United Kingdom, Europe and other countries.

ISBN 978–1–137–34389–5

This book is printed on paper suitable for recycling and made from fully managed and sustained forest sources. Logging, pulping and manufacturing processes are expected to conform to the environmental regulations of the country of origin.

A catalogue record for this book is available from the British Library.

Library of Congress Cataloging-in-Publication Data

Colleary, Susanne, 1970–
Performance and identity in Irish stand-up comedy : the comic 'i' / Susanne Colleary.
pages cm
Includes bibliographical references and index.
ISBN 978–1–137–34389–5
1. Stand-up comedy—Ireland. 2. Comedians—Ireland. I. Title.
PN1969.C65C65 2015
792.7'609415—dc23 2014038798

Typeset by MPS Limited, Chennai, India.

Contents

Acknowledgements

For all those who have helped me through this journey, I offer my heartfelt thanks. First and foremost, I wish to thank Tommy Tiernan, Dylan Moran and Maeve Higgins who all very kindly granted permissions to use their work and interviews for the book. I am very grateful; the book would not exist without you. Among my friends and colleagues, I especially wish to express my gratitude to Finola Cronin, Eamonn Jordan, Marie Kelly, Cathy Leeney, Carmen Szabo, Eva Urban, Ian Walsh, and Colette Yeates. I particularly wish to thank Audrey McNamara, who is such a good and true friend. We are soldiers of fortune together. I would also like to acknowledge the contributions of Karen Jackman, Anne Cleary, Hilary Gow and Pauline Slattery. My thanks to all my colleagues in Sligo Institute of Technology and Carlow Institute of Technology and also Carmel O'Sullivan in TCD for her support in recent years. Eric Weitz was a great support and believes in the comic spirit as much as I do. My thanks to Sue Morris who has been brilliant as always and to Sue McDonnell, who has lent me her ear more than she deserved. I am very grateful to my husband Thomas Doyle, for his everlasting gobstopper amount of patience, understanding and support. I could promise to do the dishes for the next six months but it would be a lie. Thanks also to Brian Doyle, who is a gifted proof-reader. He should turn professional. And a final thank you to my family, to Kathleen and Eddie, for their unwavering faith in me; and to my brothers Niall and John, who, when we were kids, often made me spit my tea out while we were seated at the table. It really annoyed our mother. They were trying to make me laugh. Mostly they succeeded.

Aspects of this work appear as articles in other publications. 'God's Comic,' in *Staging Thought: Essays on Irish Theatre, Scholarship and Practice*, ed. by Rhona Trench (Bern: Peter Lang, 2012); And 'Eating Tiny Cakes in the Dark: Maeve Higgins and the Politics of Self-Deprecation' in *Performing Feminisms in Contemporary Ireland*, ed. by Lisa Fitzpatrick (Dublin: Carysfort Press, 2013).

Introduction

The Warm Up

This is a book about stand-up comedy in Ireland. It is written for people who have a tendency to see the funny side, even when they should not. The book began as research into broader comedy stores, of which Ireland has a rich and sustained tradition. In academic circles there are currently relatively few books about stand-up comedy. Oliver Double's contribution in that regard is significant, along with works by Tony Allen, Dixon and Falvey and Carr and Greeves, so a debt of gratitude is owed. Having said that, books about stand-up in Ireland are rare, and it is hoped that this contribution will add to the stock of knowledge.

This book is an exploration into stand-up comic worlds. It makes enquiry of stand-up comic processes and performance. It questions how the everyday self becomes the performed self in stand-up. It offers an analysis of stand-up as a form with the power to make meaning in contemporary culture. In doing so it considers the work of three successful Irish comics. Taking the relevant critical discourses into account, the work suggests a small formulation, called *the comic 'i,'* as one means through which to look at performed subjectivity in the form. Stand-up comedy (indeed, all comedy) is a tricky subject for examination. This is not an original assertion. Just when you think you have it by the neck, the comic will wrest itself from your grasp. It will make a fool of you. Its inherent trickery is its attraction. So then, and most importantly, this book is written in the spirit of the thing itself, of knowing that stand-up comedy will grapple with you. It won't give in easily and it will put up a very good (slapstick) fight before giving away any of its secrets. That much is certain. That's the fun of it. The book begins with the broader historical contexts of music hall and vaudeville as forerunner to what

is understood as stand-up comedy today. It makes a potted history of those frameworks and traces the development of the form to contemporary times. The work then takes some time gathering the association of ideas that lead to the comic 'i.' The book focuses on the performances of three Irish comedians, Tommy Tiernan, Dylan Moran and Maeve Higgins, as exemplary case studies. All three are gifted comics, who have achieved both national and international success. The book offers a series of analyses in order to examine each comedian's performance works along with notions of the enacted self in stand-up. What each comedian is in the act of telling has much to say about subjectivity as comic performance, along with its keying to the broader community. There is also some small consideration of the stand-up self as it connects to deeper pools of comic identity. It is hoped that the work can be read in two ways. The case studies, for the most part, can stand on their own. In that sense the work can be read as a series of performance analyses or it can be read with the critical framework as layering for those case studies. In this way the reader can choose the best approach for her needs. Mostly, I hope that the reader enjoys the work, finding amusement as well as some elucidation between the boards.

Chapter overview

Chapter 1

This chapter takes the reader through a brief history of vaudeville, music hall and variety as the historical precedents for stand-up comedy in America and Britain. In parallel, the chapter traces the history of popular entertainments in Ireland from the late 1800s onwards. Making links to British music hall and vaudeville, the chapter traces developing Hibernian varieties to modern evocations. The chapter spends some time looking at stand-up as a product of popular culture traditions, before moving to current conceptions of stand-up comedy in Ireland.

Chapter 2

Chapter 2 begins as an examination of narrative identities, as the storied self that reaches out in the performative field of the everyday and into more formalised notions of performance. The chapter also takes an in-depth look at stand-up comic processes and practices in an attempt to understand how stand-up comedy functions as performance. The chapter proposes the comic 'i' as a loose association of ideas that encapsulate a means of looking at performed subjectivity in stand-up

comedy. Having established the comic 'i,' the chapter looks at the mediating factors which influence and at times radically contextualise that formulation. The chapter concludes with a discussion on stand-up as comic 'i'dentity and offers a small consideration on stand-up as embodied comic dialectic between the 'self' and 'selves' in society.

Chapter 3

The promotional images for Tommy Tiernan's *Crooked Man* (2010–11) tour show him holding rosary beads in one hand and what looks like red and black lingerie (or perhaps it is a clown's mask) in the other. Tiernan's facial expression suggests that he is either in pain or screaming. Maybe he is laughing, it's hard to tell. One way or another, the imagery is provocative and is in keeping with Tiernan's comic style. Tiernan's career has been approximately 18 years in the making. In that time his creative output – his live shows, tours, television appearances and DVDs – has been both prolific and very successful. While the topics that form the basis of Tiernan's comedy are too large to encompass here, his subjects range widely: men and women; relationships; childhood; sex; religion; politics; fatherhood; addictions; interculturalism; disability; and ethnicity. The subject of the Catholic Church or other institutionalised religions, ideas on the sacred and the secular, paganism, existentialism and even morality, recur so often that they have formed a central thematic throughout Tiernan's stand-up career. This chapter constitutes a series of performance analyses, which interrogate a number of motifs in the works. Chief among them are Tiernan's dialogues on religion, on faith, and of God as they inform the comedy. The work focuses on Tiernan's game play with ideas of transcendence. The chapter will also examine Tiernan's comic persona as the 'controversial' comic whose career suffered because, through many eyes, he overstepped the bounds of comic licence. The work will also explore Tiernan's comedy as a series of interrogations, which make incisive commentary on social relations and communal structures in society. In addition, the chapter examines Tiernan's comedy as a system of contraries, which accommodate ideas of both the Priest and the Jester. The chapter will argue that despite his denials to the contrary, there is desire signalling in the work, whether sacred or secular, that urges us to reach toward what "might be, could be, should be."[1] Finally, this work will examine Tiernan's comic 'i' as subjectivity in comic performance, and what value there may be as he transmits those signals out and into the collective.

Chapter 4

In 2010 Dylan Moran released a 'best of' DVD of his live performance works spanning seven years of his career. The DVD, entitled *Aim Low*, is in a sense indicative of the performance persona that Moran has crafted and honed throughout these years.[2] Moran's comic persona is embodied in the curmudgeonly miserabilist who, on the one hand, can be "all charm and word magic."[3] On the other hand, words like misanthropic, morose, and surrealistic, also spring immediately to mind. As with Tiernan, Moran works within the broad fabric of stand-up territory, ranging across subjects including relationships, children, politics, gender, ethnicity, women, age, youth and death. His material is very much grounded in everyday behaviour and phenomena, in the comedy of recognition, however de-familiarised, or fuelled by poeticisms and absurdities. In the work under consideration here, Moran's comic material consists of a series of social and personal observations of human behaviour. This chapter interrogates Moran's mapping of the 'potential matrix' for the audience. He draws out the complex narratives that boundary imagined possibility and the proclivity for self-deception that puts paid to even the best potential self. The work will also examine Moran's takes on language to chart the territory in romantic relationships. In this aspect of his work, Moran uses the everyday phrase, innocuous or even mildly chastising comment to expose the tortures of language-based power play in a couple's world. The work will investigate his derisive critique on certain contemporary middle-aged male behaviour along with the deception carried out by his children, as they take language and the future from him. This chapter will also interrogate Moran's considerations of time (running out), the inescapable betrayal (deception) of the body, and the inevitability of death. Finally, the chapter will argue for Moran's comedy as fundamentally tied to the collaborative spirit and of Moran's laughter as perhaps the best and only response to the 'experience of absurdity,' which ghosts our reflections of everyday life. The work suggests that Moran's comic 'i' as subjectivity in performance signals that laughter as response to the broader community, which turns on a very old Hindu saying: "there are three things that are real: God, human folly and laughter. Since the first two pass our comprehension, we must do what we can with the third."[4]

Chapter 5

Maeve Higgins loves telling stories. Her comedy has been described as a "great relief from the big loud boys, [winning] many people over with

her quietly charming quality of comedy."[5] Higgins has been winning people for a decade as a professional stand-up comic, and has created a comic persona, which is aptly described as 'deceptively charming'. Often depicted as a variation on a theme, that of a '"deliciously awkward, deceptively clever delight,"[6] Higgins's material is centrally concerned with the detailed minutiae of her everyday life, and her comedy involves stories of family, of childhood, of female body image, and of sexual politics and interpersonal relationships. Higgins's comic persona is a clever construct: on the one hand sweet, self-conscious and amusing, full of stories about her cat, or baking cakes, or getting locked out of her apartment. On the other hand, Higgins consistently undercuts the surface of her quirky persona with a series of subversive critiques, targeting social and cultural expectations of women's identity. This chapter will examine those recurring themes, which populate Higgins's stand-up comedy. The work will interrogate Higgins's deployment of the comedy of intimate recognition, which seeks to make connection through evoking a sense of shared experience and ideas of the collective with an audience. This chapter will also examine Higgins's neuroses and stories of her personal anxieties about her body image. This work will also look at Higgins's stories of failure in dealing with the game play of sexual politics. The last scenario under discussion in these pages will examine Higgins's interrogation of that which constitutes male and female comedy. In doing so Higgins exposes a tradition of gendered politics in stand-up comedy itself. The chapter will argue for Higgins's comic 'i,' as subjectivity in performance, which is signalling into the broader community; messaging, at times 'through the looking glass darkly' the ongoing social, political and cultural 'inscription' of women's identity in contemporary society.

Final Remarks

To conclude, the work invites the reader to consider some of the current discourses and shifting notions on what constitutes value and meaning in a society. Those discussions pivot on ideas of art and stand-up, of art and popular culture. Comparisons between the artist and the stand-up comic may divide opinion. My considerations here suggest that the stand-up comic emits multiplex signals, interpreting cultural signification for the community. They read and convey the experience of the everyday for those who act as witnesses, and they ask the fundamental questions, 'Who am I?', 'Who are we?', and 'Where are we going?' At the close, I suggest that the stand-up comic keeps traffic moving in both directions across the bridge that spans the gap between the 'self' and the 'selves,' between self and society. A collective superhighway.

A small discussion of terms at the beginning

It is important at this point to make clear that the performance analyses within these pages are in large part (although not exclusively) carried out on recorded stand-up comedy performances. Performance theorist Peggy Phelan has created what she describes as 'ontology of performance,' to articulate her ideas on the quality of live performance over and above mediatised representations. What distinguishes live performance for Phelan is the ontological fact that its:

> only life is in the present... Performance occurs over a time which will not be repeated. It can be performed again, but this repetition marks it as different. Performance honors the ideas that a limited number of people in a specific time/space frame can have an experience of value, which leaves no visible trace afterward.[7]

For Phelan, the quality of live performance is tied intrinsically to the idea of its non-reproducibility. In this way, live performance can resist being appropriated, so that performance has "independence from mass reproduction, technologically, economically, and linguistically, is its greatest strength."[8] However, Philip Auslander challenges Phelan's ideas, he makes his point when he states, "I doubt very strongly that any cultural discourse can actually stand outside the ideologies of capital and reproduction or should be expected to do so."[9] Additionally, Auslander asserts that live and recorded performance is in fact deeply connected, so that "live performance now often incorporates mediatisation such that the live event itself is a product of reproductive technologies. This is true across a very wide range of performance genres and cultural contexts, from the instant replay screens at ball parks to the video apparatus in... performance art."[10] He takes as an example the performance artists Laurie Anderson and Spalding Gray whose work has successfully crossed over from "vanguard to mass cultural status that many current performance artists seem to hope for."[11] Auslander makes that point that Anderson and Gray's works exist in tandem with the films, videotapes, records and books drawn from their live performances. In considering Anderson's and Gray's crossover mass-market appeal, Auslander admits that he was in fact "privileging the live performance as the origin and source of the other cultural objects."[12] On closer inspection, Auslander asserts that this idea does not agree with the cultural facts, and again using Spalding Gray as an example, he argues that:

It is not, however implausible that Gray... has encountered audiences whose interest in his performance derives from their experience of Gray on film or videotape... the traditional privileging of the "original" "live" performance over its "adaptations" is reversed and undermined: the recorded performance has become the referent of the live one.[13]

This idea accords equally well with the performance form of stand-up comedy. Again Auslander contends that as the process of mass mediatisation of stand-up comedy has developed in the US, "cable networks have discovered that audiences *will* go to see the same comedy routines performed live that they have already seen on television... [an audience] want to see the comic perform his or her greatest hits."[14] He is not suggesting that there is no difference between performance artists like Laurie Anderson and Spalding Gray in their respective live and mediated forms. However, in the sense that both performance artists have successfully bridged the gap between vanguard and mass culture, he suggests, "live performance has no greater or different cultural authority then its cultural adaptations."[15] Auslander's thinking flies in the face of those who privilege live performance over the mediatised artefact; those discourses continue and will not be resolved here. Having said that, the threat perceived by Phelan and others in the field is also echoed by Patrice Pavis who argues '"the work of art in the era of technical reproduction' cannot escape the socio-economic-technological domination which determines its aesthetic dimension."[16] However, for the purposes of analysis Pavis offers a way in which to study the technological artefact. The performance analyses under discussion in these pages, extracted from commercial DVDs, constitute an examination of an historical event. In that sense they can only hope to restore certain elements of the event, serving as a "theoretical framework that the analyst will employ if the need arises, so as to detail certain aspects of the performance."[17] Additionally in relation to the performance analysis of material which was filmed by the author, this work too, even as it was recorded live and as such speaks of the experience of the live event, is understood as an historical event also, in consideration of the length of time that has passed since the work was filmed. As such, all the works under discussion here must of necessity be distinguished as reconstructive, as analyses of past performances of Tommy Tiernan, Dylan Moran and Maeve Higgins through the medium of digital technology.

Within the parameters of this book, it is also important to take a brief account of issues surrounding ideas of humour and laughter as response. Henri Bergson, in his by now famous discussion of laughter, observed that "laughter is always the laughter of a group... however spontaneous it seems, laughter always implies a kind of secret freemasonry, or even complicity, with other laughers, real or imaginary."[18] Eric Weitz utilises Bergson's theory as well as the work of Alfred Schutz to explore the "theatrical humor [sic] dynamic"[19] in multicultural performances on the Irish stage in recent years. Building on Schutz, Weitz argues:

> ...cultural inscription includes 'systems of knowledge' acquired through ones 'cultural community,' which become self-evident matrices of interpretive apparatus. Beholden to these structures, any given persons 'biographically determined situation' implies a 'stock of knowledge,' continually accessed and updated through experience – which, incidentally, provides the reservoir of material, humor [sic] attempts to exploit.[20]

Combining both Bergson's ideas of the laughter of the group and what Schutz calls the 'stock of knowledge', Weitz argues that:

> a joke separates its audience into an 'in-group' for which it is aimed (those who possess the stock of knowledge and cultural dispositions it seeks to validate) and an 'out group' (those who do not). We carry a basic element of joking success in our bodies, through our socio-cultural inscriptions and acquired attitudes..., which are made up not only of what we think, but how we feel about things, and, indeed, the entirety of our worldview.[21]

My aim here is to problematise any default position, which oversimplifies the complex nature of the relationship between humorous intent and laughter as response that may seem to validate that humour. Michael Billig argues, "It is difficult to define humour in terms of the laughter that it evokes... moreover, the reception cannot be guaranteed... Accordingly humour cannot be defined purely as that which elicits the response of laughter."[22] Billig goes on to argue that laughter can be "the laughter of hostile ridicule or the laughter of friendly appreciation; one can laugh *with* others and *at* others. As such, laughter can join people together and it can divide; and it can do both simultaneously when a group laughs together at others."[23] From a practitioner's point of view, Jimmy Carr states that the laughter of a comedy gig should not

be viewed simplistically as an audience in agreement with the attitudes and views of a particular comic. An audience may well laugh in recognition of their own feelings and attitudes. However, by the same token, Carr suggests that interpretations of an individual laugh may well throw up a myriad of reasons for why that person responded with laughter. As Carr says, "Laughter can express the joy of transgression: 'I can't believe he just said that.' It can express community: I'm so glad we came to this comedy club for Stig's stag do.' It can express rage: 'Yes! I HATE MY WIFE TOO!' It can express anxiety: 'I must laugh at these jokes so the guys don't realise I'm gay.' And it can express high spirits: 'I just had six tequilas. Woooo!'"[24] In discussing these ideas I am in a sense bracketing the terms of my own discussion in the book. This book does not take on the conflicted and complex historical, socio-economic, cultural, and political relations underpinning ideas of humour and laughter as a response. That discussion is well beyond the scope of this study. I draw attention to these arguments as a way of preface to the performance analyses under discussion in these pages. I do not take any default position or seek any simplified connection between humour and laughter as validation. As such, any dialogue of laughter does not constitute an empirical analysis of audience response. In that sense, the performance analyses do not seek to qualify or validate audience response to the performance works. Rather audience response is detailed where necessary as part of the general discussion used to inform the reader of the broad humour dynamic operating in the comic works. Finally, the system of notation utilised in these pages to transcribe and describe the comic works are not in any way prescriptive. The notation style was created by this author as part of the overall effort to capture something like the sense of 'liveness' for the reader. They are subjective and have been created as a guide, which will, I hope, illuminate the comic works for the reader. Finally, in sections of this work the gendered inflection has been a male one, and I acknowledge the male emphasis in several of the primary sources and quotations. However, it is important to stress that it is certainly not the ethos of this book, nor is my intention to engender the figure of the comic in any way or to feed into any into any reductive social stereotype through these pages. Quite the opposite.

1
The Trailblazers: Vaudeville, Music Hall and Hibernian Varieties

1.1 A brief history: vaudeville to stand-up

It is a widely accepted fact that stand-up comedy as we understand it today has its roots in the vaudeville tradition of America and in the music hall tradition of the UK and Ireland. In America, by the 1850s, popular entertainments included the attractions of concert saloons, 'free-and-easies' and music halls.[1] These places offered such varieties as "minstrelsy, burlesque, music, dance and sexual play in a confusion of combinations."[2] With that, different establishments often catered to different sections of the community, with high-end concert saloons catering for wealthier men, while 'lesser' music halls catered for both the working class and those of lower stations in life. However, by the beginning of the 1860s these entertainment houses were to undergo significant changes in how they conducted their business. Those moral 'reformers' (alongside others) of popular entertainments were on the move. Their objective was to take both music hall and variety from notorious respectable venues, to sanitise "the environment by removing prostitutes and liquor and ensuring 'chaste' performance, and to invite women and children by offering matinees and reduced admission."[3] Tony Pastor is chiefly recognised as the man who managed the transformation to new-found respectability.[4] Initially, he created entertainments for "working-class Irish and German families." His attractions included matinees with half price for children and free admission for ladies on Fridays if accompanied by a man. Pastor also removed alcohol from the refreshment saloon, and as reported, "excluding the rowdyish and troublesome elements," from the audience.[5] By 1875, Pastor was seeking to attract a middle-class audience by moving his theatre from the Bowery to Broadway, and again a few short years later to Union

Square, on Fourteenth Street, known for being the heart of New York entertainments. Others inevitably followed suit. B.F. Keith and Edward Franklin Albee built upon Pastor's successes,[6] operating a variety show out of Boston. They too ensured that all acts were more than suitable for a typical family audience. The entrepreneurs were the first to label this type of family-oriented entertainment as "vaudeville." Interestingly, the term vaudeville itself is thought to derive from the French Vau de Vive, a valley in Normandy that inspired drinking songs and eventually metamorphosed into "voix de ville," or "street voices."[7] That said, and in parallel with others, including Fredrick Freeman Procter, Keith and Albee continued to develop their theatres, along with a national booking agency in the East. Their endeavours became big business, as well as being widely known as the "'Sunday school circuit' because of their squeaky clean image of family entertainment."[8]

The running format of a typical evening's vaudeville included an opening show of five or six different acts, followed by a somewhat longer show of two hours, which would consist of perhaps eight or nine acts. The first act would typically include a "dumb show," which may have included acrobats, jugglers or trick animals. The purpose of such a show was for latecomers and as entertainment for those in the audience who did not speak English.[9] The main performance included dancing numbers, comedy acts and various entertainers, but the next to last spot in the second half was the crucial spot because "vaudevillian audiences loved comedians, [and] a comic often occupied that spot."[10] Among the many performance conventions that constituted vaudeville, chief among them was the interaction between performer and audience. Some theatre managers frowned on audience participation, for fear that it might offend the more 'refined' clientele. Despite that sensibility, the audience–performer relationship in vaudeville continued to be vital and robust – for example, the vaudevillian Nora Bayes considered the relationship as "an intimate chat with one or two friends." In addition, perceived (or real) transgression(s) of the theatre managers' rules created a 'conspiracy' of sorts between performer and audience, which allowed the performer a degreee of control and licence over the crowd. Performers considered such command and manipulation to be vital to the success of their acts: "they prided themselves on their ability to read the audience and considered themselves "mechanics of emotion."[11] At amateur nights, vaudevillian performers who did not make the grade 'suffered' at the hands of their audiences. Management often encouraged their clientele to shout for the 'hook' so as to remove below-par performers from the stage. They held up signs saying "'Beat It,' squirted

the performers from a seltzer bottle, chased them off the stage with an inflated bladder and often closed the curtain."[12] The ghosts of these performance conventions still to a certain degree remain with the form, and I will return to this subject somewhat later on in the work. That said, among the comic greats produced by vaudeville were the legendary George Burns, Jack Benny, Milton Berle and the Marx Brothers.[13] According to Lawrence J. Epstein, these comedians shied away from doing Jewish 'bits' to provide a more universal model of humour. Indeed Double's list of vaudevillian comics overlaps that provided by Epstein; he includes "Buster Keaton, Charlie Chaplin, the Marx Brothers, Mae West, W.C. Fields, Eddie Cantor, Fred Allen, Bob Hope, Jack Benny and Milton Berle."[14] Some of these comedians performed something akin to what would be understood as a stand-up routine today. Interestingly, Milton Berle rejected the use of the term stand-up comedy to define his comic style of performance (one which he shared with others, including Jack Benny and Bob Hope). He stated, "We were monologists. Not stand-up comedians. That's a new term. You know why? Because all they do is stand there and take the microphone off the stand."[15] Berle believed that monologists' acts were concerned with more than just telling jokes, the 'patter' informed only part of the overall act, which might also include songs, dance numbers and impersonations. That being said, the monologists are recognised as the precursors to stand-up for a number of reasons; the style of performance was similar, the monologists addressed the audience directly and, toward the end of the vaudeville era, these performers began to emphasise the telling of jokes over other aspects of the performance.[16]

Over time, vaudeville began to decline following the rise of the film industry in America. Silent movies and, later, sound cinema in the late 1920s, dealt it damaging blows. Broadly speaking, the cost of movie tickets was cheaper than even the cheapest vaudeville seat, causing *Lippincott's* magazine to state that "the movies caused decreases in box office at legitimate and vaudeville theaters and disbanding of theater companies... 'it is a common occurrence to enjoy amusement by machinery in what was a regulation playhouse.'"[17] As the stock market crash brought the 1920s to a close 'the whole of American life was about to change. The economic collapse, the technology that led to radio and sound films, the emergence of a new generation and the rising horror in Europe all combined to make the 1930s and 1940s an entirely new world.[18] So, the bell was tolling for live popular formats, meaning that by the 1930s vaudeville was on its knees. Of course, some of its major stars, including Jack Benny, Fred Allen and Bert Lahr,

did manage to make successful transitions to the 'talkies,' as well as being absorbed into the exciting new medium of radio broadcasting at that time.[19] By 1935 vaudeville was in sharp decline and what little remained acted as entertainments while the projectionist changed the reels in theatres and cinemas around the country.[20] Although vaudeville was now disappearing, variety performance and comedians did have a number of alternative performance options open to them. One such alternative was the so-called 'Borscht Belt,' an umbrella term for a series of over 500 hotels which catered to New York Jews in the Catskill Mountains, one hundred miles north-west of New York City. The 'Borscht Belt' became increasingly popular after the First World War as a vacation spot for middle-class and wealthy American Jews. While the movie industry was becoming an increasingly popular leisuretime activity across the country and changing audience behaviour so that "the talking audience for silent pictures became a silent audience for talking pictures",[21] live performance was continuing hail and hearty in the mountains. Comedians including Milton Berle, Fanny Brice, Mel Brooks, Lenny Bruce, George Burns, Danny Kaye, Judy Holliday, Jackie Mason, Joan Rivers and Jerry Lewis were among the many who performed at the resort in the Catskills.[22] The resorts were very popular and many holidayed there for a variety of reasons. As Epstein notes, in the Borscht Belt, "Jews were in the majority, and there was no external pressure to conform to American values... the resorts were the Jewish way station between immigrant life and comfortable assimilation."[23] Many also went to the mountains to escape the growing anti-Semitic sentiment in the USA during the years leading up to the Second World War. However, in the post-war years, with their increasing acceptance in broader society, American Jews began going to the same resorts as their fellow countrymen. These shifting cultural forces, along with the invention of television, and the unlikely influence of the air-conditioner all contributed to the decline of the popularity of the 'Borscht Belt.'[24] The Catskills suffered a slow demise and although it would remain a training ground for later comedians such as Lenny Bruce and Woody Allen (who played there in 1956); like many other performers, they had their hearts set on the wider American audience. Entertainment routes other than the 'Borscht Belt' saw comedians migrating into what was then known as the 'Chitlin Circuit.' This was the name given to a variety of venues that provided entertainment for black audiences in the larger American cities, including Chicago, Detroit, Cincinnati, Baltimore, Washington DC and Philadelphia. The jewel in the crown of this group was Harlem's Apollo Theatre, still in operation today. The 'Chitlin Circuit' has a long

and rich history, which is far beyond the scope of these pages. That said, the circuit became very organised from the 1930s onwards, playing host to comedians including "Pigmeat Markham, Moms Mabley and Redd Foxx [who] appeared alongside jazz bands, bluesmen, tap dancers and doo-wop groups."[25] In addition, during these years, places like Las Vegas increasingly paid headlining comedians large sums of money to perform there. So too, the country music scene produced white comedians like Minnie Pearl among others and beyond these more mainstream opportunities, stand-up comedians continued in an ad hoc fashion in bars, restaurants and cafés.

From 'sick' comedy to cultural icon

From the 1950s onwards stand-up comedy in America began to resemble more modern conceptions. Venues such as the 'hungry i' (intellectual) in San Francisco, which catered for a clientele made up largely of beat-niks and folk singers, hosted comics which ran counter to the style and format of more traditional forms. Mort Sahl epitomised this shift with material that was informal and conversational in style. Sahl was also unafraid of controversy and made an art form of "socio-political material... always with the cynic's eye, Korea, Khrushchev, Eisenhower – all [became] grist for Sahl's highbrow mill."[26] Sahl impacted the style of comedic performance by speaking his mind, by making intelligent socio-political material, and by resisting the more familiar 'patter and razzmatazz' of 'vaudevillian'-style comics. Sahl and a little later Shelley Berman (described as an Everymanic-depressive) were comics who became known for their conversational non gag-premise style of comedy.[27] These comics were hugely influential, and they, and others like them, broke the ground for what is considered stand-up comedy today. They were being inventive, innovative and even unafraid of contentious material or conservative backlash. Sahl, Berman and others came to be known as the 'sick comics'[28] for their fearlessness, their controversial style and their subject matter. A slew of talent followed including, "Lenny Bruce... Dick Gregory, Mike Nichols and Elaine May, Jonathan Winters, Phyllis Diller, Bob Newhart, and Woody Allen."[29] In many eyes, the most accomplished exponent of the 'sick comics' was the infamous Lenny Bruce. As Berger noted, "the relevance Mort Sahl initiated, Lenny jazzed up."[30] He did not 'tiptoe about,' either in his early career or later, when he became increasingly well known. His risky, and at times dangerous, approach to the material became the stuff of comic legend, and Bruce, along with his contemporaries, "massively expanded the possibilities of stand-up, in terms of both presentation and subject

matter."[31] These, and those that would follow them, lit the torch for a new comic style – informal and conversational, with a relaxed and natural delivery. The work consisted of intelligent and sophisticated thematic routines where comics expressed their opinions and people listened up. These 'sick comics' were unafraid to take the audience into more uncomfortable areas of discomfort and unease, stepping away from the style of older comics and shaping the stand-up form as it is recognised today.

The very first dedicated stand-up comedy club opened in Sheepshead Bay, New York, in 1962. It was here that George Schultz hoped to profit from how cool and hip stand-up comedy had become due in large part to the efforts of (among others) Sahl, Bruce and Gregory. And it was here that stand-up comics could perform without having to share the stage with poets, exotic dancers or performing animals. Schultz named the club *Pips*, which still survives today. By the mid-1970s other New York clubs were popular, including the renowned club the *Improv* (Improvisation Café), along with the *Comic Strip* and *Catch a Rising Star*. Last, but by no means least came the *Comedy Store*. This was the brainchild of one Sammy Shore, an entertainer/comedy promoter, and was situated on Sunset Boulevard in Los Angeles. It opened its doors in 1972 and the earliest comedians to appear there were not actually paid at the Store; the thinking behind this was that the club gave budding comedians a chance to hone their skills, and the hope that talent scouts might pluck them from obscurity.[32] In the 1970s American stand-up was again transformed following the growth of cable TV. Stand-up 'comedy concert films' were proving increasingly popular with cable companies as they were cheap to produce and achieved good ratings. Even today, a Home Box Office (HBO) 'special' can catapult a comic's career into the big leagues.[33] By the dawn of the 1980s stand-up comedy was about to explode, with a proliferation of clubs popping up all around the country. Franchises of the most successful clubs such as *Catch a Rising Star* and the *Improv* also began to appear across the country. By the 1990s, stand-up was being hailed as 'the new rock and roll.' The proliferation of films, books and plays on or about stand-up comedians as well as the birth of comedy cable channels point, in Philip Auslander's view, to the "current power of the stand-up comic as a cultural icon."[34] That said, over time business did slow to a more realistic rate, with some clubs inevitably closing down as the market attained a steadier pace.[35] Currently, the American stand-up comedy scene, both from a live and mediatised perspective remains (at the time of writing) in very rude health.

1.2 A brief history: music hall to stand-up

It has been widely accepted that American comic consciousness has laid claim to the stand-up form. However, Double counters the facts somewhat by suggesting that although other countries may make claims, "if you accept music hall as a form of embryonic stand-up, then Britain was probably the first to come up with it."[36] Music hall had begun even before vaudeville. Not unlike vaudeville, British music hall emerged from taverns and public house entertainments, sometimes known as 'penny gaffs,' where the working or lower classes and their 'acts' would assemble to carouse and sing. In the early days, women were not generally admitted to such establishments; however, prostitutes frequented the stalls, while the entertainments, which were often lewd, acted principally as an adjunct to the food and drink.[37] The man most often attributed with establishing what was to become classic music hall was Charles Morton. He bought the Canterbury Hall in London in 1848, and initially it operated in the traditional style. However, he reopened the Hall in 1852, and, on this occasion, he "presented a high quality of refreshment and entertainment... and he gradually introduced the idea that ladies might come to the music hall. This of course meant a toning down of the bawdier aspects of the entertainment."[38] Classic music hall entertainment carried healthy doses of comic songs and sentimental ballads that were "devised for mass community singing... without a PA system."[39] Roger Wilmut also suggests that early music hall fare did lace strong elements of social satire through the performances. As music hall became more respectable, those satirical qualities were, in Wilmut's view, dampened down somewhat, in favour of preaching an acceptance of the harshness of life.[40] That said, by the end of the nineteenth century, comics were becoming among the most popular of music hall performers. So too music hall itself was undergoing further changes in the type of entertainment that it produced. Instead of a show comprising almost exclusively of singers, the ticket increasingly boasted a broader range of performance styles and subject matter. People began to move away from understanding these entertainments as music hall, referring instead to the various sets of acts as 'Variety.' Inevitably, the range of entertainers grew ever larger and more varied, from the "comics, usually presenting a character study in song, or a song with patter [to]... acrobatic acts, animal acts, dancers... family acts,"[41] and so on. However, over time, this type of format was increasingly being left behind in favour of a shorter bill, presented twice nightly. The licensing acts at the time also influenced music hall conventions. The Theatre

Act of 1843 stipulated that theatres and entertainment houses had to "either... present plays, subject to the Lord Chamberlain's censorship, but be forbidden to serve food and drink... or... be allowed to sell food and drink... but be forbidden to present performances that might be construed as plays. This meant anything involving more than one person speaking."[42] As mentioned above, Double suggests that the form of stand-up comedy is evident from the very beginning of music hall as the songs "were often comic and were sung directly to the audience... through time they became more like stand-up, as a patter section was introduced with the orchestra stopping and the comedian telling a series of gags."[43] British comedian Tony Allen notes: "Patter became one of the comedian's creative options and although it may have been officially described as music, with regular piano chords punctuating the spoken word, it was undoubtedly the beginning of modern stand-up comedy."[44] Over time, the "patter" became just as important as the songs that book-ended the joke telling. Dan Leno, in particular, who was celebrated as the 'King of the Halls,' and one of the greatest music hall comedians of the late nineteenth century is attributed with injecting longer sequences of patter between songs.

There is some thinking that pinpoints the demise of British music hall 'proper' somewhere around 1919, with variety taking over once and for all as its popular entertainment equivalent. And if music hall was six feet under by this time, variety itself was singing something of a swan song. However, as Wilmut notes, if "Variety was dying – it went on dying for forty years, and it was not until 1960 that the corpse was truly cold. And in those forty years there were many fine artists..."[45] That said, from the 1920s onward, variety in Britain, not unlike its American counterpart, faced some stiff competition from the rise of radio, silent movies and the sound stage. Performance styles were also on the move during these years. While the song and 'patter' format had all but died out in the variety era, 'front cloth' comics further shaped the nascent stand-up form. Conventionally, such performers would stand proud of a dropped curtain and entertain the audience while 'variety' scene changes occurred behind, ensuring the show could run smoothly. Among the comedians to emerge from this ilk were "Max Miller, Tommy Trinder, Ted Ray, Billy Russell, Suzette Tarri, Beryl Reid and Frankie Howerd [who] performed something which was stand-up comedy in all but name."[46] Throughout the 1930s and 1940s, with only a few exceptions, comedians still tended to wear either formal or exaggerated costumes and be possessed of a character (George Formby Senior's northern nitwit or Sam Holloway's 'Old Sam' were popular)

with which the audience could easily identify. Oliver Double suggests that these single character comedians set the standard for their successors, including exaggerated personas like Max Miller's "sex-crazed libertine" or Frankie Howerd's "outraged gossip."[47] Interestingly, Miller, who raised the bar for pure gag telling, also loved to conspire with the audience in 'breaking' the rules of the house, echoing earlier vaudevillian and music hall styles. He also managed to raise the dirty joke to something almost respectable.[48] Although variety outlasted vaudeville because of the commitment of people, including the impesarios George Black and Val Parnell, by the 1960s even this entertainment form was on the decline.[49] After the Second World War, comedians tended to revert back to the former style of character comedians, fearing that they would lack individuality without the framework of a comedy character. In addition, booking managers and promoters, including Val Parnell, began to bring over American acts, including Danny Kaye, Harpo and Chico Marx, and Carmen Miranda among many others. Similarly, pop and 'rock and roll' music stars such as Johnny Ray and Bill Haley and the Comets came to play longer sets than the normal twenty minutes usually afforded to a 'variety' performer.

Others tried to stem the tide by presenting nude revues, which began appearing with increasing frequency on lesser variety bills; however, they were to prove a "death blow to [variety]... because they drove away the family audience."[50] For a time radio broadcasting and variety were to enjoy something of a symbiotic relationship, which helped to sustain the medium for a little longer.[51] That said, the post-war years saw "a gradual desertion of variety by its audiences in favour of broadcasting – the box in the corner, either radio or television, which could provide entertainment without the need to go out to see what was beginning to seem an old-fashioned medium."[52] In addition, there were changes in the type of comic material that the public enjoyed, increasingly influenced by radio programmes such as *Hancock's Half Hour* with Tony Hancock, Sidney James and Bill Kerr and *The Goon Show* with Spike Milligan, Harry Secombe and Peter Sellers. While *Hancock's Half Hour* took situation and realistic comedy to new heights, *The Goon Show* took surrealistic radio comedy to its highest point. As radio comedy began to die off in the 1960s, both of these shows (along with many others) influenced the expansion of comedic form and content on television in the years to come. The medium of television dealt yet another blow for live performance, by absorbing the best of the new talent.[53] Among those performers who did succeed in bringing the spirit of variety to a television format were Ken Dodd, Les Dawson, Eric Morecambe and

Ernie Wise, all of whom had learned their craft in the halls.[54] That said, as variety was expiring from the onslaught of shifting cultural forces, variety performers had to find fresh fields. Entertainers began to look to Working Men's clubs for employment. The clubs proved to be a difficult transition for some variety performers. Clubs could tend to favour bawdy comedy, something which many variety comics disliked, although the younger comics began to acclimatise to and cater for this type of humour. As entertainment thrived in the clubs, private night-clubs also appeared, based on the same model but with bigger budgets, and able to attract big name stars and comedians, such as Tommy Cooper and Dave Allen.[55] That said, those who plied their trade on the club circuit relied heavily on a comic style that involved the delivery of quick-fire unrelated, mostly unoriginal gags. All that, however, was about to change.

Alternative comedies – 'What's yellow and goes into the toilet?' 'Piss'

By the early 1970s the British comedy world was getting ready to undergo a series of seismic cultural shifts. In 1971 Granada Television broadcast what was to become a popular television show entitled *The Comedians*. The format was a simple one. The show featured a large number of comedians, each of whom would tell at most two or three jokes, producing a fast-paced, tightly edited programme. The comedians themselves were professionals, gathered from nightclubs and Working Men's social club circuits run, in the main, by the Club and Institute Union (CIU). As Andrew Stott states:

> To a certain degree, the material reflected the context of the perfor-mance, as the style suited a rapid non-narrative delivery – practical means when coping with large and sometimes difficult crowds for whom the comedian was simply one more act on a variety bill.[56]

Much of the comic material presented in the show came to be recog-nised as having "an aggressive subtext, expressing in particular racist, sexist, and homophobic sentiments."[57] The TV show brought national exposure to the performance of "sanitised versions of their xenophobic, woman-hating live stage acts in front of a studio audience," sparking off a series of rejections to this kind of joke telling.[58] One such revolt, in what came to be known as the 'alternative wave', found its safe house when Peter Rosengard opened The Comedy Store in May 1979. The Store was housed above a strip club in London's Soho district and was

inspired by its counterpart in Los Angeles. The Store was the first venue in England to dedicate itself to stand-up comedy and is recognised as the starting point for some of the most talented comedians of the last 35 years.[59]

In the beginning the club's ethos as an alternative comedy venue was not immediately apparent. The Store hosted a gamut of comic styles, from more traditional club comics to unfunny amateurs to the pioneering nonconformists of the comic world. As Double describes it, "For a year or so, the old guard shared the stage with the new wave of comedians, with a kind of rivalry that the eccentric hippy anarchist Tony Allen described as a civil war, before they were eventually swept away and the Store became a bona fide alternative comedy venue."[60] The heady, experimental and at times politically charged atmosphere was created by maverick comedians, including Tony Allen, Keith Allen and Alexei Sayle, who ruled the Store from late 1979. A most distinctive audience participation device that the Store used was the omnipresent "gong." Rosengard realised that not only was it essential to have really bad performers that the audience could take "perverse pleasure" in watching; the other ingredient for the success of the club was the 'gong'. He notes, "in much the same way that the early music-halls had a man with a shepherd's crook pulling the unwilling performer from the stage, the gong was our shepherd's crook."[61] The 'gong' sat at the side of the stage with Alexei Sayle acting as the 'gong' master. Comedians who were not good enough were shouted down by the audience's crying for the 'gong.' If a clear majority were in agreement, Sayle would 'gong' the comedian off the stage.[62]

Within ten months of the Store's opening, a 'second generation' of comics were already making themselves felt at the club. Not as political perhaps as the comics that had come before, but still left wing and liberal enough in their values and beliefs. Among these 'second wave' comedians were Rik Mayall and Adrian Edmondson.[63] Working with three other comedians under the title *20ᵗʰ Century Coyote*, Mayall and Edmondson's work at the Store consisted mainly of two routines, the "Angry Poet" and "The Dangerous Brothers."[64] Another double act that was making an impact around that time was *Outer Limits*, involving Peter Richardson and Nigel Planer, who pushed the boundaries of stand-up comedy with anti-joke parodies of traditional joke structures. "What's yellow and goes into the toilet? Piss," was intended to demonstrate the narrow-mindedness and dreariness of the older comic style.[65] Along with the popularity of the Comedy Store, other moves were afoot. The Comic Strip opened its doors in October 1980 at another

strip venue called Raymond's Revue Bar. However, unlike the Store, the Strip, opened by Peter Richardson (the other half of *Outer Limits* with Nigel Planer), was more theatrical in its presentation, with theatre lights and a proper stage. Another comic couple at the Strip joined Richardson, Planer, Mayall, and Edmondson. Dawn French and Jennifer Saunders, who later had huge TV success both together, with *French and Saunders* and individually, with *The Vicar of Dibley* and *Absolutely Fabulous* respectively, made up this core group of double acts with Alexei Sayle as the compère.[66] Tony Allen often did guest spots for the Comic Strip, but he did not like the more formalised theatrical setting. He was much more at home with his 'Alternative Cabaret' – a crew of rag-tag "fringe theatre actors, buskers, speakers and musos."[67] Formed in 1979 Allen, along with his band of performers, played at pubs and clubs in the city of London and outward beyond its limits. As a group, 'Alternative Cabaret' is significant as it spawned the subsequent successes of (mainly) pub based comedy clubs, within and beyond the major cities.

Mayall has stated that the first year of the Comedy Store was its best. At that time, both the performers and the audience embraced the Store's ethos of experimentation and risk, where anything could happen. Mayall recalls, "you have to remember it came out of punk as well... So if you were lying, or a hypocrite, you got gonged... when they took the gong away it was a terrible mistake."[68] Keith Allen has criticised the rise of what he felt were middle-class comics hoping to make a career, which he regarded as diluting the anarchic atmosphere witnessed in the Store's early days. Some 35 years later the Store (now run by Don Ward, who was there from the beginning) is recognised as being integral to British stand-up comedy. The club and other alternative comedy venues helped launch the careers of comics, including Jo Brand, Ben Elton, Eddie Izzard, Peter Kay, Ross Noble and Jimmy Carr among many others. In its heyday British alternative comedy "sought to raise awareness of the prejudice that lurked in much mainstream comedy, and in making audiences increasingly intolerant of it."[69] Currently, however, alternative comedy perhaps retains only vestiges of its once political and liberal ethic, subsumed as it has been over the years into the big business of mass media cultural production. Oliver Double remains optimistic, however. Because of its popularity, the alternative comedy scene is controlled now more than ever before by filthy lucre. Big business may have de-radicalised the scene; yet, Double believes that stand-up in Britain still has the power to produce comedians with calibre, chops and real comic depth.[70] Finally the comedy critic William Cook

believes the biggest contribution that the 'alt' wave made was its "establishment of the comic as sole author and rightful owner of his own material," rather than championing anti-racist or anti-sexist humour.[71] Tony Allen disagrees. He argues that although alternative comedy did both, they were not the only ones challenging normalised prejudices. Through the 1970s raconteur comedians, including the likes of Billy Connolly, Mike Harding, Jasper Carrott and the Irish comic Dave Allen, were using the material of their personal lives for public amusement. Further, racist and sexist sentiment was being confronted and rejected throughout the contemporaneous radical and broader arts.[72] That said, there are few perhaps who would disagree with Cook's summing up of 'alt com' ethos; "Alternative humour celebrates similarity rather than condemning difference. The best of it hits hard and it hurts, but it's philanthropic, not misanthropic, a bridge and not a wall. Above all alternative comedy reveals something of the real life of the comedian. Since 1979 a laugh has become a means and not an end."[73] The long histories of stand-up comedy in both Britain and America have their respective origins in a strong music hall, variety and vaudeville tradition. Stand-up was born of these respective popular forms, and in many ways British stand-up and its American counterpart have developed in parallel. Clearly, and even from the potted histories of both traditions here, it is safe to say that British and American stand-up, have grown from rich, sustained and evolving popular culture traditions. Further, at the time of writing, the performance genre of British stand-up comedy, (along with its American counterpart as discussed), enjoys an international and commercially successful reputation.[74]

1.3 Hibernian varieties

In his history of stand-up, Allen makes some comments on the popularity of burnt cork minstrelsy. Allen acknowledges that British white actors had been 'blacking up' and performing black comic characters as early as the 1730s. In 1828 a white actor in New York, named Daddy Rice, performed (during an interval) a character named 'Jim Crow,' blacked up with burnt cork and singing a song of the same name.[75] The 'act' was an overnight success and, as Allen notes, Jim Crow was touring Victorian music hall within two years. Not long afterwards and from as early as 1837, Irish audiences had the pleasure of Jim Crow at the Theatre Royal in Dublin. As Morash notes, the success of Daddy Rice (Thomas Dartmouth Rice) sparked a wave of minstrel acts throughout the 1800s, chief among them being Eugene Stratton who performed in

the Theatre Royal in the 1890s.[76] Notwithstanding the popularity (as odious as it appears now) of minstrel shows with Irish audiences in the 1800s, the theatrical and popular entertainments landscape in Dublin at the fin-de-siècle was plentiful and eclectic. By the early 1890s three theatres were licensed to produce drama in Dublin, the Queens Royal Theatre, the Gaiety Theatre and the Theatre Royal.[77] While the Queens Theatre and the Theatre Royal had been in existence for some time, in 1871, brothers Michael and John Gunn opened the Gaiety Theatre, declaiming their intent to "give the public in Dublin the best in variety and excellence the world can afford."[78] The Gaiety Theatre constituted a departure from traditional repertory theatre, which housed a resident company of performers and technicians staging their own productions. Instead, the Gunn brothers operated the Gaiety Theatre as a dedicated touring house. The house accommodated the growing number of English and American theatrical companies coming to Ireland as a result of new rail and steamship routes. In 1874, the Gunn brothers took over the controlling interest at the nearby Theatre Royal and ran it as a touring house in much the same vein as the Gaiety until the Theatre Royal was destroyed by fire in 1880. It was reopened in 1897, when it again ran in something like the same way. During these years, typical bills at the Gaiety would include regular offerings of Shakespeare, along with operas including Wagner, Verdi and Bizet. Goldsmith, Sheridan and Wilde were presented, so too Gilbert and O'Sullivan were popular as were farces and romantic or musical comedies.[79] Not far away, the Queens Royal Theatre, under the directorship of Arthur Lloyd, "increasingly presented music-hall fare – comic turns, songs and performing animals."[80] This was to change materially in 1884 when the Queens Royal Theatre proclaimed itself to be (under new management by a British playwright and entrepreneur, J. W. Whitbread) the "Home of Irish Drama."[81] Although the Queens (as it came to be known) continued to host staple imported comedies it increasingly began to "adopt with relish the tradition of nationalist melodrama established by Dion Boucicault and developed by Hubert O'Grady."[82] Recent scholarship claims that Irish political melodrama was giving "expression… to problems which were vexing the minds of Irish men and women in the street, to matters of national concern and thence to aspirations of nationhood."[83] Others agree, with Philip B. Ryan stating, "The Queens will always be remembered as the home of the old Irish melodrama, long before the opening of the Abbey theatre."[84] If Irish nationalist melodrama gave "dramatic entertainment suitable for the satisfaction of a vast and largely uneducated audience,"[85] it was not the only form

of 'popular' entertainment to do so. In fact the people of Dublin had all manner of delights to choose from to ensure a decent evening out and about.

The entrepreneur and comic Dan Lowrey looms large on the Irish popular landscape, and could be considered a counterpart to Charles Morton and Tony Pastor. In 1879, Dan Lowrey launched the Star of Erin music hall (later to be renamed the Olympia), which is still in existence today. As a boy Lowrey, a native of Tipperary, had emigrated to England with his parents. Starting out as a comic singer in music halls, he had become a successful businessman in Liverpool, running a number of musical taverns, which provided entertainments along with food and drink. Lowrey then returned to Belfast, opening the Alhambra Music Hall in 1871. In 1878 Lowrey made his way to Dublin, where he surveyed a site in Campton Court off Dame Street in the city centre. In the early part of the century, Peg Woffington had sung there as a child in what once was the 'Widow Quinlan's Free and Easy.' In 1855 the Widow Quinlan's had become Connell's Monster Saloon Music Hall. When Lowrey opened the doors of the Star of Erin he presented a genuine music hall to the people of Dublin; admission was charged to pay for the entertainments, and it seems to have catered for a mixed-sex patronage. Although Dan personally kept his hall from degenerating into a 'free-and-easy', in the very early days, places like Connell's, which can lay claim to being Dublin's first music hall proper, "did acquire a certain naughty kind of glamour from the Nightlife of music and smoke... the raffish company and the 'shewing of limbs.'"[86] The Star of Erin, along with two other smaller entities, the Grafton and the Harp, all pronounced themselves to be music halls in the new meaning of the word (although some were more in line than others) in the sense that they were been pulled by the bootstraps out of the 'frowsy' free and easy style of saloon entertainments.[87] The Harp tried hard and was "well run [by a favourite Dublin comic actor Pat Kinsella] but remained primitive, and rather a Free-and-Easy,"[88] until its end in 1893. The Grafton sustained a fair reputation and managed to appeal to the workingman as well as a more sophisticated clientele. Reportedly Dan Lowrey also took over or managed the Grafton (although there is some variations in the accounts of what happened). The theatre became the Bijou (under Lowrey) and then the Savoy before closing for the last time in 1898.[89] Other halls in the city included the Hibernian Theatre of Varieties, although this was known locally as 'The Mechanics.'[90] The Dublin branch of the Mechanics Institute was in the habit of renting out their stage to theatrical companies. Regarded as a shoddy and low

music hall, somewhere between a tavern and a theatre, local authorities shut down the institute in 1902 because it did not come up to fire regulation standards.[91] The hall was pulled down and on its site was built the original Abbey Theatre, which was destroyed by fire in 1951. The Abbey was restored, and reopened in 1966; where it stands as Ireland's National Theatre. Other venues included the Ancient Concert Rooms, the Molesworth Hall, the Dublin Coffee Palace Hall and the concert halls in the Gresham and Grosvenor hotels.[92]

In much the same way as the British music halls operated, the Star of Erin, along with the others, was "not a legitimate theatre, but what could be termed as a 'people's theatre' as it had not the necessary licence or patent to perform plays, or even sketches involving two people, but it could supply music."[93] Clearly some halls flouted the licensing acts of the time including the Mechanics, which presented "variety, some early films and the occasional Irish play, performed in contravention of the patent laws."[94] The Star of Erin hosted many famous music hall stars from international circuits. Among those who performed at the Star of Erin were Bessie Bellwood, Marie Lloyd and the 'King of the Halls' Dan Leno (whose 'patter' between songs can be understood as an embryonic form of stand-up comedy), as I mentioned earlier. Over time, Dan Lowrey passed the management of the theatre to his son Dan Jnr, who changed its name to Dan Lowrey's Music Hall and Dan Lowrey's Theatre of Varieties, before Dan Lowrey Senior's death in 1890. In February 1897 Dan Jnr closed the theatre for further refurbishment. The theatre reopened in November of the same year, under the new name the Empire Palace. Now part of the renowned Moss circuit, the Empire could boast appearances by leading variety stars of the day.[95] Despite this, some critics were unhappy. *The Irish Playgoer* lamented the "circus form of entertainment... what we want here is variety, and we have not been getting it."[96] The Empire sat up and took notice, presenting music hall stars such as Florrie Forde, Vesta Victoria and Ella Shields. Johnny Patterson, known as the rambler from Clare and the comic Pat Kinsella (of the Harp), "represented Irish performers amongst the endless stream of comic acrobats, jugglers, sister acts, singers, and troupes of dancing girls who were guaranteed to empty the bars."[97] Broadly, and from a stylistic point of view, comedians during this period were character studies and singers of comic songs, and it is said that Charlie Chaplin and W.C. Fields both appeared at the Empire Palace, along with Gus Elen, Harry Champion and George Formby Senior, the aforementioned northern nitwit character.[98]

In 1897, the second Theatre Royal (after a stint as the Leinster Hall which seemed to cater more for recitals and operas rather than

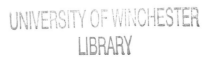

theatre or variety) finally opened its doors again. The new theatre held 2,011 seats and felt that "Grand opera, Shakespearean plays and serious drama would be more suited to the Royal stage" than the lighter musicals hosted by the Gaiety; however, the theatre did host a number of musical comedies in the early part of the century.[99] As musical comedy began to fall out of favour, the theatre is said to have turned more toward music hall turns. It is thought that Charlie Chaplin may well have played the Royal in 1906 as part of a song and dance troupe named 'The 8 Lancashire Lads.' While unremarkable music hall turns came and went during this period, other more renowned acts included Charles Coburn whose song 'The Man Who Broke the Bank at Monte Carlo' was very popular and who appeared at both the Theatre Royal and the Empire. Clearly, at this time there was healthy competition between theatre and variety houses in Dublin; in fact, Christopher Fitzsimon makes the point that "they all housed opera, operetta, music-hall variety and other types of spectacle... it is not possible to state that any one house maintained any particular policy towards its presentations over a sustained period."[100] The Gaiety Theatre is certainly a case in point. Seen by many in the fashionable set as the leading playhouse of its day, it continued to present a phantasmagoria of entertainments; from opera, Shakespeare and the Classics to melodrama, musical comedy, farce, pantomime and from around 1900 onward the Irish Plays. Over the road, the Empire was facing some new competition from the Lyric Theatre of Varieties, which opened in 1898. Charles M. Jones, who was also the manager of the Palace Theatre in Cork, was employed to direct operations. Originally built by Dan Lowrey in 1897, the Palace Theatre soon found its way into the hands of a Dublin consortium. This meant that acts that performed at the Lyric would often play at the Palace shortly afterwards. Of the many music hall acts that took to their boards, records of a handful of names remain, including Morny Cash, J.W. Rickaby, the patter comedians Karno and Lester, the singer Alice Lemure and (again) George Formby Senior.[101] Even from this brief snapshot, it is clear that the Irish (in the urban centres at least) had a wealth of choice when it came to cross-pollination entertainments during these years. That being said, and just as America and Britain had experienced, change was coming fast to Irish popular entertainments. In the years leading up to the First World War, music hall was gradually being replaced by new performance conventions, where "artists were given less time on the bill and sketches and cross-talk comedians were introduced."[102] Variety had arrived.

Meccas of entertainment

The coming of the First World War was, of course, to prove a difficult period for all of Dublin's theatres. Conscription and travelling restrictions made it almost impossible for overseas performers to honour their commitments. Needless to say, the momentous events of the Irish fight for an independent nation and the Easter Rising of 1916 held its own set of consequences. Irish performers tried to bridge the gap left by British music hall stars. The Theatre Royal and the Empire struggled but managed to keep their doors open. The Gaiety had advertised the start of a season with the D'Oyly Carte Company, to begin Easter Week 1916, but "history decided otherwise and instead they found themselves besieged in the Gresham Hotel, as bullets flew in O'Connell Street."[103] The Lyric, which was renamed the Tivoli Variety Theatre in 1901, also struggled to fill its advertised dates for similar reasons. The booking agent Charlie Jones tried to facilitate all: "I kept a 'nest' of artists together in Dublin and would assemble them every Monday morning while awaiting the usual urgent messages from theatres in Dublin, Cork, Belfast, Limerick and other places that so-and-so had failed to turn up... and always managed to complete the dates this way."[104] The years of fighting took its toll on the Queens, leaving the theatre closed for the majority of 1920 and 1921 after which the "aggressively heroic melodramas of P.J. Bourke and Ira Allen were badly out of touch with the dour post-Civil-War mood, and so the theatre reverted to earlier, more conciliatory Irish plays."[105] In June 1928 the Queens showed its first moving picture, a promise of things to come as cinema began to absorb the entertainment marketplace. By 1930 there were at least eight 'first run' cinemas in the city centre, in addition to the live shows offered by the Royal, the Gaiety, the Queens and the Olympia (in January 1923, the Empire reopened under its newest incarnation). The Tivoli was now deemed to be too small for the new fashion of cine-variety and it closed its doors in 1928. The La Scala Opera House on Prince's Street opened in 1920, before being renamed the Capitol Theatre in 1927. The theatre dropped its live show format in 1934 in favour of a full-time cinema. This may have seemed a strange choice, as the Capitol had a reputation by then as "The Mecca of Entertainment in Dublin."[106] However, when the lease changed hands again in 1934, the new management decided on a theatre, which was to present films only.

In the same year the second Theatre Royal was demolished to make way for the impressive third Theatre Royal, which reopened its doors

in September 1935, boasting a seating capacity of 3,700 and a winter garden. The theatre promised to dedicate itself to:

> the entertainment of the people of the Irish Free State and to Visitors from all countries. The New Theatre Royal would present to theatregoers Grand Opera, Musical, Comedy, Drama and Variety under conditions which had never before obtained in the Irish Free State, and in fact, are not excelled elsewhere. Every encouragement would be given to local Artistes.[107]

The new Theatre Royal provided an excellent setting for cine-variety, which "would include an electric Compton, a troupe of dancers and a film, and would provide a platform in Dublin for some of the best local and international variety performers and Hollywood stars."[108] Gracie Fields topped the bill there in July 1936, and a short film of J.M. Synge's *Riders To The Sea*, which Fields had backed, played during that week also. Other stars that appeared there during these years include Jimmy Durante, along with the famous British comedians Max Millar, Max Wall (Prof. Wallofsky), Tommy Trinder and Florence Desmond. The famous Irish comic Cecil Sheridan, described as 'The Parody King', because his comic songs stayed as close to the original songs as possible, first appeared on the Royal Stage in 1937. Meanwhile, the Queens continued to show films and cine-variety until the Second World War. During these years the Gaiety was under the management of the Elliman family who also took over the Queens in 1935/1936. By the 1940s the Elliman family controlled most of the cinema business in Ireland, as managing directors of Odeon (Ireland) Ltd, Irish Cinemas Ltd, and Amalgamated Cinemas (Ireland) Ltd.[109] The Queens continued to stage its pantomime (the famous comedy actor Jimmy O'Dea debuted there in pantomime in 1923) until the early 1950s, however, in the main it presented revue performances along with cine-variety.[110]

Whilst the theatres in Dublin were registering and adapting to market forces in post-World War and Civil-War Ireland, the number of 'fit-ups' or travelling companies reached something of a peak. Fit-up companies had traversed the length and breadth of Ireland since at least the early nineteenth century. By the 1930s there were around sixty companies on the roads, the overwhelming majority of which were presenting revues, drama and variety bills of fare. They gave struggling Irish performers work, which helped to supplement the sporadic offerings of the principal stages, which were very often occupied by British and American entertainments. So much so that the good people of rural Ireland may

have been just as familiar as their urban relations with the talents of Irish performers.[111] Along with the jobbing work of fit-ups, many Irish performers also managed to find success overseas. Although the likes of Shaun Glenville, John Ashcroft and Pat Rafferty had preceded him, arguably the most famous star of Irish variety during this period was Jimmy O'Dea, now fondly remembered as *Jimmy O'Dea, The Pride of the Coombe*. The song of the same name was written by Seamus Kavanagh in the 1930s and was made famous by O'Dea in the character of a Dublin street seller, Biddy Mulligan, in the 'Dame' tradition. Biddy was hugely popular to audiences of the time and so too, the Dame tradition was a convention broadly used during these years. Perhaps 'The Parody King' Cecil Sheridan's most famous creation (although he had many of them) was the character of a Dublin 'wan,' Martha Mary Anne Magee, who "was smarter than any girl you'll see. Although I'm over forty, I'm the best of company... when there're home on leave, who have the boys got on their sleeve?"[112] Well (no surprises) it's Martha Mary Ann Magee. Or on something of a related theme, although not in the Dame tradition, was comic entertainer Jack Cruise's John Joe Mahockey from Ballyslapadashamuckery, a parody of a 'culchie' or rural Irish man let loose in the big smoke. That being said, Jimmy O'Dea might well have been the people's favourite. Known as the 'King of Comedy,' his style can be described as that of a comic actor and character comedian; O'Dea could play anything from Shakespeare to revue sketches. He had his own troupe of successful performers and actors, including Noel Purcell, Connie Ryan, Fay Sargent, Eileen Marmion, Tom Dunne and Harry O'Donovan. O'Dea and Harry O'Donovan had formed a partnership in 1927 and as well as their collaborations on sketches and revue-style entertainments, they also found success in the early 1940s with the BBC radio series *Irish Half Hour*. O'Dea's career in variety and drama was extensive and (along with others, including Eddie Byrne, Al Sharpe and Ella Logan) he also went on to forge a successful film career. While he did star in a number of movies, he is perhaps best remembered for his role as King Brian in the film *Darby O'Gill and the Little People*. When he died in January 1965, the noted Irish actor Cyril Cusack dedicated his poem 'To a Dead Comedian' to the loss of a good friend. Cusack spoke of the blustery day that left little time for sentiment when he "attended the comedian's funeral, his going down... it was a rough day, a rough day for the theatre."[113]

Swan songs

The Second World War again brought difficult times to the Dublin theatres. In stringent circumstances, Louis Elliman managed (the Elliman

family empire had also taken over the Theatre Royal) to keep operating with almost exclusively Irish talent, including the theatrical expertise of the O'Dea/O'Donovan Company and the Edwards/MacLíammóir Gate Theatre Company. Through this period and beyond the Queens gradually established a troupe of performers known as the 'Happy Gang,' who lasted until 1951. At the time Elliman and Lorcan Bourke (of the Olympia) also fostered amateur companies in the city. Among the performers and companies that kept the theatres open in these troubling times were "Jack Cruise, Cecil Sheridan & Co; Frank O'Donovan & Co; Harry Bailey & Co; and Edgan Benyon – the Great Bamboozalem."[114] Most of these companies went on to achieve varying degrees of success in Britain, but they kept the Irish theatres open during the war years. The Olympia, which was now owned by Bob Morrison and Issac Bradshaw, survived due to the efforts of Bourke who engaged and fostered those "touring companies which in normal times would have been forced to exist in the Irish fit-ups."[115] According to David Devitt, "it was during this period that the [Theatre] Royal earned the great affection of Dublin audiences by helping to dispel the threat and gloom of the Emergency (Second World War) with lively and humorous revues, sketches and pantos."[116] Inevitably, and as in the cases of Britain and America, Irish 'fit-ups' and variety suffered the slings and arrows of radio, the film industry and television from approximately the 1940s onwards. The amalgamation of such forces delivered the deathblow to the mass popularity of the performance form. As in Britain, comic tastes were changing, and an Irish audience also tuned into the same BBC radio shows. The rise of television would finally kill off the variety star. Shows, including the likes of *Sunday Night at the London Palladium*, were beamed into front rooms around the country and variety just could not compete. Although performers, such as the noted comedian and actress Maureen Potter in her "*Gaels of Laughter* shows and Jack Cruise in his *Holiday Hayride*, fought a rearguard action for a little while" in reality the writing was on the wall.[117] Many of the stars of these pages continued in live performance, on Irish radio and on television both at home and abroad. So too in the 1970s and onwards through the succeeding years, performers, including Rosaleen Linenhan and Des Keogh, continued to fly the variety flag proudly with revue-style shows, written by Fergus Linehan among others.

The Theatre Royal finally closed its doors on 30 June 1962. The theatre was waked in style. Jimmy O'Dea, Milo O'Shea, Danny Cummins, Pauline Forbes, Harry O'Donovan, Jack Cruise, Noel Purcell, Cecil Sheridan and Mickser Reid performed their last "Star Spot" on the

Royal stage. The demolition ball began its grisly work on the follow-
ing Monday morning. The Queen's Theatre suffered a similar fate. The
Abbey Company, which had taken possession of the theatre (evicting
the 'Happy Gang' in the process) after the Abbey was destroyed by fire
in 1951, finally took their leave in 1966. In 1969 the Rank Organisation
gave the order for the demolition squad, the theatre was razed and
Pearse House was erected in its stead. The Queen's is remembered as
"the cradle of native Irish Drama and training ground for its finest
actors and actresses... during the war years, like the Royal it evolved a
distinctly Irish genre of light entertainment."[118]

The Capitol was also demolished in 1972. And the Olympia very
nearly suffered the same fate. By the 1950s onwards the theatre had
also registered the decline in the popularity of variety, and by the early
to mid-1970s funds were badly needed for the theatre's restoration. An
application for money to restore the theatre was not supported by the
city council. In 1975 the famed Irish actress Siobhan McKenna laid a
wreath at what was the Queen's Theatre to draw attention to the plight
of the Olympia. The might of the artistic professions from the world
of variety and theatre walked the streets of Dublin in protest. In what
Maureen Potter described as "the greatest selection of street walkers
Dublin has ever seen," the stars of Irish variety collected donations and
rallied support from the public.[119] Their efforts influenced city council-
lors, who eventually managed to find the funds to restore the building,
which reopened in March 1977. The Olympia also secured a preserva-
tion order, which continues to protect the theatre to this day. As a final
word here, it could be argued that Irish variety theatres faced their big-
gest challenge through wars and revolution. In an industry where the
top billing was usually reserved for British or international acts, during
the fighting years access to those variety stars was severely restricted.
In the face of such trials and tribulations Irish performers took to the
stages, establishing themselves as professionals with enough drawing
power and skill to attract Irish audiences both in city and in country.
In Philip Ryan's opinion, "that feat was accomplished mainly by the
comedians."[120] Names such as Jimmy O'Dea, Harry O'Donovan, Cecil
Sheridan, Noel Purcell, Danny Cummins, Harry Bailey, Jack Cruise, Hal
Roach, Patricia Cahill and Maureen Potter still resonate for many in liv-
ing memory. These Irish performers were a versatile bunch. The names
included within and without these pages worked across performance
styles and genres. Variety performers did their 'Star Turns' in panto, in
revues, in sketches and in drama. Cross-pollination was necessary per-
haps in order to secure work in the relatively small business of variety,

fit-ups and theatre in Ireland. The light entertainment genre is replete with comics and actors held within a rich tradition of music hall and variety. It is they that forged Irish variety and it is because of them that Ireland is endowed with a wealth of talent that forms a significant weave in the tapestry of Irish theatrical and popular culture history. As a final note, I want to make mention of my purpose here. The aim of this section of the book was to give a sense of the trailblazers; those who helped create and shape stand-up, as informing and underpinning the body of the work. I wanted to briefly document the American and British histories and traditions as comparative and influential models for Irish popular entertainments and our own comic evolutions. In that sense this is a potted history, which sought to give a flavour of those traditions. What I found was that the comparison of record, conventions, performance and comic styles when brought up against British and American knowledge, while very useful, also highlighted gaps. To my mind the scholarship in Irish popular histories and entertainments as outlined here is underdeveloped. There has, of course, been some work carried out, and sources include those who have had a personal interest in the history of popular entertainment and theatre in Ireland. More research is much needed in the field. Investigation into the development of performance conventions as well as specific enquiry into comic forms in Irish entertainment could yield rich results. The influences and connections between Irish, British and American popular genres would also be a very interesting area of enquiry. I suggest that research into these and related fields of interest will illuminate what is a fascinating area of popular culture in this country. That research may also add significantly to the body of knowledge on Irish performance histories, conventions and development, as well as a deeper understanding of how comedy works in Irish culture. Oliver Double recently published a book on variety in England in which he suggests that "Variety's influence can be seen in anything from the Futurist movement to Joan Littlewood's theatre workshop... yet in spite of this few people have attempted to take variety seriously."[121] Even then, British histories on music hall and variety are more extensive than our own. Double clearly states in his introduction that his aim is to 'fill the gap in [variety] literature;' we could do worse than take a leaf out of his book.

A small detour into Irish TV comedy

Paul Whittington has observed that in Ireland home-grown television comedy was very thin on the ground until the 1970s. Whittington observes that "the closest we came to Irish TV comedy in the 1960s

was Hal Roach on *The Late Late Show*, though in fairness, that show did expose us to international comic trends when the likes of Spike Milligan and Billy Connolly became regulars in the 1970s."[122] Irish TV comedy truly arrived with the magazine show *Hall's Pictorial Weekly*, written and presented by Frank Hall, and including sketches and monologues performed in tandem with the talents of Frank Kelly and fellow comic and actor, Eamonn Morrissey, among others. The programme, which ran from 1971 to 1980, was considered quite controversial as it satirised Irish life and politics at a time when voices of dissent were held in deep suspicion (as, indeed, some would argue they still are) by instruments of the state and institutional religion in Ireland. As Whittington reminds us, "no one who lived through the dark days of the 1970s will forget Morrissey's 'Minister for Hardship,' a [scathing] portrait of [then] Taoiseach [Premier] Liam Cosgrave in tatty bowler hat and fingerless gloves."[123] Arguably the next good comedy show came in the unlikely form of ex-RTÉ continuity announcer Mike Murphy. Beginning in 1979 *The Live Mike* hosted by Murphy, had a Candid-Camera-style format, playing pranks on unwitting members of the general public. It also produced comic sketches among which featured the comedian Dermot Morgan's first clerical creation, that of 'Father Trendy.' Morgan went on to star as the eponymous and hugely successful *Father Ted* for Channel 4 in Britain through the 1990s. *The Live Mike* ended in 1982, and was followed in the late 1980s by *Nighthawks*. Hosted by Shay Healy, this show was another magazine format, mixing short bursts of interviews with celebrities and politicians, along with sketches and 'bits,' including performance by comedians such as the laconic Kevin McAleer and (some would say) the iconic Graham Norton. McAleer continues to produce comic shows, which he tours nationally and internationally. Norton, who also played Father Noel Furlong in several episodes of *Father Ted*, has carved out a hugely successful career, first as presenter of his Channel Four show entitled *The Graham Norton Show* and latterly on BBC1.

Moving on and into the late 1990s then, among the most noteworthy shows was *Bull Island*, whose political satire regularly took great pleasure in lampooning elected representatives of the day. The show ran from 1999 to 2001 with a brief stint on RTÉ radio. A mention should also be made here for another very successful radio show called *Scrap Saturday*. The show, which ran from the late 1980s into the early 1990s, was the brainchild of a number of performers: Dermot Morgan, Gerard Stembridge, Owen Roe and Pauline McLynn. *Scrap Saturday* took great pleasure in mocking the political and business establishment in Ireland

at the time and there was an outcry when RTÉ scrapped it with little in the way of explanation. Additionally, the national broadcaster, RTÉ, has increasingly filled its comedy schedule over the last ten years with programming hosted or created by stand-up comics. The list is a long one and includes Jason Byrne's *The Byrne Ultimatum* (2009), Maeve Higgins' *Fancy Vittles*, *The Modest Adventures of David O' Doherty* (2007), *Naked Camera* (2005–07), *The Panel* (2003–), *Pictorial Weekly* (2012–), (a nod to the earlier show) and *The Savage Eye* (2009–). *Pictorial Weekly* and *The Savage Eye* can be regarded as two of the best satirical comedy sketch shows in recent years, proving very popular, from both a critical and a ratings standpoint, as part of RTÉ's current comedy scheduling. Finally here, it would be remiss to overlook the wealth of reality TV shows that have incorporated the talents of stand-up comics in Ireland in recent years. Shows such as *Karl Spain Wants a Woman* (2005), which follows the stand-up comedian Spain in his search for a potential girlfriend, have been well received, but perhaps the most popular of this type of programming has been the formats employed by the popular stand-up comedian Des Bishop. Bishop's work includes *Des Bishop's Work Experience* (2004) and *Joy in the Hood* (2006). His 2008 vehicle, *In The Name of the Fada* (2008), followed Bishop's life for 11 months in the west of Ireland. His objective was to live in the Gaeltacht and learn Irish, so as to "reclaim the tradition of the seanchai in its modern incarnation – stand up comedy."[124]

1.4 Stand-Up: alternative Hibernia

Perhaps in the minds of many people who frequented the Capitol Theatre on Prince's Street, which was demolished in 1972, Mike Nolan stood out more than most. I begin with Mike Nolan as precursor to the alternative comedy scene in Ireland, as along with appearances as a Dame, Nolan performed something resembling a stand-up comedy routine. Interestingly, lamenting the fact that Nolan did not have a "character" or persona of his own, one Dublin critic noted:

> Mike Nolan created no easily remembered character like Jimmy O'Dea's Mrs. Mulligan, Jack Cruise's John Joe Mahockey, or Cecil Sheridan's Martha Mary Ann Magee... he had the readiest of wit and an enviable flow of authentic Dublin wise-cracks... great in his simplicity of manner, his total absence of pretentiousness.[125]

Nolan's style of comedy, which was seemingly regarded as slightly askew by the comedy pundits of the time, was evidently a forerunner

to growing ideas of stand-up comedy on Irish stages. Among the others playing the Dublin stages of the time, a young Frank Kelly was learning his craft. Although he considers himself to be an actor rather than a comedian, Kelly began his career at the Old Time Music Hall at the Eblana Theatre in Dublin. Kelly worked with Cecil Sheridan and Jack Cruise, as well as Jimmy O'Dea in 'panto' and revues with bouts of straight acting work supplementing the comic bill from time to time.[126] In terms of his beginnings in variety, Kelly can certainly be regarded as one of the few remaining performers that constitute a "living link between the era of music hall stars such as Jimmy O'Dea, Jack Cruise and Cecil Sheridan and the 1990s comedy of Ardal O'Hanlon, Tommy Tiernan and Father Ted."[127] In the 1970s comedians, including the likes of Frank Carson and Jimmy Cricket (James Mulgrew), broke into the British market and built successful comic careers, although some would argue that those careers, especially in the case of Jimmy Cricket, were largely fashioned on the back of Irish stereotypes. Jimmy Cricket's act had a recurrent theme of getting the 'letter from Mammy', and he wore Wellington boots, which had L and R painted onto the fronts of them. Unfortunately, he also wore them on the wrong feet. Arguably the most influential of those breakthrough comics was David Tynan O'Mahoney, who adopted the stage name Dave Allen. He made it all the way to his own British TV shows, such as *Tonight with Dave Allen* and *Dave Allen at Large*. Allen's style was casual, most often sitting in an easy chair, chain-smoking while drinking (or at least appearing to drink) whiskey. His laid-back conversational style of performing has been described as "incorporating the Irish storytelling tradition... [with] scathing sketches about the church and hilarious monologues about how he lost one of his fingers."[128] His method of performing inspired a generation of comics that followed him, including Dylan Moran, who has observed that he had really admired Allen as a child. In Moran's view, Allen "was really good at describing a perfectly ordinary thing that people did every day and taking it apart and showing people how absurd it was. It was, and is, a great method: just to stop and look longer than other people."[129]

Back in the late 1970s in Dublin a young rock promoter by the name of Billy McGrath (who also went by the name Magra) was determined that comedy in Ireland needed his brand of organisation. Short-lived clubs such as that in Harcourt Street (Kevin McAleer appeared at the club in the early days of his career. He was 'gonged' off, 'Comedy Store'-style after only a minute or two) popped up and disappeared. Tony Allen had even come across the water for a couple of shows; however, the comedy scene in Ireland at this time was sporadic and disorganised. Enter Billy

Magra, who felt that like the Comedy Store in London, the spirit for stand-up was riding high in Ireland; Magra felt the thing to do was, "Find your own venue, and if you're exciting enough... people will follow and if you're not exciting enough and you don't deliver and you short-change your audience... then you will disappear."[130] Magra was aware that Dublin could not support a full-time comedy club, and so sporadic gigs would appear at sporadic events such as the Project Arts Centre or the Sportsman's Inn, with Magra eventually opening the *Gasworks* comedy club in the Waterfront Café on Sir John Rogerson's Quay in the city centre. In an interview with Fintan O'Toole in 1983, Magra made clear his feelings on ideas of Irish comedy as being a story of opposites:

> ...It's either Sheridan and Wilde and Joyce or else its Hal Roach in Jury's cabaret... everybody talks about the wit and natural humour of the Irish and you go into pubs and there it is, but it's a different story when they're on their own on stage. It's always been character comedy, with the comedian adopting a role. That's really false... And they become stuck in those roles... I think there's a far more danger-ous element to it. There has to be.[131]

Magra was determined and it was only a matter of time before the Irish approximation of the Comedy Store was born. Oliver Double pinpoints the opening of the Comedy Cellar in Dublin at the International Bar in 1988 as central to the birth of the Irish alternative comedy scene. The Comedy Cellar came into being as a result of the efforts of a bunch of like-minded Irish comedians in the mid-1980s, including Ardal O'Hanlon, Barry Murphy, and Kevin Gildea. Dermot Carmody and Anne Gildea also came on board. Coming up for a name for themselves, Murphy, Carmody, Gildea and O'Hanlon decided to call their comedy troupe *Mr Trellis the Mormon*, which, in time, became simply *Mr Trellis*. Mr Trellis have been described in retrospect as a comedy group that realised:

> a fresh approach at physical, surreal and scatological comedy. The three [Murphy, Gildea and O'Hanlon] met at the National Institute for Higher Education (NIHE), now Dublin City University (DCU) and Mr Trellis began performing in the International Bar, inviting other acts to test their mettle. The Comedy Cellar was born.[132]

Ardal O'Hanlon describes the situation at the time. The Comedy Cellar was set up as the last recession in Ireland was beginning to show signs of slowing down. However, at the time, it had done its job very well, the

country boasted few jobs and fewer career opportunities. The setting up of the club was a "reaction to the conditions we found ourselves in... It was about having fun and doing something useful and creative. What else was there? Despair... or poetry."[133] In creating the Cellar, O'Hanlon observed that the group saw themselves as '"sort of the equivalent of German intellectual radicals and we had all these ideas about shaking up comedy and society... I think we really did want to live some kind of bohemian existence."'[134] The Cellar very quickly gained a reputation for alternative comedy, against a backdrop of Irish comedians in the more traditional style, including the comic talents of Brendan Grace and Niall Tóibín. As Barry Murphy tells it, "There were no rules – only that you had to be original to earn your place on the stage."[135] Before long, anybody who was anybody or wanted to be somebody in the new wave of stand-up comedy in Ireland took to the unlit, un-miked stage on Wicklow Street.

If the Cellar established itself as the centre of a growing stand-up comedy circuit in Ireland, it was integral in placing Ireland firmly on the map of a broader and international stand-up comedy landscape. There were, however, some trailblazers who had already set a precedent for stand-up success on other shores. As William Cook noted "A comic isn't accepted as a proper star in the provinces until he's made it in the Big Smoke, and this perverse logic even applies to such Irish comics as Sean Hughes and Michael Redmond."[136] Redmond garnered considerable success in Britain in the 1980s and 1990s and is particularly renowned for his portrayal of Father Stone in *Father Ted*. The comic began his stand-up career in 1982 at the Sportsman's Inn in Mount Merrion, Dublin, which was then run by Billy Magra. Redmond also wrote scripts for RTÉ, but the financial uncertainty of the comic's career drove Redmond to London. Journalist, Ian Doherty noted:

> the English comedians were a product of the time and a lot of the comedy was reacting against the environment, whereas the Irish lads were just a product of their own demented imaginations. I suppose it was that, sandwiched between the agit-prop comics who barked at you and were members of militant Labour and the whole holier-than-thou trend, the ideas of a guy like Michael Redmond coming out with utter nonsense – but inspired nonsense – would have been exciting. It's impossible to imagine Redmond going on stage and saying "Margaret Thatcher – what a bitch.[137]

The British public, certainly in the eyes of Sean Hughes (although he may have been a little biased), adored Redmond, and for some years

Hughes found it hard to live in his shadow. In fact, it was Hughes who persuaded Redmond to try their luck on the British circuit. Hughes may have initially felt somewhat inferior to the talents of Redmond, but his feelings of inferiority were to prove short-lived; the comic, who has been compared to "Samuel Beckett if he'd grown up listening to The Smiths,"[138] went on to carve a very successful career in Britain.[139] That said, the Cellar established strong relationships with British and international comedy circuits, with perhaps Redmond and Hughes being among the first to establish themselves within the thriving British scene of the time. It played host (and still does) to aspiring comedians from both Ireland and abroad. Dylan Moran, Tommy Tiernan and Dara Ó Briain all established their early careers in the Cellar and as the club garnered a reputation, comics of the ilk of Eddie Izzard also gigged there. The Cellar was very supportive of the comedians, as were the audiences. Dylan Moran recalls:

> I always remember that in the Comedy Cellar, where I learned my stuff, and where most of my Irish contemporaries did, the audiences were really wonderful – although they had a breaking point, mostly they would sit there and watch anything. Which is what you want when you are at that point. But in England it's hit them, hit them, and if you don't hit them you're off the stage.[140]

The Comedy Cellar is now readily accepted as the birthplace of alternative Hibernia. Its significance rests in the fact that it gave a home to and established a stand-up comedy scene, which was experimental and which challenged more traditional comic conventions and styles. It also located Ireland within international comedy circuits and networks. In its current guise, the club runs once a week alongside the International Comedy Club, which is managed by the successful comedians Des and Aidan Bishop. The International Comedy Club currently runs four nights a week, with two shows on a Saturday. Other comedy clubs in Dublin include the Laughter Lounge, which also advertises its power to attract Irish and international acts. The Capital Comedy Club at the Ha'Penny Bridge Inn runs two nights a week and promotes itself as a venue which has played host to the all the major stars of Irish comedy, and larger venues such as the Olympia Theatre, Vicar Street and the O2 (Point Depot) in Dublin all offer Irish and international comedy acts. Arguably the Store also directly influenced the explosion of the stand-up comedy scene around the clubs, pubs and venues of Ireland. That scene currently boasts a proliferation of comedy clubs in the major and

provincial cities and a thriving comedy circuit, playing in all manner of establishments around the country.[141]

O'Hanlon, Murphy and Kildea all went on to successful comic careers of their own (Murphy is probably best known for *Après Match*, a parody of sports commentary programming) and the club is perhaps not the *tour de force* that it once was. There are those, including Murphy, who have been accused of holding too much reverence for the Cellar. Brian Boyd makes the point that the '"veneration of the Comedy Cellar is detrimental to Irish comedy. It's actually quite ridiculous – the Cellar now is a very different thing to what it was. How important is the Comedy Cellar now? It's nostalgia really, isn't it?"'[142] There are others whose view is not quite as negative as Boyd. Alex Lyons observed in 1998 that the Cellar:

> [has] been consistently there for 10 years and once in a while it does get back to that atmosphere it once had. There is still that feeling about the place. It's given a platform and it's totally unpretentious and it's never been into money... if it was a theatre, it would have produced Liam Neeson and Gabriel Byrne. It's an extraordinary record of a small room above a pub.[143]

Twenty-five or so years ago there was virtually no alternative or stand-up comedy scene in Ireland until Billy Magra and the comedy stylings of *Mr Trellis* established one. For the scores of acts that have come through the doors of the Cellar, many have gone on to national and international success, including the likes of Tiernan, Izzard and Moran. Murphy may well be accused of nostalgia when it comes to the club, but he is not alone. Ardal O'Hanlon feels that the club never quite reached its true potential. However, O'Hanlon is appreciative of what the club did achieve, "it shaped all of us in some way. And, despite its humble origins, it was a huge influence on modern Irish comedy. I'm immensely proud to have been involved in it."[144] The founders of the Cellar did move on, O'Hanlon to heights of fame in *Father Ted*, Gildea to success on the London circuit, and Carmody to his own web design business. So too, Anne Gildea has achieved her own successes with the "agricultural Spice Girls on acid,"[145] super group, *The Nualas*. Barry Murphy does admit to being very romantic when he recalls the early days of the Cellar, describing the kind of comedy produced by *Mr Trellis* as a beautiful thing. Murphy chose to forge a successful career in Irish radio and television as the others moved on to the London circuit and beyond, keeping the Cellar going in the gap left by the departure of Moran, Gildea and O'Hanlon. For that and for his sustained and largely

successful efforts at getting Irish comics on Irish telly (*Couched, Soupy Norman, Après Match and Pictorial Weekly*), it is, therefore, no real surprise to hear Murphy described as the "Godfather of Irish Comedy"[146] for his role and influence on the Irish comic landscape.

In a recent article in *The Irish Times* Brian Boyd points up the irony that after so many years of growing a strong and healthy club circuit, Irish stand-up comedy has entered mainstream entertainment from its humble beginnings in a room over a pub. Open-mic spots on Irish television such as the *The Panel* and well-received satirical comedy sketch shows such as *Pictorial Weekly* and the *The Savage Eye* (as already mentioned, and among others) have placed stand-up comics as a mainstay of Irish television entertainment. This kind of exposure ensures that upcoming stand-up comics are "watched by all the movers and shakers in the comedy industry (bookers, agents, management), and also on UK channels, by millions of viewers."[147] What Boyd is suggesting here is that learning the craft of stand-up on the club circuit can be overleaped by mass media exposure. That exposure also works to keep people watching their favourite comedians in the comfort of their own homes, rather than in live venues. The influence and the power of mass media on stand-up comedy are evident, in this country and elsewhere; however, I would argue that the Irish scene and circuit is still a healthy one.[148] Paul Whittington believes that since the millennium Irish TV comedy has entered its "golden age."[149] So too, Irish stand-up comedy in all its guises and formats (which has heavily influenced and shaped national TV comedy programming in recent years) is thriving. Irish stand-up comedy has the capacity to draw large audiences, with Tiernan's record-breaking box office sales in Vicar Street being just one case in point.[150] Clearly then, the Irish stand-up scene has a symbiotic relationship with its British and American counterparts. Irish comics work both national and international circuits and international stand-up comic stars and performers play the major (and minor) venues in Ireland. All three were born out of the popular entertainments of music hall, vaudeville and variety. In the end here, I would argue that Irish stand-up comedy is both exportable and successful; that Irish comics are well represented as part of the form's international market share of popular entertainment in both live and in media formats; and, finally, that stand-up is possibly one of the strongest forms of entertainment on the current landscape of Irish popular culture.

2
The Comic 'i'

2.1 Stand-Up – the personal dimension

In Chapter 1, I discussed how the art of joking became more closely associated with the personality and life of the comic from around the time of the rise of the 'sick comics' in America, and how that ethos and approach infiltrated comedy styles in Britain and Ireland. There are many ways in which a comedian will connect with his or her audience and I will return to the subject in more detail a little later in this study. From more traditional (at times) and contemporary standpoints; the means by which a comedian will attempt to connect with an audience is tied intimately to ideas of self-expression. That is, the comedian is communicating to the audience something drawn from the experience of his or her own life. The comedian may well frame the performance of him or herself as:

> The real deal: this is me exposing the humorous side of my life... [so much so] that some comedy audiences refuse to believe the material is prepared at all, expecting comedians to produce a new set of jokes every night, as though they were evangelists speaking in tongues.[1]

Mort Sahl, whose style (as I have already discussed) is said to have laid the groundwork for today's stand-up comedian, determined that expressing his opinions meant that he "acted like a human being rather than a night club comedian."[2] However, not all comedians work from the viewpoint of self-expressivity. The idea of character comedians, those who play roles away from themselves, can, to an extent, be viewed somewhat askance by their peers in the industry. The British comedian Frank Skinner echoes the sentiment, "I've never been so crazy

about character-comics... I know it can be really funny but, personally, I like to know the person who's up there. I want their opinions and attitudes... if I want characters, I'll watch a play."[3] Shazia Mirza, who became famous with her post-9/11 joke, 'my name is Shazia Mirza – at least that's what is says on my pilot's licence,' realised that the way to talk about her life became less about well-constructed set-up/punchline gags and more about recounting her experiences.[4] Similarly, comedian-turned-playwright Patrick Marber states that stand-up is based on the premise, "This is my view of the world, this is my little angle on life," and Harry Hill is of the view that "once everyone started doing their own material, most people are putting over something about themselves, no matter how hidden it is."[5]

Those brave enough to attempt to define the performance form of stand-up comedy acknowledge its inherent slipperiness. Oliver Double, for example, recognises that concrete definitions of the form are notoriously difficult. He makes a comparison between "stand-up and comic poets, circus clowns, storytellers and performers of character monologues."[6] A more recent redefinition of the form is:

> It puts a person on display in front of an audience, whether that person is an exaggerated comic character or a version of the performer's own self... [it signifies] a direct communication between performer and audience... an intense relationship... a conversation made up of jokes, laughter and sometimes less pleasant responses... in the present tense... it acknowledges the performance situation.[7]

Double suggests that despite the hazards taken by a comedian when he or she puts aspects of his or her private self on display, stand-up is an art form which allows material drawn from real life to become the subject of laughter. Current understandings of stand-up are peppered with the telling of personal experience, of stories of an autobiographical nature, of personal attitudes and everyday life choices, no matter how 'hidden' it may seem at times. The comic is telling the audience, 'hey this is me and this is the funny side of my life', or 'here are my experiences and views of the world, but I still want to make you laugh.' That said, stand-up comedy has various styles of performance, many of which are very far from a style embedded in personal experience, opinions and attitudes. Yet stand-up comedy does clearly remain a performance form heavily invested in ideas of self-expression and it was this fundamental aspect of stand-up that became the starting point for my investigations six years ago. And it is with this notion in mind that I again set out

my stall today. I wish to begin this chapter by considering ideas of self-identity. To do so, I have chosen to examine how the storied self, that is the self as constituted in narrative, may connect to the performed everyday self and reach out to more formalised notions of performance. I do this in order to gain an understanding of how self-identity is at work as performance in stand-up comedy. I wish then to look at how stand-up praxis works, as process and product, in the hope that the discussion will illuminate how the 'self' becomes the comic self in performance. Building on these discussions, I want to propose a small formulation, which I have called the comic 'i' as a useful means of understanding how the 'self' is transmitted by means of a comic persona on the stand-up stage. Finally, the chapter will look to those mediating factors which materially contextualise how the comic 'self' works within the rules of the comic frame, which of necessity emits the 'Hey! I'm only joking!' signal. As the chapter unfolds, I will be referring to the three case studies that form the later part of this book as well as the work of other comedians to illuminate the discussion. However, in the main this chapter deals with the theoretical frameworks, which will add ballast through the succeeding chapters of in-depth analyses on the comic works of Tommy Tiernan, Dylan Moran and Maeve Higgins.

2.2 The storied self

Paul Ricoeur's work on narrative identity is very useful. In his essay, *Life in Quest Of Narrative*, Paul Ricoeur draws from modern narrative theories, that of Russian and Czech formalism, French structuralism, and Aristotle's *Poetics* to reinterpret the relationship between lived experience and narrative fiction. Ricoeur casts significant doubt on the maxim that "stories are recounted and not lived; life is lived and not recounted."[8] He grounds the relationship between life and narrative within the concept of tradition and initially interrogates narrative in terms of the literary work over time. In doing so, Riceour proposes a model, which rests on the twin concepts of sedimentation and innovation. Utilising Aristotle's concept of emplotment, Ricoeur argues that it is sedimentation which retrospectively creates what he terms a "typology of emplotment," allowing a categorisation of literary types over time.[9] It must be understood that the typology does not represent conservative understanding of "eternal essences... rather the typology must be understood as proceeding... from a sedimented history whose genesis has been obliterated."[10] Such work of classification and identification has, however, an opposite pole, that of innovation. However,

the models of innovation work in a number of ways upon models of sedimentation. Ricoeur argues that the models of innovation draw from the models of sedimentation, which were themselves innovative at one time and as such provide an experimental framework. Although tradition may resist innovation, that which is new in the narrative domain, so too innovation is influenced by the rules of what came before; in other words, it is bound in certain ways to tradition. The work of imagination, as Ricoeur tells us, "does not come out of nowhere. It is tied in one way or another to the models handed down by tradition. But it can enter into a variable relation to these models... between servile repetition and calculated deviance, passing by way of all the degrees of order distortion."[11] Ricoeur suggests that the concept of deviance lives within the temporal dynamic imagination in dialectic tension between the poles of sedimentation and innovation.

This discussion has looked at the literary work over time. What is useful for my purpose is Ricoeur's ideas of sedimentation and innovation when applied to individual life stories.[12] Ricoeur suggests that the interpretation of experiences in life can be categorised in Aristotle's definition of narrative, as "the imitation of an action, *mimesis praxeos*."[13] Narrative may be understood to function by way of its attempt to imitate action from an imaginative perspective. Narrative understanding of experience and its expression operates in a number of ways. What Ricoeur defines as *semantics of action* is understood as the comprehension of human action by means of our ability to utilise, in a meaningful way, all the communicative and conceptual frameworks employed by natural languages.[14] In this way we understand human action in much the same way that we describe the plots of stories. Understanding narrative in this way points us toward Ricoeur's third point of anchorage between narrative understanding and experience, which Riceour describes as the "pre-narrative quality of human experience."[15] Held within this concept is the argument that life may actually be understood as an emergent story and further that life is always in pursuit of narrative. It seems a circular argument as Ricoeur acknowledges:

> If all human experience is already mediated by all sorts of symbolic systems, it is also mediated by all sorts of stories that we have heard. How can we then speak... of a human life in the nascent state, since we have no access to the temporal drama of existence outside of stories recounted about this by people other than ourselves... is the notion of a potential story unacceptable?[16]

Ricoeur responds by way of a set of situations. Borrowing from psychoanalytic theory, Ricoeur suggests that the narrative purpose of the discipline and the analysand is an attempt to reveal the splinters of the patient's lived experiences and episodes that have been either repressed or untold. In doing so the analysand draws from the patient a series of fragmented stories toward the construction of more tangible narratives which the patient may understand and accept responsibility for. In this way the actual stories revealed, which the subject takes control of, may constitute his or her own *"personal identity."*[17] Accordingly, the concept of personal identity can be understood as pursuit of self-identity and assures a continuum between the potential story and the actual story one may own. In terms of self-understanding, then, and borrowing from the concept of narrative understanding, personal identity can be construed as a productive active exercise, that which is not inflicted from external sources, but is instead one of personal discovery, which may constitute our own *"narrative identity."*[18] This sense of narrative identity does not function as unconnected and episodic and nor is it in any sense fixed or unchangeable. It is within these two poles that narrative identity or composition finds its force.

Aligning the ideas of narrative identity and subjectivity and bringing them side by side illuminates a number of points. It is within these terms of self-understanding borrowed again from narrative understanding that one can apply to self-understanding the concepts of sedimentation and innovation discussed earlier in terms of the literary work. In other words, in applying to self-understanding the concepts of traditionality embedded in the literary work, wherein the author operates within the concept of sedimentation and innovation, then it is possible to become the *"narrator* and the hero *of our own story* without actually becoming the *author of our own life."*[19] If we accept this, we then must also accept that as well as the continual construction and dynamism of narrative identity there is also the point at which narrative identity must also reinterpret itself in the light of the continual construction and circulation of narratives offered to us from our own cultures. If it is true that we can never become the author of our own life and in this the gap between fiction and life is a gaping one, then we must concede the maxim held by those who insist that stories are told, life is lived and never the twain shall meet. However, we may redress the balance somewhat if we consider our ability to co-opt the stories and symbols from our culture as an irreducible dimension of our own narrative composition. In other words it is by trying out and role-playing imaginatively with the plots and stories of our culture that the self continues

actively to pursue narrative understanding, as an activity in pursuit of narrative identity, which operates in the space between absolute change and absolute permanence. It is in this continual sense of becoming through our own potentiality as a narrative understanding of the self and through appropriating the narratives of various cultural traditions as part of that becoming that we close the gap between a life that is lived and stories that are told.

The noted psychologist Ciarán Benson calls upon Ricoeur and Jerome Bruner, among others, to situate and underpin his work on narrative and identity. From Benson's perspective, fundamental to the cultural psychology of selfhood is the argument that "the story or stories of myself that I tell, that I hear others tell of me, that I am unable or unwilling to tell, are not independent of the self that I am: they are constitutive of *me*."[20] Central to Benson's work is the idea that "A story is an answer to a question. Who are you? Where do you come from? What do you do? Why did you do it? What happened? What happened next?"[21] The tale that is told in response is never a complete story, for there is always another direction in which the story could travel, and there will always be something more to say. The reply will always be mediated by "the conditions shaping the act of asking the question, and the freedoms and fears of the person asked, [which] give substance to the story told."[22] Benson argues for a synonymous relationship between the self and the story of the self. The story that one tells of oneself, then, can be understood as a narrative construction or representation, mediated by particular restraints, freedoms and circumstances in the moment of telling. In this way the story of the self foregrounds the idea that a life is always constructed as an ongoing discourse with the self and with others. In similar vein, Ochs and Capps argue that because personal narratives are grounded within our subjective involvement with the world, they can only ever be partial representations, they are "versions of reality… they are how we attend to and feel about events… partial representations and evocations of the world as we know it."[23] Further Ochs and Capps suggest, "selves evolve in the time frame of a single telling as well as in the course of the many tellings that eventually compose a life."[24] The story of the self is continually informed by the choices made in moments of telling, so that "my 'life' will always be edited version."[25] Drawing upon these discussions, then, I wish to put forward an idea. I suggest that self-identity, in which the story of the self is not independent of the self, but that which constitutes the self can be connected to ideas of comic persona(e) in stand-up performance. I am going to interrogate the possibility of this notion here. I do

so in order to connect the story of the self as constitutive of 'me' when brought up close to the *performance* of the self on the stand-up comic stage. However, connecting the story of 'me' as self-identity and the story of 'me' in stand-up performance is radically contextualised by a number of mitigating factors. In order to interrogate those connections, I want to look at how the self-expressive medium of stand-up comedy creates the 'material' product for performance, which troubles any easy assumptions of the 'truthful self' at work in the form. Secondly I want to look at how that 'material' is communicated to an audience through the prism of a comic persona. Finally, I am going to open up the discussion on the relationship between the story of 'me' as and its connection to that comic persona by suggesting a particular formulation. I want to suggest the concept of a comic 'i' as a useful means of analysing identity in stand-up performance.

2.3 Comic strips

In 1959, Erving Goffman became one of the first theorists to look to ideas of theatre as a model through which to analyse everyday behaviour. Goffman recognised and separated out ideas of the "individual complex identity and the specialized function of a person in a social role."[26] That said, his work made a significant contribution to understanding how "everyday social interactions consist of pre-established patterns or routines."[27] Goffman used a theatrical paradigm to describe how social interactions are staged: "people prepare their social roles (various personae or masks, different techniques of role playing) 'backstage'" and then enter the "'main stage'" areas in order to play out key social interactions and routines."[28] These communicative tools are utilised to signify social status within the group, and may be intended as either deceptive or genuinely intended to reflect the "reality" of the self. Goffman believed that all human behaviour exhibits features of the performative:

> A theatrical performance or a staged confidence game requires a thorough scripting of the spoken content of the routine... It is expected that the performer of illusions will already know a good deal about how to manage his voice, his face... The legitimate performances of everyday life are not "acted" or "put on" in the sense that the performer knows in advance just what he is going to do... the incapacity of the ordinary individual to formulate the movements of his eyes and body does not mean that he will not express himself through

these devices in a way that is dramatized and pre-formed in his repertoire of actions.[29]

In recent years, the performance theorist and theatre practitioner Richard Schechner posed the question that Goffman had asked in 1959; "How can you distinguish between performance and non-performance, between art and life?"[30] In a world where, until relatively recently, some degree of fixedness existed between the categories, those boundaries have now become increasingly blurry. And so there is "theatre in the theatre; theatre in ordinary life; events in ordinary life that can be interpreted as theatre; events from ordinary life that can be brought into the theatre and as continuations of ordinary life."[31] If, as Goffman argues, all human behaviour contains elements of the performative, what is the difference between what we formally understand as acting and the performative behaviour of the everyday? 'Nothing' would seem to be Schechner's response, and he is not alone in drawing this conclusion. In his view, the theatrical event is theatre because that is how it is perceived, presented and received, and the frame "this is theatre" identifies theatrical behaviour.[32] So, the "difference between performing myself – acting out a dream, re-experiencing a childhood trauma, showing you what I did yesterday – and more formal "presentations of self"... is a difference of degree not kind."[33] Schechner argues for his performance model of 'restoration of behaviour' as constituting that linked continuum between the self, the performing self and the performance itself, so that "living behaviour... restored behaviour is the main characteristic of performance."[34] He defines his paradigm:

> Restored behaviour is living behaviour... These strips of living behaviour can be rearranged or reconstructed; they are independent of the causal systems (social, psychological, technological) that brought them into existence. They have a life of their own. The original "truth" or "source" may be lost, ignored or contradicted – even while this truth or source is apparently being honoured and observed. How the strip of behaviour was made, found, or developed may be unknown or concealed; elaborated; distorted by myth and tradition. Originating as a process, used in the process of rehearsal to make a new process, a performance, the strips of behaviour are not themselves process but things, items, 'material.'"[35]

Schechner's continuum between presentations of the self and the means of presenting others, as in drama or dance, can equally be applied to

the performance form of stand-up comedy. Stand-up 'material' can be understood as strips of living behaviour reconstructed or rearranged, elaborated or distorted and independent of the causal systems that made them. To look at these ideas of 'material', which begins as process, and is used as rehearsal process to become the process of performance can characterise how the material of stand-up comedy is created. The creation of comic material comes in many forms. Currently, while it is not totally unheard of for stand-up comics to use writers, comedians tend to create their own material. Just how they do that has fascinated many and been the source for constant inquiry. Reportedly, John Cleese got so fed up with interviewers asking him where he got his jokes from that he replied; "I buy them from a little man in Swindon."[36] Notwithstanding the value of a little man in Swindon, stand-up comics produce and create their material in a variety of ways. A small survey on those processes reveals a multiplicity of methods. The American comic Richard Lewis observed that most comics of his generation (in the 1970s) made use of notepads in the creation of material. The idea would come, the premise, the connection, and the twinkle in the eye, writing it down before it was lost or forgotten. Lewis felt that at the time he was working most comedians worked in this way, "like one time we (group of comedians) were talking and I noticed something funny... I immediately got out my pad... silence. They all got uptight. They all thought they missed something."[37] Another seminal stand-up, Lenny Bruce, was fond of writing on the back of matchbooks, napkins and memo pads, and acting out his notions in his apartment.[38] The British comedian Jenny Eclair describes her way of making stand-up in the following terms: "I need loads of time. Every word is totally scripted... What happens is you write material, you try it out, if it works you keep it in, and then you edit. You find themes and shape it until it has a movement of its own."[39] A similar process is reflected in Ben Elton's views on his performance work. He observes: "To me, performing is an extension of writing. Everything for me starts with the words, the writing. I write my act just as I write a novel, or... sitcoms... or whatever [even improvisation is a] sort of writing on the spur of the moment."[40] One of the case studies discussed later, Dylan Moran, describes his creative process as a distillation of his writing: "I have hours and hours of material that I've written... it's like an endless stew, or compost, I am constantly shovelling new bits in and the old bits get displaced. That way... I don't get bored."[41]

Interestingly, if there are various methods of creating stand-up material for performance, rehearsal processes are also very fluid. Tommy

Tiernan describes the loose structures in motion between ideas of creating, rehearsing and performing his material. Tiernan observes that:

> I'd have loads of ideas that are written down, ideas about time, evolution, Jesus, whatever. I would end up on the stage knowing that idea that I had about evolution... that I thought was funny during the week... that's not going to work here... because it's too wordy... it's a written piece... [stand-up] is an oral art form... when I have an idea for a story [most of that story] is created onstage... muscling around in it with the audience and listening to their reactions to it and daring them to go places with you and having enough energy to go all the way with the story wherever that may be.[42]

This comes close to Jimmy Carr's way of thinking, who believes that stand-up material comes from "ten per cent inspiration and ninety per cent whittling and crafting – much of it in front of an audience – until the joke is finished."[43] There are those who totally memorise their sets, and then there are those who have a much looser approach, as Jeremy Hardy puts it "I try to run through things in my head, but I don't rehearse saying things."[44] Some comedians rehearse more formally, and others use their families as a sounding board: Alexei Sayle, for example, rehearses for his wife and cat in the conservatory.[45] Tiernan and Moran have also spoken of rehearsing or running comic material past their wives when preparing a show. And then there are those with a great gift for the improvisational. The British comedian Eddie Izzard works with set lists, "It just says European History and I go into it. And sometimes, on different nights, I'll do totally different material on the same idea."[46] That said, stand-up comedy processes can be understood in a 'Schechnerian' sense as 'material', to be worked on separate from the causal systems that made it, channelled through rehearsal processes toward the process of performance. And as stand-up material is detached from larger schemes of action for manipulation, there is also an *attitude* of disconnectedness necessary in those comic processes. The American comic Jerry Seinfeld has stated that the gift of the comic is a sense of detachment, which feels Brechtian and allows the comic to view everyday situations from an ironic distance. Those experiences, whether those of the comic or of others, and ranging from the mundane to the tragic, become fodder for manipulation, editing, and changing; nothing escapes in the pursuit of the comic angle. As Carr puts it, the mind of the joke-writer is specially adapted to transform ordinary humorous observations into neatly packaged jokes... a comic

goes through life constantly on the look out for the funny angle." Carr uses Seinfeld to strengthen the point; that the comic is "constantly watching proceedings with a certain ironic detachment, [designed] to transform ordinary humorous observations... into fodder for jokes."[47] What Seinfeld terms the 'third eye' is that critical distance essential when mining everyday experience for the purpose of laughter. Clearly, both the manipulation of material and an attitude of detachment are central components underlying the creation of comic material. In this way Schechner's model is useful as a means of understanding stand-up comedy's performance processes. If, as Schechner suggests, restored behaviour is the principal characteristic of performance, then the model has clear implications for use as analytic tool to be applied to the stand-up comic form.

The idea that comic routines are created, as Dylan Moran's 'endless stew' of experience, as 'material' which is shaped, manipulated and crafted into performance matter, gives something of a lie to the medium as champion of the self-expressive mode. Put another way, the idea of a comic routine being detached from their causal origins (which may not even be the comic's own), reconstructed and rearranged for laughter, would seem to undermine a comic's expression of his or her own experience, of his or her own version of truth. Yet many comedians are defenders of that faith. The American comedian Tim Allen calls his stand-up the "truthseeker's truth."[48] In Allen's view, the comedian "has the power to stand-up there for an hour and tell the truth about anything."[49] Similarly, Richard Pryor, when asked whether he wrote his material with comedy or truth in mind, replied, "Truthful, always truthful... and funny will come."[50] An audience can employ a suspension of disbelief when a comedian inflects or presents the work of fantasy or absurdity; however, in the main there is an assumption that "truth is a vital concept in most modern stand-up comedy because of the idea that it is 'authentic.'"[51] While Dylan Moran's style may be surrealistic at times, he has often stated that his comedy is rooted in the importance of everyday experience, anxieties and concerns. Maeve Higgins is very clear that her stand-up is based in the minutiae of her own life transformed into comic material. Tiernan has also described his stand-up as 'dialogue' with the audience, for him, 'it is not [about] presenting a piece.' Tiernan has gone one step further, by stating that if he is not exactly himself on stage, he is *not not himself* either, an observation that is of significance to the discussion and I will return to the point a little later.[52]

Tony Allen boils down any real effort at distinction between constructions of truth and fabrication in stand-up comedy into a single word,

"nebulous." Self-described as a raconteur comedian "who walks onto the stage relatively naked… [who] speaks directly to the audience in the first person. There is no contract, only a nebulous agreement that the performance is spontaneous and authentic."[53] On the other hand, and almost in the same breath, Allen makes plain the common myth that the art of the raconteur comedian is a "natural gift, despite the fact that any deconstruction reveals it to be honed, heightened and carefully selected re-runs of normal speech and behaviour."[54] So too, Shelley Berman holds the view that the material of authenticity is mediated by the necessity of focus for a story to work. He explains:

> In order to create a piece of theatre, especially if one is using himself and his own history, there has to be some licence… so no, it is not absolutely the way it actually happened, but – it's the way it happened. Listen, it's a piece of artistry; it's a piece of work. It's a one-act playlet; it can't be without some focus on the story I am trying to tell.[55]

Jimmy Carr's pithy notion of truth and outright invention in the perfor-mance form suggests that "A professional comic's routine may be based on true personal experience, although personal experience doesn't tend to come with a neat punch line. This goes some way to explaining why most comics are such outrageous liars. In fact the commonest lie they tell is 'this really happened to me I swear."[56] That being said, the story of authenticity and honesty in stand-up still holds a lot of water, with Oliver Double's argument for the form's ability to deal with the truth of things as central to the art of stand-up; in his view (and he is by no means alone) it is that very ability to handle the truth that makes stand-up so powerful. Schechner's paradigm describes very well how stand-up 'material' is taken up and used as process and as performance, which certainly goes some way to undermining notions of truth and legitimacy claimed by the form. In addition, a comic's material is con-siderably contextualised by the *act* of performance. In other words, sub-jectivity and subject matter are filtered through a comic performance frame described as "brutal" by Jimmy Carr. That comic frame privileges the pursuit of laughter above all else, which actively blurs the bounda-ries between truth and fiction in the name of good comedy. If stand-up comedy works to achieve several differing objectives (and it does), laughter is the form's driving force. There are two sides to the story, then. However contextualised a comic self may be by the demands of the comic frame, stand-up comedy is fundamentally rooted in the projection of an 'authentic' self, as integral to the form. In this way no

matter how mediated by the demands of the comic form's processes, telling 'genuine' versions of the self is a vital and central component of stand-up.

2.4 The comic 'i'

Tony Allen poses a set of questions, which could be given to any given comic on any given stage. Those questions ask, "who are they up there... who are they under pressure... who do they become when they are faced with an audience. What revamped part of themselves do they show us?"[57] In stand-up comedy, the comic's persona or 'personality' is understood as central to the form. In Double's opinion, personality, whatever its shape and form, "is absolutely crucial to [a comic's] act. It provides a context for the material, it gives the audience something to identify with, and it's what distinguishes one comic from the next."[58] A case in point were the thoughts on the subject by the American talent manager, Jack Rollins.[59]. After many years spent developing comedic talent Rollins knew that comic personality was an essential component to success:

> If an audience can sense the personality underlying the comic – if they can make contact with that personality, they'll enjoy him more. So I was saying to Woody [Allen]: It'd be nice if you'd come out and say, 'Good evening... how are you?'... 'Talk to them... each person in that room has to have the feeling that the comic is talking to him, as though there are two people in the room.[60]

Rollins was attempting to "expose [Allen's] persona, rather than his being a faceless actor reading jokes."[61] Acknowledging that 'personality' in stand-up comedy comes in all shapes and sizes, audiences, in the main, look for a direct emotional connection with the comedian on stage. They want to identify with the personality of the comedian, and that identification marks the relationship between the comic and (on a good night) notionally, each person in the room.[62] If comic personality is vital to the form as a mode of connection, identification and recognition, how connected is that comic performance of the self to the comic's own self? British comedian Jeremy Hardy is very aware of his onstage persona and his comments echo Goffman's ideas of everyday performative behaviour:

> [T]here's a persona in as much as we have different personae that we use in our lives, you know like talking to your mum, talking to the

doctor, we adopt slightly different voices... So it's not acting in the sense that it's an observed and learned and performed character, but it's acting in the sense that it's a performance,... We're all kind of performing all the time in a sense, albeit subconsciously, and [stand-up is] just one of the performances that we give.[63]

In my interview with Tommy Tiernan, he offered some thoughts about how he perceived himself in performance, "Who I am onstage is not a lie, but who I am offstage is not a lie either."[64] Tiernan's viewpoint on his persona, which I mentioned above, comes close to the performance artist Rachel Rosenthal's conception of her "performed selves:"

In acting or playing a character, you want to impersonate the personality of a person that is not yourself. A persona, however, is an artefact, a fabrication that corresponds to what you want to project from yourself, from within. It is like taking a facet, a fragment, and using that as a seed to elaborate on. It is you and yet not you – a part of you but not the whole. It is not a lie but neither the full truth.[65]

The indistinct boundaries between notions of a 'real' and a 'fabricated' self in performance can again be viewed through the lens of Schechner's 'restored behaviour' model. When put in 'personal terms' the model is embedded in what Schechner calls 'multiple me's.' He describes 'multiple me's' as "me behaving as if I am someone else" or "as if I am 'beside myself,' or 'not myself,' as when in trance. But this 'someone else' may also be 'me in another state of feeling/being.'"[66] Schechner's description of 'multiple me's' can be a useful way of thinking about the created comic persona in performance, the sense that a constructed persona is "me" and yet "not me", or "not me" and yet "not not me."[67] A persona that is 'not me' and yet at the same time is 'not not me' accords very well with Rosenthal's conception of a persona as performed self. That performed self, who is a part but not the whole, a kernel through which to grow and project fragments or aspects of the self that one may wish to illuminate from within. It is also very close to Tiernan's idea of who he is onstage, his not being himself, but yet *not not himself*. A related view, which incorporates the comic audience dynamic, also suggests that all acts of communication and interaction, be it in everyday life or as artistic performance, cannot exist "between a 'pure me' (myself) and a 'pure other' (self of another person). [The act of] communication is the fabrication of personae that make contact and interact with the other's multiple personae [and that] performing is a means to

communication."[68] Again, something like an echo to Goffman's work carries here. In terms of the more formalised notion of the 'staged' self, (Allen's 'range of Attitude' works here too), the suggestion that fabricated personae makes contact with an 'other's' multiple persona implies that the multiple personae which constitute any given audience, can somehow appropriate those acts of communication. Tony Allen asked the question: who is the comedian onstage? His response again locks in Schechner's 'multiple me's.' A stand-up comic suffers a kind of "strategic identity crises,"[69] predicated perhaps by the desire to make a group of strangers in a room laugh by numbers in a performance form where "you're only as good as your last joke, not even your last show – your last *joke*."[70] In that crisis on the stage, and in order to live to tell the tale, there emerges a slew of minor personalities which come to the aid of the comic. Each one should be given a hearing because, in Allen's view:

> How we recognise and then express these sides of our personality, how we assemble an individual palette of available emotional states, how we learn to switch seamlessly from one to another, and how we laugh at ourselves and the world around us, is the stuff of discovering our own unique range of Attitude.[71]

A 'unique range of Attitude' which brings forth a 'slew of minor personalities' makes for good running with Schechner's 'personal terms' and with both Rosenthal and Tiernan's viewpoints on their performed 'selves.' Clearly, a comic's personality or comic persona(e) operates as an essential instrument in stand-up comedy. A comic persona acts as a device; it is a construct, which operates as the connective tissue between a comic and audience, it defines the comic–audience relationship. The significance of a comic persona also lies in the fact that as that device, it can also act as the vehicle through which aspects or fragments of the self are projected onto the stand-up stage. In that sense then it seems possible to suggest that a comic persona offers a way in which to examine how subjectivity is operating on a stand-up stage.

A small detour, an observation – and back to the comic 'i'

I am making a small detour here to account for observational comedy. Observational comedy is a fundamental aspect of stand-up and the term 'observational' is used often to describe a comic's style. Ideas of observational comedy are deeply connected to ideas of sharing, so central to the form. The comic in the main and regardless of the particular quirks of a performance style is sharing something of him- or herself with an

audience. A very common means of that expression happens through the lens of observational comedy. Observational comedy can be described as "the comedian talk[ing] about everyday phenomena that are rarely noticed or discussed... sharing is built into the very language of observational comedy."[72] In observational comedy, the manipulation of comic material, is most certainly involved; Jerry Seinfeld's 'third eye' may well be at work, or Carr's belief that observational comics can create bizarre situations in everyday life in order to gather comedy material.[73] As discussed, Allen suggests that, as a raconteur comedian, there is 'nebulous' agreement with an audience to be spontaneous and authentic, even as both understand the performance conceits involved. The lines between what is personal and what is more broadly observational are blurred in the stand-up form. Interlocking notions of observational comedy can come to rest on any of the comedians under discussion in these pages to varying degrees, they in effect imply that the comedian will draw in an audience through a process of shared understanding and experience. The comic is saying to the collective, 'hey this is my understanding of 'the murky world of relationships,' or this is my understanding of 'my mother, mid-life crises... world hunger... dogs... nostril hair,' do you recognise it'? In other words, whatever the subject matter, ideas of observational comedy can be played near to and away from the idea of immediate or personal experience. However near or far, the comedy of recognition involves some mutual understanding and is, in the main, underpinned with aspects of the comic self, if projected at times through a more observational lens. In that sense, it cannot be excluded from this discussion.

I believe that Schechner's performance model can once again clarify the point. If ideas of performing the self constitute a fluid continuum so that the "difference between performing myself – acting out a dream, re-experiencing a childhood trauma, showing you what I did yesterday – and more formal 'presentations of self'... is a difference of degree not kind,"[74] then 'degree and not kind' can extend to the notion of comic styles of performance also. The continuum has room to incorporate the many ways in which the self can be performed in stand-up comedy. I suggest that the formulation works well to accommodate broader comic techniques and, specifically, that observational comedy can operate within this remit. This is not to suggest that all stand-up comic styles can be rooted within the model. However, as observational comedy is so deeply embedded within the form, I would argue that its value as a self-expressive tool in performance makes it a worthwhile inclusion. What I am suggesting, then, is that ideas of the self in stand-up can operate

in something of a fluid structure, which incorporates a more immediate and personalised style with, at times, a broader observational style. With these ideas in mind then, I wish to put forward an idea, drawing once again on Ciarán Benson's work. He argues for "identity as a woven narrative... in which the shape of a life is made and remade by the story a person tells of herself or himself."[75] As discussed a little earlier in the work, Benson suggests that "the story or stories of myself that I tell, that I hear others tell of me, that I am unable or unwilling to tell, are not independent of the self that I am: they are constitutive of *me*."[76] The story that constitutes 'me' can connect to Rosenthal's understanding of her 'performed selves;' as a fabrication that equates to aspects or fragments of the self projected from within, it is not a fully a lie, but it is not the whole truth, it is the illumination of a self-selected fragment. This connection of ideas offers a very useful way of understanding the comic self in performance. I suggest that it can be used as a means through which to look at ideas of subjectivity in stand-up. I propose then that the story which constitutes the ongoing and edited version of 'me,' as fragments or aspects of the self, selected and projected outward from within by means of a comic persona, and bound by ideas inherent to the comic frame, can be understood as the comic 'i.' For the purposes of the work then I suggest that the comic 'i' becomes an umbrella term for the association of ideas that constitute the expression here and will be signalled throughout the work where subjectivity in stand-up is being considered. I make no claim to comprehensiveness with this notion and I am not solving any problem; rather, I am suggesting that the comic 'i' be considered as one means among many of perceiving and examining ideas of the self, identity and performance in the form. However, if the comic 'i' can work in the ways described, there is something more to be said for other mediating factors which heavily contextualise the formulation. Ideas of comic licences and boundaries of permission do exert considerable influence and materially shape how the comic 'i' can operate. To go back to the hoary old chestnut and lest we forget, stand-up comedy is essentially about the pursuit of laughter. That frame radically contextualises *all* telling on a stand-up stage. So that *acts* of communication projected through the multifunctional lens of comic persona(e), which embraces the comic 'i' are deeply embedded within another set of tensions. In other words, stand-up comedy fundamentally resists the serious mode. And as the form resists that mode, the question becomes situated for the moment, not in *how* the stand-up comic treats the world playfully, but *where* the stand-up comic treats the world playfully, for comic space has a very close relationship to the playful world.

2.5 Comic heterotopias

Although there are many ways to approach the notion of comic space, Michel Foucault's concept of heterotopic space is most useful for my purposes here. Foucault speaks of space(s) in modern life as a "set of relations that delineates sites, which are irreducible to one another and absolutely not superimposable on one another."[77] While each site may be defined by analysing the set of relations that constitute them, what is of interest here is how Foucault describes the idea of certain sites that "are in relation to all the other sites, but in such a way as to suspect, neutralize, or invert the set of relations that they happen to designate, mirror or reflect..."[78] Foucault defines the qualities of these sites as utopias or heterotopias. Utopian spaces are sites which inhabit no real space in a society. While they have an analogous relation to real space, they represent society in an idealised or inverted form and, as such, are essentially unreal. In contrast heterotopias are real places, real sites wherein all the other sites at work in society can at once be rehearsed, challenged or inverted. They can also be understood as being set apart, singular and beyond all places, even though they may well be located in reality. While he does make some conceptual crossing points between utopias and heterotopias, as classification, Foucault illustrates several principles to define heterotopic sites. However, it is his meaning of the function of heterotopic space in relation to all the other spaces that is of most value. Foucault describes two heterotopic outposts. One is "to create a space that is other, another real space, as perfect... as ours is messy, ill-conceived and jumbled," and the other at the opposite pole is to "create a space of illusion that exposes every real space – all the sites inside of which human life is partitioned, as still more illusory.[79] Because the function of these counter sites is to represent, contest or invert all the other real sites of a culture, heterotopias can on one level be understood as offering a suspension of the everyday in favour of alternative conceptions of reality. Foucault's conception of a heterotopia as a 'space of illusion that exposes every real space... as still more illusory' could equally apply to the functioning of stand-up space. The seminal American stand-up Bill Hicks had a related view on the purpose of comedy itself. He was absolutely opposed to any view which suggested that comedy was essentially about benign escapism, believing that the power of comedy lay in its ability to expose the absurdities of everyday reality with the laughter of recognition. He wrote:

If comedy is an escape from anything it is an escape from illusions... the comic reminds us of our True Reality, and in that moment of recognition, we laugh and the 'reality' of the daily grind is shown for what it is – unreal... a joke. The audience is relieved to know they're not alone in thinking, 'this bullshit we see and hear all day makes no sense. Surely I'm not the only one who thinks so.' Good comedy helps people know they're not alone.[80]

Clearly Hicks was absolutely opposed to that thinking which suggests that comedy acts only as release or as diversionary tactics from the tensions of everyday living. As Foucault's argument states that heterotopic space can work to expose the illusory qualities inherent in our daily lives, so Hicks believed that the power of comedy lay in its ability (within comic spaces) to recognise those absurdities in everyday living.

If Foucault has resonance with Hicks, then Tiernan's views on stand-up comic space also come close to a Foucault heterotopia. When reviewing the Kilkenny Cat Laughs festival in June 2009, Peter Crawley summarised Tiernan's opening gambit to the crowd: "A comedy gig is a sacred, protected space set apart from the hypocrites and liars of society, [Tiernan explains,] albeit in slightly different words and with a bit more swearing."[81] At various other times, including during my interview with him, Tiernan has described the stand-up comedy gig as a "sacred space"[82] and Vicar Street in Dublin as the "cathedral of Irish Comedy."[83] On several occasions Tiernan has also defended the controversial nature of his comic material in terms of that idea of hallowed, marked-off space:

The ceremony of stand-up is a special one because you say: 'we will go into this darkened room and he will be lit up. He is not who he is normally, he is in this other space and we are just going to go with the flow.'[84]

Clearly both Hicks's view of comedy and Tiernan's concept of comic space, understood as ceremonial, as edged around, a site where the normal rules of daily living are temporarily suspended, can equally apply to Foucault's heterotopia. A space that is separate but related to all the other real sites, a place located in reality which can at once represent, trouble and invert every other 'real space' in a culture. A space that can function to expose the illusory qualities of daily existence. With that in mind, I would like to suggest the notion of *comic heterotopias*. Borrowing

from Foucault's conception, is it possible to conceive of the comic space as a comic heterotopia, or comic heterotopic space? It seems a useful idea, yet the notion of a comic heterotopia must come to terms with the idea of comic space as that which resists the serious mode. Stand-up comedy treats the world playfully. That said, there are, in fact, commonalties between a comic heterotopic space and a playful space.

The scholarship of play marks a comprehensive field of study and, as such, goes far beyond my purpose here.[85] However, parallel modalities between comic heterotopic space and play space can be brought closer together when looking at Johan Huizinga's widely accepted formulation of play:

> Summing up the formal characteristics of play we might call it a free activity standing quite consciously outside 'ordinary' life as being 'not serious', but at the same time absorbing the player intensely and utterly... It proceeds within its own proper boundaries of time and space... marked off beforehand either materially or ideally, deliberately or as a matter of course... [as] forbidden spots, isolated, hedged round, hallowed, within which special rules obtain.[86]

Huizinga also examined the relationship between the characteristics of play and ideas of the comic. He suggested, however, that the "comic comes under the category of non-seriousness but its relation to play is subsidiary... in itself play is not comical either for player or public."[87] In contrast, Sophie Quirk revises what she considers Huizinga's confused analysis. She places the 'subsidiary' practice of joking firmly within the play world.[88] Peter Berger also describes the connections between ideas of play and the comic, however he also suggests that the dissimilarities are just as important to recognise.[89] Having said that, Berger and Quirk make connections between Huizinga's characteristics of play as a 'stepping out' of real life, of places marked off and bound by particular sets of rules as applicable to comic worlds. The idea of a comic heterotopic site can serve equally well. Comic heterotopic space can be conceived of as temporary, informed by its own set of characteristics, of being 'hedged around' both 'materially and ideally' from 'real' life. To go one step further and to use Foucault's terms, it is also possible to conceive of comic heterotopic space as that which can incorporate the non-serious mode within its borders or set of relations that delineates the space. Thus, in my reading the non-serious mode becomes one of the characteristics that demarcate the comic heterotopic site. As such, and for my purposes, it is a most useful method of specifically understanding

the stand-up comedy space as that which is located in reality; as constituting "something like counter-sites... in which the real sites, all the other real sites that can be found within the culture, are simultaneously represented, contested and inverted."[90] However, as useful as this formulation is in order to discuss comic space, the site is bound by the *totality* of its set of relations, those rules that classify the nature of the space. What I mean by this is that a comic heterotopic (as with play spaces) space must be bound in particular here by another related set of rules. Those rules govern the significance of comic permissions and are a fundamental aspect of the form as they navigate the relationship between an audience and a stand-up performer. In other words, comic permission or licence in stand-up materially contextualises that which happens on a stand-up stage and actively mediates the relationship between the stand-up comic, the material and any given audience.

Comic licence

John Morreall argues (among others) that comic licence comes about as a consequence of joke telling understood as something of a borderline practice. In other words, when telling a joke, the joker can be understood as akin to the "inhabitant or creator of a marginal reality... the joke takes place in a safe-space, on the side of everyday interaction, where many of the rules governing honesty and decency may be relaxed."[91] The nature of comic licence is embedded in the idea that "jokes are managed by special rules, in particular, as recipients of the joke, we must not be troubled by concern about either truthfulness or repercussions upon the well being of those involved."[92] Those permissions are negotiated in play between an audience and its comic. Under these terms, the comic heterotopic space can be understood as a safe space of play where ideas of risky material can be played out or tested in front of a live audience. That said, the comic heterotopic space is also troubled by the notion that an audience may revoke a comic's licence. Mary Douglas argues that jokes "have a subversive effect on the dominant structure of ideas... the joke affords opportunity of realizing that an accepted pattern has no necessity."[93] However, she also asserts that consensus is an important factor in all joking so that a comedian will be subject to social requirements that may deem a joke to be too risky or near to the knuckle to be the subject of humour.[94] To Douglas, the comedian has little real agency and can "merely express consensus, safe within the permitted range of attack, [s]he lightens for everyone the oppressiveness of social reality."[95] In a sense she gifts the comic with a certain toothless quality, flying in the face somewhat of

those comedians who do attempt to push permissions to their limits and beyond. As a case in point the British comedian and social commentator Mark Thomas vehemently denies that comedy is essentially strangled by ideas of consensus. Thomas, whose work is deeply rooted is using humour as a political weapon, asserts what he believes to be the spirit of stand-up:

> It's about play, it's about interplay. It's about expectation and defying expectation, and if you can't make that political and change people's minds, then you're in the wrong fucking game [...] The whole point about this is it should be fun, but it also should have a significance. If you can't play with these big ideas, then [...] what you're saying is that some things are sacred, and we can never change them. And as soon as you say that, it's just like you've just become part of the obstacle [...] the whole point is it's open to change [...] change occurs all the time. It's about whether you can shape or change or influence its direction.[96]

Thomas's work is based within an ethos, which encourages dispute, question and dialogue with any given audience. In this sense, there is an open forum, egalitarian quality to his work. An audience can interact with Thomas's material, which would seem to accommodate challenge, discussion, or agreement with Thomas's political and social commentary. However, Quirk interrogates the idea of comic licence and Thomas's egalitarian style of comedy itself by questioning "the extent to which the audience may police the boundaries of comic licence against the possibility that the comedian may dupe them into laying down their resistance altogether."[97] Despite Thomas's views to the contrary, which are strongly held, there is also validity to Quirk's point; it could certainly be seen to speak to the power that a high-profile comedian may decide to wield over his or her audience.

That said, the comic must make decisions about the work in order to successfully maintain the balance between the desire to break the rules of comic permission and the risks involved should the material go a step too far. Comic licence is in large part evoked by an audience's contract with the comedian to play with a culture's praxis, and it can be revoked when a comedian goes beyond what is agreed as acceptable. Tiernan is a fitting case in point here. His material has landed him in hot water on many occasions over the years; however, his risky material has helped to build his stand-up career, perhaps as much as it has harmed him. He did gather a reputation in Ireland and abroad for being the comic who

could say anything and get away with it. However, in 2009 his career was damaged by what many perceived as his anti-Semitic comments, to the extent that, "the heavens of moral indignation opened on him... the 'scandalous Irish comic' made the front page of the *Jerusalem Post*, tours were cancelled in North America and boycotts were organised."[98] Tiernan told Brian Boyd that at the height of the storm, he got a call from the head of an elite Garda (Irish police force) group. He said to Tiernan "we have reason to believe that two people are on their way from Germany to kill you... We're not taking this too seriously. But if anything does happen to you, well, we told you."[99] This series of events would certainly support Quirk's opinion of the very real dangers that comedians sometimes face, where the marginal reality of joking as a literal and figurative safe space simply disappears. Quirk quite rightly makes the point that "comedians are not marginal figures, who are safe from reproach, but mortals who are vulnerable to attack."[100] Even so, and for many comedians, chewing at the bit of comic license constitutes the very heart and soul of stand-up. Oliver Double argues that while "some stand-up comedians do express consensus... many stand-ups work by pushing at the edges of consensus"[101] and that subversion and transgression marks the rubber stamp of truly good stand-up comedy.[102] It seems that the seesaw of tensions inherent in ideas of licence constitute an ambiguous contract between a comic and an audience. That contract navigates the relationship between a comic, the comic material and, to varying degrees, certain sanction by the audience. What is allowed within the permitted range of comic attack and what is considered too precious to be a subject of that scrutiny is highly culturally specific. In Tiernan's case certainly, his stand-up work transgressed boundaries in a very real way for certain sections of the community and Tiernan certainly counted the cost in terms of damage to his career. This is a subject to which I will return later in these pages and with respect to all three case studies. That said, it would seem that surfing the boundaries of permissions even within the comic heterotopic space as described in these pages can and does carry real risks. Breaking faith with those boundaries and societal consensus can be something of a knife-edge gamble, which has the potential to make or break a comedian's career.

2.6 Comic 'i'dentity

In the final section of this chapter I would like to consider ideas of comic identity. Circumscriptions in criticism occupy a vast field and are well beyond the scope of this book. I will limit my discussion to the theories

that come close to my purpose. Tony Allen quite rightly asked 'who' comedians *are* on stage, which, as he observes, is not a "wholly personal question... distanced [as it is] by the act of performance."[103] Who are they and what do they signify beyond the confines of "this darkened room [where] (s) he will be lit up?"[104] Lawrence E. Mintz links the stand-up comic to the figure of the trickster, the con man, the buffoon or the clown, which he describes as the "negative exemplar."[105] The comic, through licence from his public becomes the butt of the joke, a marginal figure that people can laugh at and feel superior to. On the other hand, the stand-up comic can exist in opposition to that way of thinking. He or she can take up the "role as our comic spokesperson, as a mediator, an 'articulator' of our culture and as our contemporary anthropologist."[106] In their exploration to uncover the spirit of the joke, Jimmy Carr and Lucy Greeves spend some time linking the stand-up comic to the concept of the Jungian trickster.[107] In terms of the subversive qualities inherent in the archetype, it is not surprising that the idea of the trickster still holds. Tony Allen links the stand-up comic to the shaman, who "takes risks and investigates the dark side... The shaman can be outrageous and provocative. He may even be feared. The shaman asks the audience 'Who are we? What are we doing? And is this the interval?'"[108] What can be understood, even from this cursory glance, is that evocations of the trickster, the buffoon and the shaman all inhabit the spirit of comic identity in stand-up. Understanding that comic figures can operate as cultural signifiers allows me to speak briefly here about broader ideas of humour, function and society. Michael Billig works toward a social critique that "places ridicule at the centre of social life and that locates humour in the operations of social power, [moving away] from more good-natured even sentimental theories of humour... which currently predominate."[109] In Billig's view, some theorists, including Simon Critchley and Peter Berger, "have often concentrated on the rebellious aspect [of humour] to the exclusion of its disciplinary aspects."[110] Billig, building on the work of Bergson and Freud, "suggests that ridicule lies at the core of social life, for the possibility of ridicule ensures that members of society routinely comply with the customs and habits of their social milieu."[111] Billig's final words on the subject are "some theorists such as Peter Berger or Simon Critchley write in praise of the human genius of humour... Others don't."[112] Both Berger and Critchley have dealt with the ideas of humour as negative, regressive or reactionary, though clearly not to Billig's satisfaction. Their perceived positivism would seem to jar with Billig's view.

That being said, differing positions and analyses of the comic in life would seem to fall into two broad camps. Taking into account where

these lines do blur and overlap, there are those who tend to view the potential in humour as a tool of social transformation, and there are those who tend to view the potential in humour as a weapon of social control. And never the twain shall meet. There are those who believe that the comic merely expresses consensus. There are those who believe that the comic can move past rebelliousness within the permitted range of attack to expose and criticise hegemony, or to subvert the status quo, or to punch holes in the operation of social powers, mores and values. Within these tensions, Andrew Stott's idea of comic identity is useful:

> ...[C]omic identity appears to be found in a sense of division or incompleteness... In an historical context, to such dividedness there is attributed a philosophical or mythic dimension, as in the case of folly and tricksterism, that asserts the existence of a universe outside the individual and a higher power that controls it. In the modern age, the dividedness of comic identity and the fluidity of meanings that accompany it could be read as symbols of increasingly individualistic egos and the estrangement of self and society. Either way, comic humans are incomplete.[113]

That egoism and fluidity of meaning that Stott refers to in modern conceptions of comic identity is mirrored by Schechner's view that "multiplex signals is the main mark of post modern theatre" and that the "'I' at the centre of the world is a modern feeling."[114] The increasingly individualistic ego and estrangement of self and society problematises the notion of stand-up comedy itself. Auslander contends, "comedy by definition requires stable referents, norms against which behaviours may be deemed humorous. In the absence of such norms it is impossible to define comedy."[115] Auslander speaks of Andy Kaufman and Steve Martin's comic routines in particular which shunned the notion of a consistent comic persona and who took as their subject the "impossibility of being a comedian in a post-modern world."[116] Perhaps. I would argue that that there are other ways of interpreting comic persona(e) as discussed. I would also say that an audience may well look for, access and judge stand-up from a variety of positions, values and meaning-making and not just necessarily from the standpoint of its impossibility. Stand-up comedy occupies a number of tensions and paradoxes. Current conceptualisations include ideas of self-expressivity, of honesty, of authenticity; of material carved from the comic's own experiences of life. Stand-up is also full of fabrication, with fictions and manipulation of material for laughter. Within these sets of relations,

I have placed the comic 'i.' The comic 'i' is a formulation, which offers one way among many to look at ideas of how performed identity may be examined in stand-up comedy. The comic 'i' is understood here as that which constitutes 'me,' as fragments or aspects of the self, selected and projected outward from within by means of a comic persona, and bound by ideas inherent to the comic frame. In this way, the formulation looks to subjectivity in comic performance, and how that staged subjectivity is keyed to broader social and communal structures. Some suggest that postmodern culture may privilege how the story is told over and above what that story is telling. Stand-up comics take narrative bits and pieces of experience, pull them apart, manipulate them, change, defamiliarise and refashion them, to create comic business for laughter. It foregrounds the performed self lensed through the comic frame, which does not suggest that one necessarily precedes the other. I spoke above of archetypes as cultural signifiers that ghost ideas of comic identity in stand-up performance. More contemporary models also speak to the form. Stott suggests comic humans are incomplete, and that modern versions of comic identity suggest an increasingly individualistic ego, which symbolises the estrangement of the self from society. I would like to add my thoughts to that idea. Is it possible to look to stand-up as, if not a bridge, then a structure that can speak into that idea of rupture in some way? Stand-up comic identity does carry that which came before. Further, stand-up, even as it is centred on the 'i' in performance, consists of *acts* of communication between the comic and the audience, between the self and the selves. In my view stand-up offers a way to stage and mediate that estrangement that Stott speaks of; comic identity as embodied comic dialectic between self and society. I wish then to begin by conducting a series of performance analyses, which examines the comic works of Tiernan, Moran and Higgins. I want to then connect the works to a discussion of how the comic 'i' as performed subjectivity may be seen to operate in each case study. I will also explore what purpose and value may be wrought when connecting the comic self in stand-up to the wider community; as the 'self' speaking to the 'selves.' With this in mind, I raise a question here as the main point of departure for the coming chapters, namely that in the comic heterotopic space, *what* are the comics telling, *who* is experiencing that telling, and in the end, *why* does that telling matter?

3
Messages

3.1 Messenger from the other side

Tommy Tiernan: Cracked – Live at Vicar Street, 2004

Tommy Tiernan enters through an open upstage door for his performance at Vicar Street, Dublin, 2004. He moves downstage, covering the space from left to right as he welcomes the audience and thanks them for coming. The stage space is inhabited by what could be regarded as a theatrical set, hinting at the comic's flair for the dramatic.[1] Tiernan tells the audience that the set design means "fuck all… it's just something for ye to look at while I'm thinking."[2] Tiernan is dressed casually. He is sporting a full beard and wearing jeans, sneakers, and a paisley-patterned, salmon-coloured shirt. He is also wearing what he describes as a "hippity hoppety" earpiece, so that there is no traditional microphone or stand in this performance.[3] Having thus acknowledged the audience, Tiernan gets down promptly to the evening's comic events. Before very long, the agenda turns to the business of religion, and Tiernan devotes whole sections of this performance to that dialogue with the audience. Throughout his career, ideas of religion, faith and spirituality have recurred in Tiernan's performance works and his material choices have landed him in some very hot water, both at home and abroad. This is highlighted, for example, by his experience while performing a routine focusing on religiously themed material in Baltimore, America in 2006 when the comic was appearing there as part of his *Jokerman* tour.[4] After a few moments on a meagre stage and as part of an open-mic spot, Tiernan turned to a discussion of Jesus, his crucifixion and the Jewish Holocaust:

> I'm a big believer in Jesus. I know Jesus is very popular with black people and Jewish people… some people like the movie *The Passion*

of the Christ (moans from audience). And some people didn't like the movie... because it somehow insinuated that it was the Jews that killed Jesus. Well, it wasn't the fucking Mexicans.[5]

In response, an audience member shouted to Tiernan, "We want you to leave alive."[6] It became clear that sections of the audience had not appreciated Tiernan's comments; he held his ground and qualified his remarks so that he did, in fact, leave alive. As part of the *Jokerman* footage, Tiernan spoke to camera about his comic misbehaviour:

> The stuff I find funniest is almost the stuff that you shouldn't be saying, that you find the moments of tension... you try to dig into the stuff that people are slightly wary about. Because you know that the higher the tension, that the louder the laugh will be if you can crack it open.[7]

Things may not have come off exactly as planned in Baltimore and Tiernan acknowledged that getting into trouble in Ireland is not the same as getting into trouble in America. He commented that when causing offence to an audience, America did not feel quite as safe as Tiernan's home ground. That comment, made in 2006, was to prove somewhat prophetic in the light of subsequent events, something to which I will return later.

That said, if the Baltimore performance marks just one example of the comic's variations on a (religious) theme, earlier in this Vicar Street performance, Tiernan discusses ideas of Christmas in Ireland:

> We're a Catholic country, or at least we used to be. We're in danger of saying goodbye to all these wonderful religious festivals. And people give out about Christmas. Ah, Christmas is too commercial... Christmas was always commercial. The very first Christmas was commercial. The baby Jesus was only... born and the three wise men burst into the hut, **I got ya this, look**. Now, I didn't have time to wrap it, and I know it's Christmas and your birthday, but...[8]

Tiernan moves from Christmas to the religious observance of Lent and an imagining of what the first Mass with Jesus and the Apostles may have been really like. He then moves on to other subjects, including Israel, hairy women, PMT, children and school, before eventually finding his way back to Jesus. He introduces the following scenario, with a series of elaborate characterisations of Jesus and Satan in the desert.

Jesus was in the desert and was being tempted by Satan. Tiernan imagines for the audience what that scenario might actually have been like, before moving onto a discussion of the Irish Mass. As part of that *'Mighty Mass'* experience, Tiernan laments the ab(use) of Irish music by the Catholic Church. For Tiernan, Irish religious music is depressing. So much so that he observes, "it's no wonder we head straight for the pub after Mass [*laughter and applause*] or onto a hurling pitch to hammer seven types of shit out of one another."[9] "Where is all the wild happy traditional music in the Irish Mass... isn't that what a religion is supposed to do, come into a culture, take the best bits and 'Murph' it into something new?"[10] Tiernan invites the audience to imagine an uplifting religious version of *Lanigan's Ball*, "forty long days He spent in the wilderness, forty long days doing nothing at all, forty long days He spent in the wilderness, learning to be the Lord of us all."[11] To Tiernan in 2004 Irish Mass seems to have fallen down a hole, seems to have lost its way. Disappointed, he embarks on a global quest for a ceremony that breathes new life into the spirit:

Priest for Potato Swap[12]

I went to Mass in Australia
Hoping for a wild rugged outlaw priest
Something to light up the fuckin' ceremony
That's what you want
You want a priest with fuckin' love in his heart
And fire in his belly
You want someone who looks as if the decisions made in his life
Have had some consequences on his face
That's what you want
You want your priest to look like John the Baptist
You'd trust him 'cause you know he'd fuckin' suffered on your behalf
Coming into town once a week
On a donkey... covered in locusts
Sucking honey from a bee's hole
You'd trust him wouldn't ya?
These other fuckers
You wouldn't follow them through revolving doors
Never mind out of Egypt
This priest that I went to see down in Australia
He was nice – that was the problem
He was nice
A lovely man but he shouldn't have been trying to lead us anywhere

Too nice (*Australian accent*)

Hello, you're all very welcome to St. Cathbert's church

Today we're going to be reading from the Gospel according to St. Luke

I like Luke

Jesus went for a walk

And he came to a tree

And up in the tree

He saw Zebedee

And he said to Zebedee

"Zebedee, come down from that tree"

And Zebedee replied

"Jesus Christ I'm not coming down from the tree"

That's the gospel according to St Luke (*laughter*)

I like Luke...

It's bullshit though isn't it?

You couldn't hang your coat on that never mind your soul

We used to grow priests in Ireland

We used to grow them from bits of people that we didn't like

And books we couldn't understand

But we overplanted

We had an epidemic

We were flooded with the fuckers

So we tried to engage the rest of the world

In a priest for potato swap

We were conned by the Africans

Fucking Bastards

Took all our priests

Not a fuckin' potato between them

Pagan spud-less fuckers

Our priests went over to Africa and what happened?

THEY MELTED

All that was left of them was their hard black shoes

The very things the Africans were after in the first place

Shoe lovin' freaks

And now, what has happened?

We have run out of priests in Ireland

There's only two left per town

Hiding in the parochial house

AFRAID TO LEAVE

"We need milk"

"I went yesterday"
"Well I'm lactose intolerant"
"You're a fuckin' eejit"
We're gonna run out of priests fairly soon
And what's gonna happen?
Miracle of miracles
Like sending plastic toys to Taiwan
African missionaries are gonna start coming over here
And at first the congregation will be a little bit weary
Fuck! NO WAY!
No fuckin' way
"Are you the fella off the Trócaire box are ya?"[13]
"Jesus wasn't black"
"Was he fuck!"
"Is there a hole in your head I'd lob a few pound inta ya"
Jesus looked like one of the Hothouse Flowers[14]
'Don't leave me now now now'[15]
And it's just a guess
But maybe a Mass given by an African Priest
Might be slightly fuckin' wilder
It might engage us once again
(*African accent*)
In the name of the father, the son and the Holy Ghost
Jesus went for a walk
He wanted to get away from everybody
He doesn't have to explain himself
He is Jesus
He went for a walk and he came to a tree
And up in the tree OAAAHHHH
He saw Zebedee
The tax-collecting cunt
And he said to Zebedee
"Don't be wasting my time"
"Come down from the tree"
And Zebedee replied
"Jesus Christ, I will not come down from the tree"
Because he was a stubborn fucker
That is the Gospel according to St Luke
I DON'T LIKE LUKE
But what?... (*Laughter and applause*)
But what is the Gospel trying to say?

What is the Gospel of our Lord Jesus Christ trying to say to you?
It is trying to say
Come down... from the tree
I am waiting... for you.[16]

The *Priest for Potato Swap* scenario is highly culturally specific, being deeply rooted in traditional and contemporary religious custom in Ireland. A story of Irish Mass and the scarcity of parish priests around the country is embedded in a consensus of sorts between the performer and the audience. That consensus signals that"there is a tacit social contract at work here, namely some agreement about the social world in which we find ourselves as the implicit background to the joke."[17] This sense of social connectedness as the background to the world of the joke is a vital feature of joke telling. A good way in which to understand how this social contract works is to think of "the experience of trying – and failing – to tell a joke in a foreign language."[18] The joke fails because the cultural markers are not in place, which signal, "what constitutes joking 'for us.'"[19] So for many it is a familiar world that is evoked by Tiernan. The Irish Mass is instantly recognisable, to a greater or lesser degree, as a past and present religious observation of Catholic worship. Allied with that social contract, the scenario is working within the parameters of classic comic timing, described by many comedians as the 'rule of three.' Tony Allen illustrates his version as, "Establish, Reinforce, Surprise!"[20] The comic begins by first establishing a pattern, reinforcing that pattern throughout the second part of the joke and, finally, subverting the joke itself.[21] There are many variations of the idea inherent in a 'rule of three' structure, from "my hobbies are drinking smoking and keeping fit,"[22] to cases where politicians have been known to inject 'rule of three' lists into their speeches to elicit applause from their audiences.[23] Although this scenario is much larger than the joke structure above, the concept and spirit of the 'rule of three' pervades the *Priest for Potato Swap* scenario. Tiernan establishes the failure of Mass both at home and abroad. He embellishes that failure with the imagery of polite priests in Australia, melting priests in Africa and endangered priests at home. In doing so he emphasises the pattern of failure through the second part of the joke structure. The African priest's Gospel, as imagined by Tiernan, further reinforces the lack in faith inspired by lesser Masses. Up to this point the story has been focused on exaggerations, embellishments and personifications, which is enjoyable for the audience. However, in the last two lines, Tiernan subverts the boundaries of his own story and the work hits a deeper register. The closing lines contain the last part of the

'rule of three' tripartite structure, opening a little Pandora's box of surprise for the audience as Tiernan moves into a more spiritual space. At the end of the routine, however ambiguously and momentarily, Tiernan inflects the scenario with questions about religious faith in a culture.

Tiernan has been branded a 'controversial comedian' for, among other things, satirising both the Catholic Church and institutional religion at home and abroad.[24] On the one hand, a discussion on the nature of religious faith as part of a dialogic encounter with a full house in Dublin may strike many as surprising. On the other hand, Tiernan has also stated publicly that he enjoys talking about spirituality. In an interview conducted with Tiernan I asked if his being drawn to religious themes was subversive in some way. He replied:

Yea it's subversive, but not in a Manic Street Preacher sort of way, which is dripping with college sincerity (*laughs*)... When I started, I've been doing stand-up now for ten years, when I started doing it... it was, I was attacking an institution that held some sway. But now when I'm talking about religion it's kinda like I am ... ah... trying to regenerate... ah – ideas about something that's past its prime. So it's almost like I'm the opposite side of the river now. I certainly didn't start talking about religion because I thought it would be shocking. I started taking about it... when I left school at eighteen I went to join a religious community, so it's something that's kinda very... it's in me bones – do you know what I mean like so... Every time I come up with a bit of material about religion, part of me is saying 'jees Tommy you know... this is a bit fuckin old hat at this stage.' But I'm drawn to it – in the same way that I'm drawn to talking about sex and children, the weather... Penguins... Whatever.[25]

However, later Tiernan explained that, at times, he felt he needed to be cautious. About what, I asked? He needed to be careful about the thoughts that sometimes came into his head. While out walking in the lanes around his house a few hours earlier, Tiernan had told himself:

It's important that you become as well known as you possibly can. Because it's important for you to get your message across. Now, I said that to myself. So I would be very aware of the fact of... megalomania... I would be very suspicious of statements like that, that I would make to myself, you know, 'Cause I don't actually have a message... I'm not like Bono trying to cure fucking global debt.[26]

It is safe to say that Tiernan harbours suspicions about the nature and scope of his own megalomaniac tendencies. However, from the performance work on which we can draw it is also possible to surmise that Tiernan's work does harbour something like messages, and is inhabited by what he terms his "expressions of spirituality."[27] Tiernan may well avoid what he terms 'college sincerity' in the work, which can douse the spirit of comedy. Yet, even as he polices the boundaries of his own material from 'messages', the work does harbour recurrent themes that speak to (here) religion as well as broader ideas of communal and social value.

As discussed, embedded into the last lines of the *Priest for Potato Swap* scenario is the 'surprise!' element of the 'rule of three' comic structure. The audience have willingly followed Tiernan through stories of priests and potatoes, and are keyed toward the conventional notion of a punchline. Expecting the unexpected reflects a kind of mutual collaboration between the comedian and the audience. As I discussed above, that understanding of social contract or congruity must be in place between the audience and the comic, as the inherent background to the world of the joke. If that background and consensus are present then incongruous humour or 'surprise!" can be seen to work. Incongruity theories form one strand of the three major classic traditions associated with humour. Incongruity theories sit alongside the other two major strands of thought, those being Superiority theories and Relief theories as means of circumscribing thought on humour. These key strands of thought on humour and their meaning in cross-disciplinary scholarship are of course well beyond the scope of this discussion.[28] To illuminate the point here, a very broad and brief definition of incongruous humour describes the "experience of a felt incongruity between what we know or expect to be the case, and what actually takes place in the joke, gag, jest or blague: 'Did you see me at Princess Diana's funeral? I was the one who started the Mexican wave.'[29] A small parallel can be drawn here between joke mechanics and theory. The practitioner view of the 'rule of three', as described from within the world of stand-up comedy, is perhaps an economic version of aspects and experience of incongruity theories in performance. That said, in this scenario the audience and Tiernan are co-conspirators in the incongruous nature of the yarn that he weaves, and the expected surprise or punchline that the audience respond to could be understood to occur on the "I DON'T LIKE LUKE" line. There is a second bite of the apple as incongruity also occurs on the almost intimate delivery of the last line, when Tiernan, like the figure on the cross with arms outstretched, interprets the Gospel for the audience. Tiernan has played 'surprise!' with the audience,

following the familiar pattern, which works in the end to subvert the scenario itself. The joking structure may be conventional, the humour wrought incongruous, but Tiernan takes that subversion to another level by asking a question about faith. By staging questions of religious faith then, is Tiernan regenerating ideas that are, in his own words, 'fuckin' old hat,' and past their prime?

Bill Hicks once stated that it is the fundamental job of the comic to say "Hey wait a minute as the consensus forms."[30] It is perhaps something of an irony that Tiernan, whose career was materially aided by, in his own words, 'attacking' the institution of the Catholic Church, has come to inhabit the 'opposite side of the river,' and this scenario signals to and reflects that positioning. Is this performance then perhaps an example of what he terms his 'expressions of spirituality'? If Irish Catholicism is failing the spiritual needs of its people, what becomes of faith, firmly rooted in practice or memory for many and from within the doctrines of that church? Or does the audience's bemused laughter at times, reflect the fact that Ireland is on the move toward a 'post religious' society, a society which laughs and yet somehow looks awry at Tiernan's flagging attempts to kick-start a dialogue of faith? How the audience perceive the scenario cannot really be known. As discussed, an audience may laugh for many reasons; the presence of laughter is not always an indication of enjoyment or agreement. However, the fact that Tiernan chooses to place the question of religious faith centre stage in Vicar Street is significant. Tiernan stands downstage centre, and holds the audience for a moment. In a lower and a more serious tone of voice (still in the mask of the African priest) he tells the audience that the Gospel is trying to say, "Come down from your tree... I am waiting... for you." I would argue that the last lines of the *Priest for Potato Swap* come close to Tiernan's spiritual expression situated on a stand-up stage here. Those lines speak to a desire, which looks for meaning beyond the experience of the everyday, beyond what is given. Tiernan's placing of the Word centre stage at Vicar Street is distanced from himself through the mask of personification. However, his disavowal of 'messages' sits cheek by jowl with his 'expressions of spirituality' in dialogue with an audience. That positioning is couched in Tiernan's ambivalence expressed here as yearning for that which is beyond the material horizon, beyond contingent reality. At the same time, Tiernan never loses sight of the oppositional pole, through his negotiations with the 'stuff' of everyday. It is within this structure of ambivalence, this 'system of contraries' to put it another way, that Tiernan maps his comic play across a dialectic landscape, which speaks simultaneously to sublime and ludic value.

This is an unfinished discussion as it stands. I will return to these ideas a little further on in the chapter. That said, in order to add some ballast to the argument, I would like to look at some of Tiernan's material from within another set of oppositions. In other words, I wish to move away from ideas of the sublime and look to some of Tiernan's more absurd imaginings.

3.2 Messenger to the other side

For the moment, I want to turn away from notions of the sacred to a scenario that is very much grounded, initially at least, in the secular world. Entitled *Drug Olympics*, the routine accommodates aspects of both the sublime and the ridiculous, and will in the end bring us back to horizons beyond our ken. The scenario is taken from Tiernan's third DVD entitled *Loose*, and was filmed as part of the performance tour of the same name, which began in Ennis in 2004 and ended in Edinburgh in October 2005.[31] Again Tiernan utilises something of a set design; for *Loose*, the backdrop could be described as a carnivalesque trompe l'oeil. The audience encounter a setting bursting with visual riches. There are images of a Pope in a wheelie bin, of disparate figures standing on each other's shoulders balancing a bath, which acts as a boat. There is an ostrich and a boxer in one corner, naked people in windows wearing rubber duckies and a suited man in one gold high-heeled shoe; he is standing on a rooftop and a naked lady can be seen through a window underneath. There are cruise liners and factories in the background, lots of strewn balloons and in the centre there is a gathering of fair-day people. On the whole, the feeling is that of a weird fairground. When Tiernan comes on stage, he speaks to the audience, "I hope you like the painting by the way. It's not supposed to mean anything in particular, it's just there to set the tone... ah... this is what things would look like if I was in charge basically."[32] Tiernan then moves through many and varied topics that make up the content of the *Loose* performance tour. The subject matter includes Hitler as an Irish man, Irish Travellers, the Bible, madness, laughing, mothers, women and sex. Tiernan saves up the *Drug Olympics* scenario as the final act of the evening before the curtain call.[33]

Staged in 2005, Tiernan's vision of a *Drug Olympics* was timely and topical since that was the year that Britain secured its bid for the 2012 Olympics. In that same year the Irish print media ran a number of columns on the possibility of Ireland's bidding for the games. At that time, Gemma O'Doherty of the *Irish Independent* had spoken to Fine

Gael MEP Gay Mitchell about his hopes for a future Irish bid. In 1992, Mitchell, then the Lord Mayor for Dublin, "commissioned the first and only feasibility study into whether the capital would make a credible bid for the Olympic games."[34] That study did find that Ireland could indeed host the Olympics, by updating and restructuring its existing sporting facilities. However, Mitchell's vision was seen by many in the political arena as being far-fetched and the stuff of dreams, although he did garner some support from sporting circles. The dream was never realised. In 2005, as Britain successfully went through the bidding process and emerged victorious, Mitchell was clinging on to the vision of an Irish mirror image, stating "surely it's about time we had some sort of Olympic vision for our capital city."[35] Whether happy accident or otherwise, Tiernan's vision for an Irish Olympics arrived within roughly the same time frame. However, Tiernan's vision represents a skewed and carnivalesque hallucination. He evokes a wonderfully upside-down world, a West of Ireland Olympian dream if you will. In that reverie, there would be no sporting facilities, and pharmaceutical companies would sponsor athletes to outperform one another. Drug testing would be abolished and drug taking would be actively and openly encouraged in the pursuit of Olympian Gold.

Drug Olympics

And this is our time you know?
And we only get one go of it
And we're hamstrung by our own heads but...
Wouldn't it be great?
Do you know those visions you get when you're drunk?
In a visionary flood of alcohol, as Uncle Leonard said
Wouldn't it be great to just for once?
To do something that could send a message
To people in the future
To say "at least they knew the fucking joke"
So how can we inspire future generations?
Well people like Bono and Bob Geldof
They think we should make poverty history
And that's such a fucking boring idea
I wanna think of something brilliant
Something inspirational
And I couldn't think of something for the entire world
I thought of something for my own town of Galway

To send a message
To not take the world so seriously
I think... It's a population of sixty or seventy thousand people
Living on the west coast of Ireland
And I think we should bid for the Olympics
Get a proper fucking committee and a brochure together
We should bid on the Olympics and have no facilities
And we would let... the athletes would want to come
Because we would allow them take whatever fucking drugs they
 wanted to
The Drug Olympics
What a fucking release that would be
Just to not take it so seriously
Imagine the fucking craic we could have
They'd call it the Crack Olympics
And some people don't like drugs in sport
I say shut the fuck up
If somebody wants to run the one hundred metres in half a second
FUCKING LET HIM
I wanna see him slow down before he gets to the bendy bit
Not all the athletes would take drugs
The Africans wouldn't
They'd just take the food and be delighted to be getting it
Athletes would not represent countries
They'd represent pharmaceutical companies
You could have a whole host of new headlines
"Viagra embarrassed at relay/baton mix up"
"Prozac win nothing but still feeling fairly positive about the whole
 experience"
And there is no country on earth better suited to the Drug Olympics
 than Ireland
Every time we win a gold medal, there is something dodgy about it
Last year's Olympic Games, we won not even a number – we won a
 gold medal
A gold – fucking alphabet city – a gold medal for show jumping
And we found out a few months later
The... HORSE was on drugs
The fucking horse
And people are surprised
I say, "Why the fuck would you be surprised?"
There's no point in the jockey being on them...

The Irish jockey's name was Cian O'Connor
And Cian O'Connor said that he didn't know a thing about it
And I believe him
I believe that the horse… took the drugs himself
The big nostrils on him
Why would a horse take drugs himself?
Cause he is not stupid
He knew what his life would mean… be like after such a victory
He saw himself on a stud farm in the county Kildare
The gold medal draped around his neck
Eyelashes tinted for the winter
Shouting to some stable boy
"Back her into me P.J, just back her into me"
Now it was obvious from the footage that the horse was on drugs
He was the only horse with a clear round
The only one
Every other horse was too nervous
They were rigid with tension
Banging into poles, falling into the water
"Waterford Crystal Meths" – that's the horse's full name
He came out… Laughing
Ha Ha Ha Ha Ha
Relaxed… giving the wink to some Brazilian filly in the paddock
"How are ya… have ya ever been (*pelvic thrust*) to Ireland" (*whinnies*)
"All right Cian, you just hold on and smile, do ya hear me?"
"Take off your hat and wave at the end – Daddy's driving this one"
"All right – here we go" (*laughs*)
"Ain't no stopping us now"
"What's that? All right, all right, four legs" (*gets down on all fours*)
"I don't care – Weh Heaaa!"
He glided over the first fence
He moonwalked to the second fence
Every time we win there's something dodgy
Most of you I'm sure would have heard of Michelle Smith
Yea? Our greatest Olympian
She won four gold medals
The Los Angeles Olympics
She wasn't even able to swim the week before
She just happened to be passing the pool
"I'll give it a go"
Four gold medals

And we found out she was riddled with drugs
Fucking riddled
**It's a wonder the girl didn't dissolve when she jumped into the
 pool**
And people said she was too ambitious
That to go from zero to four gold medals is too much
I say the opposite
She had so many drugs – she could have won all the gold medals
Not just in the swimming – down the fucking track as well
Wouldn't that be a great message to send out to the future people?
Can you imagine her?
She spends the first week in the pool
She won everything – Everything
Twenty-seven gold medals in her bag
She heads down to the track on the Monday
Still in her flip flops and swimsuit
Trembling – the amphetamine shakes
After being up all night building a hotel
Down to the track at nine in the morning
"What's first? – The hundred metres"
"Yea Yea Yea Yea Yea Yea" (*running*)
"What's next, the javelin?"
"Give it to me, fucking give it to me"
"Give me that Frisbee yoke as well"
Yeaaaaaaaaaaaaaaaa
She was on so many drugs
That Cian O'Connor could have rode her in the show jumping.[36]

Tiernan begins the *Drug Olympics* with 'And this is our time you know?
And we only get one go of it.' His vocal delivery is soft. The pace reflects
the normality of an everyday exchange and his tone, physicality and
stance are relaxed and informal. For a moment, there is a feeling that
Tiernan is speaking directly to the audience, in as close an approxima-
tion to his offstage self as possible. Indeed, theatrical tradition has long
utilised the staging device of coming right down to the footlights to
engage with the audience. On one level this is because "humour and
treachery tend to gravitate naturally toward the footlights – humor
because it is incomplete without the audience."[37] Coming down to the
borders of the stage and speaking directly to an audience bridges the
distance between art and reality and gives the audience some sense of
agency in the exchange. A way to look at exchange between comic and

audience is held within Bert O. States's model of the collaborative (as part of his three pronominal modes of performance). The collaborative mode is integral to Tiernan's performance style and I have spoken of this elsewhere.[38] That said, the collaborative mode is described as theatre speaking directly to the spectator, saying in effect "Why should we pretend that all this is an illusion? We are in this together."[39] Elements of the collaborative are infused to varying degrees and throughout all the performance scenarios under discussion in these pages. That sense of the collaborative is vital to a comic–audience exchange and it is a style that comedians use often. That said, if Tiernan ended the *Priest for Potato Swap* routine with something of an abstract question for the audience, here he re-emphasises the collaborative spirit. Connecting directly to the audience, he asks a question that seems somewhat more grounded in the material world; 'Wouldn't it be great to just for once… send a message to the people of the future…to say at least they knew the fuckin joke.' Tiernan sets out his Olympian stall for the audience. The *Drug Olympics* is a fabular story, and Tiernan is without doubt a gifted storyteller. On one level he is displaying his gift for telling, and an audience are able to appreciate that virtuosity (what States refers to as the self-expressive mode) at a subtle remove from the comic world he is creating.[40] He possesses what Kierkegaard described as "exuberance" and "absolute assurance"[41] over the narrative to create a *Tristram Shandy*esque story of a county town's hosting the games through a haze of drugs. Tiernan leads the audience through his delusion of narcotic-filled athletes competing in chaotic sporting events. He elaborates on the pitiful nature and reputation of Irish sportsmanship at Olympic level. Cian O'Connor's disavowal of his horse's drug taking and Tiernan's personification (something akin to States's representational mode) of "Waterford Crystal Meths" as the steed, who wanted it all, is sustained by more or less continual and robust laughter.[42] His personification of the horse describes what Double calls "instant transition from narrator to character." In Double's opinion, the phenomenon is common in stand-up comedy, however it is rarely discussed, and comedians have inevitably come up with their own terms. Eddie Izzard describes it as "the motherlode," Tony Allen calls it "snapshot characterisation" and Double regards it as "instant characterisation."[43] He continues the point, stressing that on the stand-up stage, "even animals and inanimate objects can be characterised."[44] To borrow terminology, then, Tiernan's 'instant characterisation' of Cian O'Connor's horse is one that he spends some time on, the story of the perspicacious horse who "took the drugs himself," in order to attain a better quality of life on a stud

farm in Kildare. Mookwalking his way through the rounds, relaxed, flirting with Brazilian fillies, lifting off four legs and onto two; Tiernan characterises a horse that is most definitely in charge of his jockey. Cian needn't worry, 'Daddy's driving this one,' all he has to do is 'take off [his] hat and wave at the end.'

There is that particular fascination at play here for gifting animals with human characteristics. The phenomenon seems to give people endless enjoyment (if the clips of animals 'doing' human things on YouTube are anything to go by). Simon Critchley gives a very interesting treatment of the relationship between humour, humanity and animality. He begins by suggesting that humour is human because Aristotle made it so, when he asserted that "no animal laughs but man."[45] The phrase and the thinking behind it have worked their way down through the centuries from "Galen and Porphyry, through Rabelais to Hazlitt and Bergson."[46] Clearly, the idea that laughter is in the realm of the human has carried across time and discipline, and is beyond the scope of my purpose. However, Critchley's treatment is useful in order to illuminate the discussion of why humans may laugh at animals as humans, and humans as animals. Working off and in counterpoint to Helmut Plessner's *eccentric* humans,[47] Critchley argues "humour explains what it means to be human by moving back and forth across the frontier that separates humanity and animality." Comic inversions between humans and animals are legion in literature and drama, and can be based in certain respects on ideas of Horatian benign mockery and a blacker Juvenalian satire. On one level, Horatian benign mockery or *urbanitas* finds its humour in the "comic urbanity of the animal… the humour is generated by the sudden and incongruous humanity of the animal." On the other hand and based in ideas of a darker misanthropic Juvenalian satire, the "reduction of the human to the animal does not so much produce mirth as a comic disgust with the species."[48] Reducing the human to the animal, or raising the animal to the human, then, can produce humour, albeit from differing quarters. In *Drug Olympics*, the experience reflects one side of the satirical coin. Tiernan is not involved in reducing humanity to animality; rather, he elevates the horse and gifts it with human characteristics. The audience enjoy Tiernan's 'instant characterisation' of "Waterford Crystal Meths" (ghosted with the Horatian spirit) as benign and enjoyable. However, while Tiernan may not be reducing the human to the animal to produce Juvenalian satire, there is darker shading at work here. As Tiernan characterises the horse, he may well be making some veiled satirical comment on the farcical series of events surrounding O'Connor's victory.

On any stage there are always issues around the characterisation of real people. Representing the 'real' in performance can carry some ethical concerns; these people are in the world, they are not fictional characters. However, Tiernan avoids any real sense of 'characterisation' of Cian O'Connor (instead the horse takes centre stage). Nor does he do so with Michelle Smith.[49] Their 'instant characterisations' last only as long as they are needed to paint the picture for the audience and bear no real resemblance to their real world characters. Tiernan creates an arena where joyful misrule reigns, warning those, '[who] don't like drugs in sport, [to] shut the fuck up, if somebody wants to run the one hundred metres in half a second, FUCKING LET HIM.' That said, I do think that Tiernan is operating somewhere in the crosshairs between the poles of a good old-fashioned Horatian scolding and a more mocking 'spirit of' Juvenalian attack. To my mind Tiernan is satirising both O'Connor and Smith for the accusations and denials of alleged drug taking, specimen tampering and disappearing blood samples; highlighting the attendant scepticism felt by many when those stories entered the public arena.

Cocks, bulls and carnivals

Tiernan has laid out his Olympian scheme, he has visualised that landscape for the audience, and he has made satire from some shattered dreams in Irish sports. There is a temporal comic timing structure working at the back of the *Drug Olympics* scenario. Again, Critchley puts it very well when he envisions the telling of a joke as the stretching out of an elastic band. The question of when the elastic band will snap is anticipated but not known which is enjoyable in itself, until finally the band:

> Snaps at the punch line, which is a sudden acceleration of time, where the digressive stretching of the joke suddenly contracts into a heightened experience of the instant. We laugh. Viewed temporally, humourous pleasure would seem to be produced by the disjunction between duration and the instant where we experience with renewed intensity both the slow passing of time and its sheer evanescence.[50]

This sense of comic timing, of *duration* and *instant* can be seen to be at play here, in the way that Tiernan constructs this fabular tale of a drug-fuelled West of Ireland hallucination. Tiernan builds the story of the bidding for, hosting of, and successes involved in running the *Drug Olympics*. Toward the end of the story, Tiernan gives us his 'snapshots' of "Waterford Crystal Meths," of O'Connor and Smith, as they run

through the weave of the narrative. The story peaks on Smith and snaps goes the punch line, 'she was on so many drugs... that Cian O'Connor could have rode her in the show jumping!' That punchline cracks the world of the joke, incongruous humour satisfies expectation and the line itself is powerful enough to garner the big 'end of the evening laugh;' a fairly common convention and aspiration for stand-up comics.[51] Critchley's method of describing *duration* and *instant* is tied in certain respects to a second joking structure. Popular understanding of a 'cock and bull' story usually imply a narrative that works as a series of digressions and circumlocutions until the joke's punch line puts paid to any further dissemble. There is not that conventional sense of the digressionary here; the build of the *Drug Olympics* narrative does not go off point or become really tangential as one might expect from a conventional 'cock and bull' story. Tiernan does, however, lead the audience through the fabulous fabrications of the *Drug Olympics* for over seven minutes, and the audience consent to his doing so. He may not be typically digressive, but neither is his direction clear. The audience are held within that knowledge and anticipation of not quite knowing where they will land but fully expecting to enjoy it. In that sense I do believe the spirit of a 'cock and bull' story works here. In addition, the essence of a 'cock and bull' tale lies in its sheer outlandishness. That joyfulness turns on the story's utter improbability. The absurdity of the *Drug Olympics* vision, its very far-fetchedness, its indulgence and 'fancifulness' all represent a hearty 'cock and bull' rendition.

That said, the *Drug Olympics* acts as a skyscraper of evasion. If in the *Priest for Potato* swap, Tiernan reveals an ambivalent desire for the sacred, here there is an inversion of that yearning. This is a piece of comic business that seems firmly grounded in the secular world even as it gallops off into fabulous flights of fancy. The scenario is a sort of ecstatic rebellion, which mocks the rule and order of the everyday. In that sense it very much a carnivalesque vision. Tiernan evokes that festive spirit (also as backdrop) where the normal rule of daily life becomes inverted, turned upside down; where the mechanised structures of a culture are dispensed with if only for a brief time and hegemony and power is (seen to be) denied through mockery and laughter.[52] Bert O. States recalls Georg Lukács' as saying "Tragedy is a 'science of death moments.' So comedy is a science of life moments, of an assurance that 'the broad richness of existence' is all that really matters and that death can always be deferred."[53] In the secular here and now, Tiernan points out that this is our time and we only get one go around. He revels in the carnivalesque dream (which also denies death) he creates in the

present. He suspends the rule of everyday in ludic mockery that entreats an audience 'not to take it all so seriously.' By doing so Tiernan pokes fun at and tears holes in that very human flaw of pretension and self-importance. This is what the 'future generations,' clearly understand and something that, for now, people catch sight of only occasionally. Tiernan takes a 'scythe to seriousness', submitting the flaw to comic ridicule where it buckles momentarily under the weight of the *Drug Olympics* as a marvellous celebration of misrule. Here, there is not that sense of Tiernan's 'expressions of spirituality' as experienced in the *Priest for Potato Swap* scenario. He is not talking about religion now. He is not attempting to regenerate ideas from the 'opposite side of the river.' He is grounded in a secular future. The sacred sleeps. Yet Tiernan has envisioned a world beyond this world, which suggests the prospect of a more enlightened world, a better world than our own. Somehow the work is back in the realm of faith. So even as the story is grounded in the secular, a clarion call for temporary escape from the structures and constraints of the material world, something else is occurring. Tiernan evokes the spirit of the carnival and presents to the audience a dialogue, which both recognises and denies death, while keeping a weather eye for a sign of the next world. Peter Berger believes that "humour [lets] lets us view the folly of the world by affording us the glimpse of another world, by offering what he terms a 'signal of transcendence.'"[54] That glimpse of another world may serve to highlight this one. The vision of the future illuminates the folly of the present. By showing us the follies of the present, Tiernan "does not save us from that folly by turning our attention elsewhere as it does in great Christian humour like Erasmus, but calls on us to face the folly of the world and change the situation in which we find ourselves."[55] In the end perhaps the message is to offset what Nagel describes as "an incurable tendency to take ourselves seriously."[56] This life of ours is short, with endings hurtling toward us, it should be possessed of more pleasure, more joy, more liberation in the face of such insurmountable odds. But even as Tiernan focuses his attention here, he is also looking elsewhere. As a performer Tiernan can, in an instant, move the focus from the ordinary to the holy and back again. He celebrates evasion tactics and makes mockery of the material world. At the same time he is again speaking, albeit it somewhat more softly here, to something like a supernatural horizon. As surely as Lent follows carnival, the *Drug Olympics* sits on the cusp of a whispered spirituality; it implies faith in that which is beyond the given, it implies hope for the future, and something resembling a prayer that all will be well in the next life.

3.3 Mixed messages

According to Bob Berky, the clown can fulfil many roles. The clown may suffer on an audience's behalf, and may experience on stage that which an audience has experienced in everyday life. The clown may act as a scapegoat or whipping boy and can embody or articulate political, social and cultural praxis or concerns. That said, the expectation always remains that "the audience expects the clown to be immortal to the event... [the audience expects that the clown] will not be hurt."[57] But this may not necessarily be true. As discussed in the last chapter, comedians really do get hurt. In recent years Tiernan has often drawn fire for breaking the rules of comic licence. As is well known, the comic is no stranger to controversy. In 1997, he caused a public outcry when he appeared on *The Late Late Show*, then hosted by Gay Byrne. Tiernan, in the eyes of many, seemed to insult and degrade the rituals and values held by the institution of the Catholic Church. However, rather than damage the career of the aspiring comedian, the outcry achieved exactly the opposite effect. In a sense Tiernan became the comedian who could say anything and be forgiven for it, and as a comic who actively courts notoriety, with the ability to "get away with things that maybe other comics wouldn't."[58] In recent years, a series of controversies have put Tiernan at risk. In October 2008 Tiernan again appeared on *The Late Late Show* (on which he has been a frequent guest), then hosted by the radio and television guest presenter Gerry Ryan. During that show Tiernan joked about people who had sustained head injuries caused by motorcycle accidents. His remarks caused anger to many and resulted in complaints to the Broadcasting Complaints Committee, and the setting up of Bebo pages entitled *"We hate Tommy Tiernan"* in order to create a platform for public complaint. Additionally, *Liveline*, an 'open forum' programme on RTÉ radio hosted by Joe Duffy, received calls of complaint as people divided into camps *for* and *against* Tommy Tiernan. On the show Tiernan also made jokes about Irish Travellers, which were upheld as derogatory by the BCC. In an interview with *The Irish Times*, Tiernan told Keith Duggan that he was aware that *The Late Late Show* of October 2008 had failed spectacularly, and in a note to himself afterwards observed that "the more time I spend in that box the more I am misshapen in it."[59] In September 2009, Tiernan enraged those of the Jewish community while performing a scenario about concentration camps at the Electric Picnic Festival in Stradbally, Co Laois, Ireland. He did preface the piece by stating that the comedy stage is "about allowing whatever lunacy is inside you to come out in a special protected

environment where people know that nothing they say is being taking seriously."[60] He continued:

> But these Jews, these f**king Jew c**ts come up to me. F**king Christ-killing bastards. F**king six million? I would have got 10 or 12 million out of that. No f**king problem! F**k them. Two at a time, they would have gone. Hold hands, get in there. Leave us your teeth and your glasses.[61]

The following month the media ran the story that Tiernan has been cancelled in Canada as a result of his comments about Jewish people. In a subsequent press release, Tiernan stated "the things that I said in front of a live audience were in an attempt to explain my belief that one of the duties of the comic performer is to be reckless and irresponsible and that the things that they say should NEVER [his emphasis] be taken out of context."[62] A spokeswoman for the *Just for Laughs* Canadian comedy tour was quoted as saying that "both the festival and Tiernan agreed that it was in everyone's best interest that he drop out of the coming National tour... [adding] he deeply regrets any hurt he has caused."[63]

In an interview Keith Duggan asked Tiernan if his material on *The Late Late Show* was offensive. Tiernan's response was revealing:

> Of course it is. That's the craic! That's the fun! As a comic, it is an instinct. I can defend it intellectually but it is not an intellectual position... on stage, it is an alter ego – without it being theorized or explained... when I go on stage that is what I am doing. I am saying: 'I am not going to hide anything. I am not going to stop any thought that comes into my head.' Because this is a special ceremony. There can be no holding back on stage. And I do come off stage thinking, 'Jesus, what was that?' But I won't stop. Because I trust it... Now, when you take that person on stage and put him on *The Late Late Show*, something different happens.[64]

Tiernan's words serve well as a description of aspects of his comic persona when on stage, and as something of a defense against those who take offense at his material. In June 2009, Peter Crawley reviewed the *Cat Laughs* festival in Kilkenny, suggesting in his column for *The Irish Times* "controversy is often simply comedy out of context." He quotes Tiernan at the beginning of his routine telling the crowd '"There are no rules here. You don't come to a comedy gig with a *notebook*, stealing *jokes*, telling the *outside world* what happened here. I saw *you*. You're not

welcome *here*. You know who you *are!"'*[65] And it seems to be a point with which Crawley agrees (notwithstanding the notebook in his own pocket), saying, "Atta boy, Tommy, stick it to The Man."[66] Crawley gives a short burst of critique at the media and Tiernan's detractors who insist in taking the joke out of its context, and asserted that, "The old adage still holds: You had to be there."[67] A little earlier in the same year, Tiernan was again in some trouble, this time with the moral superiors of the Catholic Church in his adopted home town of Galway, in the west of Ireland. Tiernan had planned to perform a 36-hour stand-up comedy (aptly named *Testamental*) marathon in aid of the Local Youth Diocesan Service in Galway. Tiernan insisted on beginning the marathon on Good Friday, and because of the religious gravity associated with the day, the Youth Diocesan Service withdrew their support. He went ahead anyway. He acknowledges that 'Number Four' (the drop-in house for homeless and marginalised young people) is patronised by the Church. He also states "you can't allow that to stop young kids getting help. The money will be given anyhow. These are young fellas sleeping in car parks, not down-and-out seminarians."[68]

Tiernan has clearly offended sections of the national and the international community, and he has added insult to injury over his material on people with Down syndrome. The comic, who has worked with Down Syndrome Ireland causes in the past, has stoutly defended himself by stating that, "All my friends with Down syndrome and their families think it's funny and they are delighted to be mentioned in the show instead of being ignored or treated with pity."[69] By way of example, during his *Bovinity* tour of 2008, Tiernan, when performing in Vicar Street, had the following exchange with an audience member on his Down syndrome material. The audience member was audible in her disapproval and Tiernan's response to her is described here:

Down syndrome

One of the ways that I like to get out of my head is hanging around
 with lunatics
And I do a lot of work with Down Syndrome Ireland
"Ah No" (*Audience member, front row*)
Who said – "Ah No"?
"Navan Girl" (*Audience member replies*)
Navan Girl said "Ah No"
What are you afraid of sweetheart... 'cause you're...
There's probably a lot of people in the audience who are thinking
 the same thing

Can I put your fears at rest?

Can I?

I've been doing this material – parts of it for about three… three or four months

And there was a furore in the tabloid newspapers

That you're probably talking about

You probably saw

DOWN SYNDROME FURY

Now I don't know if you've ever seen a furious Down syndrome fucker

But it's – It kind of is and isn't scary at the same time

So that's what you're probably talking about

You probably heard *Liveline* and Joe Duffy and…

"Oh Tommy Tiernan is doing this awful stuff about kids with Down syndrome"

"Oh has he no fuckin manners"

Well number one, no I don't have any fuckin manners

And I'd be of no fuckin use to you or myself if up on the stage I did have manners

Cause that's not what it's about up here

We invited Down syndrome Ireland

And they came along

And they released a press statement

Which you can read on my website

Saying that they "fully supported Tommy Tiernan

And all his material

We don't think its offensive to Down syndrome or anybody who is connected with Down syndrome"

Now – They sent this press statement to all the tabloid newspapers that had run the story about

DOWN SYNDROME FURY

And they sent it to *Liveline*

And none of those hypocritical judgemental fuckers

Picked it up

So it's ok

So now can I tell the jokes about the spas?

Can I?

Thank you very much.[70]

Some would argue that Tiernan has crossed the boundaries of what should and should not be joked about on a stand-up stage. On the

other hand the vitriolic response to the comic and his material is not unified. It is clear that there are advocates both from the wider public domain and from within the media itself who support Tiernan's assertions that the joke-work was taken out of the live performance context. In terms of the offence he caused on television, Tiernan defends the comedic instinct and impulse that is 'misshapen' and distorted by the box in the corner. The fact that the *Just for Laughs* comedy festival and tour cancelled Tiernan's contract and his public statement of regret does speak of some damage to Tiernan's international reputation. In 2010 Tiernan's interview with Gay Byrne on RTÉ television highlighted the personable relationship between the two men, where Tiernan spoke openly of "the strong role religion and spirituality play in [Tiernan's] approach to life and comedy."[71] The interview may well have helped to ease some of the public anxieties surrounding Tiernan and his material. That said, the question that remains is, did Tiernan go too far; did he transgress the boundaries of permission on what a community considers as appropriate subjects for humour? In the eyes of sections of the community, Tiernan is certainly guilty of this sin, and they have every right to be offended. Was the work taken out of context by the media furore? Quite possibly. Is Tiernan's defence of the nature of his comedy enough? Critical discourse around the policing of comedy is hotly debated, both from within academia and in the broader social and cultural arena, and will not be resolved here. What I will say is, Tiernan's relationship with the public is tied up in a symbiosis of co-dependency. The comedian and the public have always had and continue to have a mutual need for one another. Tiernan performs his brand of comic controversy for the public appetite and the public are delighted (in the main) by Tiernan's brand of controversial comedy. He may well have gone too far in the eyes of some, and as Jimmy Carr puts it "the right to take offence is very nearly as important as the right to cause it,"[72] but isn't that what an audience or a society have given him permission to do, more, isn't this what is expected from him? Like him or loathe him, Tiernan has the ability to personify the controversial comic for public consumption. That double edge means he also has the ability to summon an audience to feelings of discomfort and unease. I spoke of consensus and licence in the last chapter, and Tiernan, who works on the edge of that consensus at times actively plays with those boundaries of permission. In so doing, Tiernan's performances occupy something of a knife-edge at times, working within a set of tensions that place him within reach of reward and risk in the same comic breath.

Clearly, then, Tiernan has a gift for tapping into cultural anxieties both in Ireland and abroad, for flexing his comic muscle and saying the "unsayable."[73] By way of a final example here, I am going to discuss a scenario that I filmed in *The House of Fun* at the Axis Arts Centre in Ballymun, Dublin, Ireland in July 2007. The routine, an extract of which is presented here, deals with the contentious issue of suicide bombers. I have called it *Suicide Bomber*, for reasons that will soon become clear.

Suicide Bomber

So Suicide Bomber
Allah Bullah
Seventy-two virgins
You'd almost be tempted yourself, wouldn't ya?
Nobody said they'd all be women though
I'm sure Daniel (O Donnell) would be there first in line waiting for
 them
"Welcome to Heaven, you done great with the wee bomb"
So the Muslim guy is there
Allah Bullah Allah Allah
Everyone is... terrified
He opens his coat
It's packed full of explosives
"Death to the West"
"I love you Allah I love you Allah"
Those Muslim prayers last a long time
Not too long, people would start sneaking out of the restaurant
"I love you Allah"
"I love you Allah"
Do you think Allah is up in Heaven?
Going, GO ON GO ON – Take that Jesus
Look at their faces ha ha
Allah Allah
Pulls the Chord
Nothing – Fuck!
Pulls the chord... Nothing!
It's been in the shed all winter
Presses the choke button three times
One Two Three
Fuck – Nothing
Nun puts her teeth back in[74]
People are looking at him

"You fucking eejit"
"Couldn't even blow yourself up properly"
He's still full of suicide energy though
Gets a fork, starts stabbing himself
Nothing
He feels ridiculous
"I'll... have a mocha"
"To go...is probably best"
"Skinny Milk if you have it...."[75]

A little later, Tiernan directly addresses the discomfort felt by some of the audience:

I know what some of ya are thinking
"Tommy, shut the fuck up"
"They'll kill ya – and not only will they kill ya; they'll kill us for laughing at ya"
That's why we have to kill all the Muslims, just to be on the safe side
Like I said folks, this is comedy world, I don't want any of you ringing me tomorrow, saying, "Tommy, I started, it's on You Tube."[76]

This routine can certainly be construed as either racist or Eurocentric. Within the experience of the live setting, the mere mention of suicide bombers sent a tangible wave of nervousness through the audience. Initially, there was a definite feeling of "Should I really be laughing at this?" Tiernan builds on that tension specifically in his repeated Muslim prayer. When he analogises the bomb to a piece of garden equipment that has been left in the shed for the winter, the tension snaps and the audience explode into laughter. Despite the subject matter, there is a buffoonish quality to the story. The audience do enjoy Tiernan's slapstick physicality in representing the suicide bomber's dilemma. The joke, it would seem, is now on the bomber as he faces the ridicule of the people in the restaurant. The image of him sheepishly ordering a mocha coffee with skinny milk operates as a second punchline and there is another round of laughter. Clearly, Tiernan is pushing consensus in discussing such a contentious subject. In addition, through the final lines he implicates the whole room, and the material, like it or not, takes on something of a collective quality. In discussing suicide bombers in this way, Tiernan is taking the audience to darker territory, to places of unease. In recent years, in the wake of terrorist attacks around the

globe and the international community's ongoing military reprisals, it is unsurprising that an audience may feel anxious at finding humour in the ideology and practice of suicide bombings. It is important to note that Tiernan does preface this scenario by stating that it is not the Muslim religion that is at issue, but rather those in power who control its teachings. He also acknowledges that Christianity has its own brand of fundamentalists; what he takes issue with is *any* ideology whose message would seem to be, 'convert or die.'[77] The line "kill all the Muslims, just to be on the safe side" can certainly be read as highly offensive and, despite the licence that Tiernan enjoys, another example of his going too far. On one level the power of this routine does lie in the fact that Tiernan is speaking on a subject that is difficult – or even taboo – for many to entertain. I suggest that this line is heavily laced with irony. Tiernan has created some 'moments of tension' in the audience. That tension is connected to an audience's unspoken fears and prejudices about racial difference and stereotyping. Tiernan is 'digging into the stuff that people are wary about' and his belief that the 'higher the tension, the louder the laugh' is working here; there are lots of laughter seams through the *Suicide Bomber* scenario. That said, I suggest the anxiety and discomfort that Tiernan has created comes, not from any belief in his risky commentary but rather from perceiving the ease with which negative racial stereotypes are projected onto others.

Jimmy Carr states that "comedians are not the kind of people you want to put in charge of protecting minority views... they're instinctively with the mob." Carr believes that joking can, by "legitimatising our anxieties about people who are different and hard to relate to... perpetuate the status quo."[78] However, he goes on to argue against those who admonish stand-up comedy for being cruel. He makes the point that cruel jokes never went away and are as virulent as ever. He cites the prolific exchange of email jokes, and the clever shifting of moral boundaries which now situates "the socially dysfunctional, the alcoholic and the 'learning-disabled' into figures of fun in the forms of Mr Bean, Father Jack, Baldrick, Frank Spencer and all sorts of others."[79] Carr also likens *Big Brother* to Victorian excursions to Bedlam on Saturday evenings to laugh at the insane. He suggests that it is better to "air our opinions in the open, exercise our judgement as consumers of comedy and allow a certain amount of rough and tumble in the name of a good joke."[80] For Carr, any professional comedian with a shred of integrity must be on guard so as not to slip into jokes which are deliberately exploitative and which legitimise prejudicial attitudes.

That can be something of a knife-edge even for the most accomplished and successful comedians. As a final note on the responsibility that the public share when considering how to police comedy, perhaps it is worth discussing the audience who laughs. An audience may laugh for many reasons, and the interpretation of laughter is highly problematic, as I have spoken of before. In all the work discussed in these pages, the audience laughed, perhaps at times it was uncomfortable laughter, and perhaps there were those who did not laugh at all, but that does not have to be the default position with risky material. Perhaps some people also got the joke, jokes which may be about much more than exploitation or pandering to prejudicial attitudes. Should public and media furores flare up surrounding comic material, then surely the laughter as response to that material also merits some attention. That symbiosis of co-dependency that exists between an audience and a comic is in need of further study. Positive, negative or sitting on the fence, laughter as response must allow for discussion to include the audience as having more than, a *passive* act in the exchange. Those discussions might prove far more enlightening than people think. In any event, the conversation needs to go deeper than describing how those who know best, take it upon themselves to police comedy. Ideas of regulating humour may just as well feed into status quo attitudes about 'risky' comic material, or into mind-sets about the desire to control comedy itself, with comics who 'act' out of turn punished as example. What I'd like to know is who's policing those who police?

3.4 The messenger

The last scenario under discussion in these pages is entitled [by the author] the *Nowhere Routine* and like the *Suicide Bomber*, this material was also filmed at the *House of Fun* Comedy Club in July 2007. This scenario is similar in ways to the *Priest for Potato Swap* routine, as each of them is embedded in the thematic of institutional religion, and look to and address a community's shared history and cultural concerns. As with much of Tiernan's work, this story is performed as a dialogic encounter with the spectator, and constitutes a series of reflections and potentials for social relations in contemporary society.

Nowhere Routine

Nobody knows how the world started
I don't think we have to know
We don't have to fuckin' know

The cleverest people in the world, all they can say is there was a big
 bang
Oh, it was fuckin' huge – huge fuckin' bang ya
People say in the beginning, there was nothing
NOTHING (*author's emphasis*)
There wasn't even nothing, 'cause in order for there to be nothing
You have to have something to compare it to.
There was me bicycle gone kind of a thing
NOTHING, NO HOW NOTHING NOTHING NO HOW NO FUCKING
 NO!
It's like that feeling you get when you're in a shopping centre with
 no money
That empty fuckin' void feeling
Except there's no you and there's no shopping centre
And some people like to believe that in this nothingness, the not no
 how, no fucking, no, no, that that's where the living loving God
 was, ha ha
Maybe
Maybe one day, we're gonna find out there is no God
We're getting so clever as people
We're finding out stuff all the time
One day we're gonna reach the end of space
A telegram will come back from Nexus 20,
"No sign of Him" (*laughter and applause*)
What difference is it gonna make?
Do ya think we're gonna have to stop looking after each other?
Do ya?
Do ya think nuns in Africa when the news comes back, will suddenly
 throw the bag of syringes onto the ground, turn to the villagers,
 and say:
"Fuck Ye! Bunch of Aids Bastards"
"Here I am sweating me hole off in Africa – could have been running
 a B&B in Galway during the races."[81]

Almost from the outset, Tiernan sets out the rules of the game:

> The things that are said here tonight, they can't be used in the
> real world. This is a special kind of ceremony where you sit in the
> dark all facing the same direction, and I say things that are shock-
> ing and wonderful and a release. Think of this as the opposite of
> Mass.[82]

Tiernan's framing of his material in this way incites the expectation of, but not necessarily the surprise of the audience. As already discussed, over the years Tiernan has constructed a controversial comic persona, who simply has "no fuckin manners." His rhythm throughout the *Nowhere Routine* is best described by Tiernan's overall understanding of his performance style as one of "panic and attack."[83] The work is punctuated by active attack and successive pauses and Tiernan tends to use this rhythm to either highlight the significance of what has just being said or to set up the audience for the material to come. At times, he moves restlessly across the stage, and at other times he crouches and roars across the footlights at the audience. His facial expressions and gestures are exaggerated throughout, although they do not fall into the realm of the cartoonish in this particular piece, nonetheless this sense of the cartoonish informs several of his comic routines. Indeed, the *Priest for Potato Swap*, *Drug Olympics* and *Suicide Bomber* all contain certain cartoonish elements. Paradoxically, his contorted physicality and his restlessness appear relaxed somehow, leaving me in no doubt that Tiernan was very much in command of the performance sphere. His tone drops, evoking a sense of intimacy on the line "maybe one day, we're gonna find out there is no God." The word "maybe" is followed by a pregnant pause. Tiernan looks directly into the audience here, indicating his uncertainty or doubt about divine existence or intervention. His tone drops into casual conversation when he delivers the news that there is "No sign of Him," which brings a spontaneous round of applause. The strength of this scenario lies in the informal way that Tiernan reveals such an overwhelming piece of news. But this is not the end, and Tiernan wraps up the scenario with his crude account of an African missionary nun's reaction to the shocking turn of events. The final lines are energised by her tirade of abuse at the villagers, and the whole story works to leave the audience with a sense of shared experience and collective laughter.

Toward the end of the *Nowhere* routine, Tiernan asks a question of the audience:

> What difference is it gonna make?
> Do ya think we're gonna have to stop looking after each other?
> Do ya?[84]

Here, Tiernan questions the relevance of the existence of God. Implicit in such a question is another, *"Does it really matter?"* Tiernan makes direct connection with the audience and asks "What difference is it

gonna make, do ya think we're gonna have to stop looking after each other?"[85] Tiernan evokes a status game with the crowd. In stand-up comedy, status is discussed in many ways, and is defined by the comic Jerry Seinfeld as a relationship of dominance and submission, so "when discussing the dynamic of their work, both male and female comedians stress the importance of control over the audience."[86] Keith Johnstone's formulation of *status games* is useful here. Devised by Johnstone for actors in improvisation training, Johnstone states that "our behaviour... signals our importance or lack of importance... we scan each other for status information" and those who accept the lower status will placate or submit to dominance.[87] When Tiernan asks the question of the audience, he consciously lowers his own status while the spectators momentarily become the high-status players. By actively ceding control, Tiernan's question takes on a collective and collaborative quality. Again, in the temporal here and now of performance Tiernan's dialogue with the audience is one which has its eye firmly trained on an imagined future. Tiernan visualises a societal horizon without the ideology of institutional religion. In so doing he questions what a society's responsibilities might be in a world stripped of the construction. This show, recorded in 2007, came at a time when a series of enquiries and publications of Church abuses in Ireland were entering the public arena and findings included the *McCullough Report* in 2005 and the *Ferns Report* published in the same year. The Commission to Enquire into Child Abuse, established by the Irish Government in 2000, was still ongoing, with its findings published in *The Ryan Report* in 2009, which detailed the abuses of children at Catholic institutions in Ireland. The reports shocked the Irish nation and did significant damage to the stability of the Catholic Church. Tiernan's question, timed as it was, involves how a community responds to a series of horrendous allegations and revelations, materially undermining an institution, regarded as the cornerstone of moral life in Ireland. In the wake of such abuse at the hands of Church and State, that response must recognise the abject failure of the community as a whole to protect its youngest, most vulnerable and marginalised citizens. Before too long, Tiernan reverses the status of the audience. By closing the gap opened up by the question, he re-establishes dominance, ending the routine with the missionary nun's stream of invective toward the African villagers. In this scenario, Tiernan offers the audience a story of an imagined future without the master narrative of religion; in so doing, Tiernan asks the audience "where responsibility lies." The audience, who have the agency to either affirm or deny the narrative, may connect to the response implicit in

the question; in the absence of the moral compass that is institutional religion, responsibility for a society's welfare rests, has always rested, solely in the hands its own people.

3.5 The comic 'i'

Consideration of Tiernan's stand-up in these pages opens up the discussion of his work as it connects to the comic 'i.' As discussed in detail in the last chapter, the comic 'i' suggests that which constitutes 'me,' those fragments or aspects of the self, selected and projected outward from within by means of comic persona, and bounded by the comic frame. The self in this reading is tied to those questions that Benson asked in the last chapter. When you are asked who you are you respond by telling the story of yourself. In a sense you interpret yourself in relation to your past history, your present situation and your future hopes, in doing so you "give a sense of yourself as a narrative identity that perdures and coheres over a lifetime."[88] Smith and Watson argue that "autobiographical telling is performative in that it enacts the self that it claims has given rise to the "I," an "I" that is neither unified or stable, but fragmented, provisional, multiple and always in process."[89] And, as Langellier notes, "identity and experience are a symbiosis of performed story and the social relations in which they are materially embedded: sex, class, race, sexuality, geography, religion and so on."[90] In this way Tiernan cannot escape the social and cultural positionings, which underpin his subjectivity, and which inflect the performance works. That sense of an ongoing "self-making as a narrative art" performed on the stand-up stage is transmitted by means of comic personality or persona.[91] That persona acts as a mode of communication and connection with an audience. It also acts as the portal through which aspects or fragments of the self flow. That is, the self as channelled through the comic persona can be understood as a part but not the whole, a kernel through which to grow and project partial illustrations of the self from within.

Talking about subjectivity in stand-up is difficult and a particularly elusive subject considering the fundamentals of the non-serious mode and the resulting levels of trickery involved. As discussed in 'comic strips' stand-up processes and performance are exactly that, practiced, honed and manipulated (with various degrees of improvisation involved) performance, repeated nightly in the pursuit of laughter.[92] The flip side advocates that stand-up is the medium for versions of truthful telling, authenticity and self-expression. In these terms, the comic 'i', as a loose

association of ideas, is one way among many through which to talk about subjectivity and identity on the stand-up stage. Tiernan connects with the audience and signals the playful comic world. The sign 'What! I'm only kidding,' is the base beat of all the work. Within that frame, Tiernan's persona communicates some of those deeper illustrations from within. That dialogue happens within the comic heterotopic space understood here as having the "curious property of being in relation with all the other sites, but in such a way as to suspect, neutralise or invert the set of relations that they happen to designate, mirror or reflect."[93] In this reading that 'relation with all the other sites' encompasses the playful mode. Interestingly, Tiernan variously describes the stand-up space in religious terms. As mentioned, he talks of the comedy gig as a 'sacred' place, couched in ceremony, the opposite of Mass, which may speak to Tiernan's (however tested) faith in the comic world. That said, it is possible to understand the performance of the self, as a 'matrix of subjectivity'[94] in something like the same way as autobiographical performance. Tiernan's 'fragmented, provisional, multiple and always in process self' is filtered through the lens of the comic 'i' and staged in dialogue with an audience. I suggest that the "enacted' self that claims to give rise to the 'I' in autobiographical performance is in parallel to the 'enacted' self, which can also lay claim to the comic 'i' as stand-up performance. Further, that provisional, fragmented and multiple 'self' is in dialogue with other self(selves), both interior and exterior. Understanding the comic self in this way returns us once more to the recurring dialogues in Tiernan's comic works; dialogues which time and again keep locking horns with ideas of the sacred and the secular. So much so, that finding a way in to describe Tiernan's relationship with the twain of divine and material worlds will, I hope, deepen the discussion here.

Does God love us? We don't know...: If God loved us he'd want to see us laugh – that's a fucking fact[95]

Pat Sheeran and Nina Witoszek's work on Irish drama offers some insight here. They introduce the concept of big and small 't' transcendence as a means of analysis, when discussing a funerary cosmology in Irish culture. Their approach is useful as a conceptual net to enmesh Tiernan in performance and as performance. The authors borrow from the writings of Franklin Merrell-Wolff, a metaphysician who describes the Transcendent as:

> In the broadest sense, the Transcendent stands in radical contrast to the empirical. It is that which lies beyond experience. Hence

> Transcendent Consciousness is non-experiential consciousness; and since experience may be regarded as consciousness in the stream of becoming or under time, the form is of necessity a timeless Consciousness.[96]

The concept of Transcendence can therefore be conceived as a desire for contact with Absolute (not to be confused with a Lacanian sense of the Absolute which grounds its theory in a materialist psychology), rather the trans-religious Absolute as quest for sublime or mystical knowledge. However, Transcendence walks with a shadow, which names its desire with a small 't.' Here the aspiration is to evade contingent reality by means of resorting to a variety of autonomous realms – of the word, of fantasy, of obsession, of dogma – each of them an ersatz of the Absolute."[97] Although both can be understood as employing differing narratives of desire, both express discontent for contingent reality. Leszek Kolakowski's noted essay 'The Priest and the Jester' goes some way towards crystallising these polarised forces within a culture. Kolakowski states:

> The antagonism between a philosophy consolidating the absolute and a philosophy questioning the accepted absolutes appears to be incurable, as incurable as the existence of conservatism and radicalism in all areas of human life. It is the antagonism of a priest and a jester; and in almost every historical epoch, the philosophy of the priest and the philosophy of the jester have been the two most general forms of intellectual culture. The priest is the guardian of the absolute who upholds the cult of the final and the obvious contained in the tradition. The jester is he who, although an habitué of good society, does not belong to it and makes it the object of his inquisitive impertinence; he who questions what appears to be self-evident.[98]

While both these figures desire that which is transcendent, they simply take different rhetorical pathways in the quest for that which is beyond the material. The 'incurable' gap between big and small 't' transcendence, between the Priest and the Jester is of most interest here. I would argue that in these pages and, more broadly, Tiernan's comic material lives somewhere in the crosshairs between these seemingly oppositional yet magnetised narratives of desire.

Sheeran and Witoszek point up some reluctance in recent Irish scholarship for ideas of the *sacrum*. They assert "where it was once shameful

to have a body, now it is shameful to have a soul. The guardians of new materialist morality are as priggish about *Geist* as their great grandparents were about their genitalia."[99] Further they contend, "as has been frequently noted by social scientists and anthropologists, past tradition and mentalité do not entirely lessen their grip and often lay far behind evolving socio-economic structures."[100] That said, and on the other hand in their discussion of Irish drama they suggest that:

> The rhetoric and imagery of traditional institutional religion are no longer capable of accommodating spiritual needs. With the Church and its representatives flayed and mocked, the characters in these plays (Friel, Kilroy, and Murphy) find themselves on their own with their aspirations and longings.[101]

Faith, the Church and religious observance are deeply engrained in Irish culture and the Irish psyche, even as the nation lessens its grip on those structures. The gap that opens up in the face of those disintegrating master narratives becomes the stuff of Tiernan's comedy, even if he is attempting to 'regenerate... ideas about something that's past its prime,' from the other side of the river. In the comic heterotopic space, Tiernan's questions of faith run parallel to the ersatz realm, where the comic's evasions of reality run to far-fetched inversions and misrule. Yet those realms are also grounded in the secular temporal reality of the here and now; Tiernan gives the lesson to 'not take it all so seriously', and of being joyful in a life so indelibly marked by its brevity. Yet even here, Tiernan's small 't' is in some whispered dialogue to its larger counterpart, to the other side, reaching out into some kind of hoped-for unknown. Tiernan also places his work within the social relations that underpin secular life. Despite the hurt caused, Tiernan has played the role of the controversial comedian, who questions society' self-perceptions, mores, and values. Expressions of spirituality shape Tiernan's vision of a world without God, of unknowing, of uncertainty as it interlocks with his beliefs about societies responsibility for the welfare of the collective in the here and now of the everyday world.

For me Tiernan lives in the 'incurable' gap between the Priest and the Jester. He articulates those aspirations and longings that Sheeran and Witoszek speak of. In danger of feeling anachronistic, Tiernan speaks of spiritual doubt and uncertainty, in the wake of crumbling grand narratives in western society. He speaks into that gap left by a floundering church unable to contain a community's spiritual needs. Tiernan's need to speak of faith also tunes his comedy toward the material world. He

may invigorate with escapist fantasy that momentarily suspend hegem-
onic structures. At the same time, the work is embedded in contingent
reality, in the social relations that underpin day-to-day life. One way
or another Tiernan is in the act of meaning making with an audience.
He holds discursive attempts to make sense of his own provisional
self as it claims the 'i' in comic performance, shared with other selves
of the audience. He talks of Jesus as a "myth that has been created to
somehow explain the mystery. 'Cause life is a mystery and we're trying
to put some sort of a shape on the mystery. And we do that through a
story. And we've done that regarding every aspect of our lives. Created
a story."[102] Dee Heddon suggests that in discursive performance "the
stories told in our culture extend the range of stories available, and
therefore available to be lived".[103] Tiernan feeds into that melting pot.
And despite his ambivalence, the work has some messages to impart.
His denials belie other interpretations; I suggest that the work carries
sporadic signals, which express the desire (whether sacred or secular)
to "reach for something better, for new ideas about how to be and how
to be with each other."[104] Tiernan's stories speak into and try to give
shape to the mystery. The overriding signal in the work is speaking
of, to and perhaps most of all, for the collective. Tiernan stages deep-
seated questions for the community; questions of belief and of Absolute
doubt, questions of meaning making which fundamentally asserts that
the substance of a life, if it comes from nowhere else must always be
wrought from one another. Faith in one another.

In the last chapter, I suggested one understanding of comic identity
as split and divided, and, in the modern sense, of the self as estranged
from society. Tiernan's comic 'i' is in dialogical movement between
Tiernan, any given audience and the broader shared structures of
identity, hewn from a community's set of norms, rules, traditions,
expectations and possibilities. However contextualised by internal and
external forces, and by the act of comic performance itself, stand-up
can act as a "bridge' or 'window' between performer and spectator, and
between performance and the world."[105] In this reading then and in
my view, Tiernan helps to keep traffic moving in both directions across
the bridge between self and society, if 'comic humans are incomplete',
this goes some way to bridging the gap. Dee Heddon suggests that
autobiographical performance acts as that 'window' to the world, mak-
ing it appealing to marginalised subjects. I suggest that Tiernan's work
can also be understood in something like the same way, as mainstream
performance. The work represents the world of the everyday on the
stand-up stage. Those representations of the self, like Brecht's theatre of

alienation, may have the ability to send audiences out into the world somehow made aware of different possibilities, like (to paraphrase) 'comic tears from the brain.' However, there is always a large caveat written into the comic contract with any given audience. Tiernan is no different in this respect. His comedy allows for multiple ambiguities. That is, the nature of the thing itself, which makes comedy a 'nicely impossible' subject as Critchley acknowledges. The work is stacked high with comic ambivalence and Tiernan is adamant that he is a comic without a message. Perhaps the final word on the subject should come from the comic himself. Tiernan encapsulates very well the series of tensions that inhabit his comic worlds. Talking to Keith Duggan, Tiernan describes those moments when he walks off stage as moments of "savage loneliness." It is in those few moments through which all the doubts and misgivings about the work surge and ebb. "That's the really daunting part of it... These are the things that dominate my mind rather than issues that the nation has to deal with. You know, what if I forget how to be funny?"[106] Say a prayer for him.

4
Everybody Knows That The Dice Are Loaded[1]

4.1 'Please help – I have no sense of self'[2]

Monster: Live – Vicar Street, 2004

When Dylan Moran appears on the Vicar Street stage in Dublin as part of the *Monster II* tour, he gestures in various directions around the crowd, throwing out a couple of 'hello's', along the way. While trying to get the microphone off the stand he proceeds to get himself caught up in the wire, swears and tells everyone he's leaving. Behind him and upstage centre is a very large and decorative picture frame. Within the frame, Moran's own series of sketches ebb and flow in slide show format. His entrance onto the stage may or may not be timed with the image of a torso in a pin-striped jacket, speckled shirt and patterned tie. There is a revolver where the head should be; it's pointing at the audience, and underneath that is a caption that reads "How may I help you?"[3] Images such as this help to set a certain tone to the evening. Apart from the cartoon gallery, which silently shifts and segues its way through the performance like an art instillation, the stage space, in the main, is typical of a stand-up comedy performance piece. A microphone, a stand, a square table just left of centre stage and a bar stool without a back. On the table there is a jug of water and a glass, a glass of white wine and no ashtray. (In recent years Moran has given up smoking, at least while performing.) However, in this instance the comic who should not be smoking stubs out his cigarettes on the stage floor. Nobody seems to mind.

He is wearing a baggy black suit over a baggy blue shirt and there is that sense of him being slightly dishevelled and awry. He takes off his jacket, hangs it on the microphone stand, which he carries upstage, he complains about being hot and begins. Moran starts the show by

discussing how Ireland has changed since his boyhood in Navan, Co. Meath. Back then, he tells the audience, "people styled their hair with buttermilk and there was four tawny yellow piano pub key teeth between a family... after eighteen thousand million years of that... [Dublin's] suddenly become a mesh of Barcelona and Miami, everybody's going out with somebody called Fjovia."[4] Since Moran's depiction of modern Irish life, Ireland has, of course, experienced the ravages of a global recession. However, in 2004 the Celtic Tiger was charging ahead at full pelt, and here Moran is referencing a thriving capital city and a booming property landscape. He gently parodies those who became victims of circumstance in that market; "Yes I have a very easy commute, I live on the Aran Islands [a remote set of islands off the west coast of Ireland], no problem, we live in a tree, yea, it was only €400,000.00, but ah..."[5] He tells the audience that he does not envy them, not one bit, for having to deal with the stresses of modern Irish life. During the 'boom' years many people entered the property market, buying their homes in an ever-widening commuter belt, while servicing heavy mortgage debt. Many of those same people are currently struggling with the enormity of those debts, along with the actuality and the prospect of job losses and emigration. However, Moran, like the rest of the population, was still unaware of what was to come. At that time, this type of topical stand-up would have been grist to the mill across the length and breadth of this country – and beyond. Moran then stops abruptly and speaks directly to the audience:

> Hello and everything by the way, I don't spend a huge amount of time on that because I find it's one of the portals of conversation people get very very freaked out about – 'cause you can use hello... And then after that you're on your own really; people get scared after hello, they go hello... do you want a pineapple? They don't know what to do next, so I just kind of skip that.[6]

Moran follows this up by telling off the audience, "Ahm, but what was I going to say – quickly quickly – I can't remember, I can't do everything around here."[7] Prompted by an audience member, Moran briefly discusses the then recently enforced smoking ban which saw droves of Irish people loitering outside establishments or gathering in 'designated smoking areas' in order to have a cigarette. He takes out a packet of what he calls 'herbal' cigarettes; they look suspiciously like Benson and Hedges Gold. He lights one up and the audience applauds. Moran's response is one of derision: "Don't clap," he tells the audience; "it's not

an act of social disobedience to have a cigarette unless you are a doctor working at an incubator. Or it should not be."[8] Before moving on Moran tells the audience "state nannyism is not going to work" and he makes a playfully ominous warning that all government smoke inspectors will eventually be found dead in a ditch covered in cigarette burns. That rebellion never flew on more than one wing, despite reports of late-night smoking marathons in pubs after closing and the odd person thrown off a train for having a sneaky smoke in the toilets.

Reviewing Moran's stage show in *The Guardian* in 2004, Stephanie Merritt describes the comic as "Ranting at the modern world: it's that bloody Irishman rambling in the bar again,"[9] and in a way this is what an audience have come to expect from Moran. Certain identifications are made which liken Moran's stage persona to that of Bernard, the anti-hero of *Black Books*, which Moran co-wrote and starred in for Channel 4. There may be some point to this; both are embedded in the qualities of the misanthropic, the anti-social and the shambolic. Moran's curmudgeon tackles broad and at times familiar territory; relationships, children, politics, religion, alcoholism, ethnicity, women, age and youth give a good sense of the range of the material. The inside menu for *Monster: Live* lists all of these and more by way of example. However, Moran has interrogated other notions. One favourite is the theme of deception, that of self-trickery and the trickery of others. A benefit held for the Asian Tsunami disaster and hosted by *Comic Aid* in 2005 offers a case in point. Moran was derisive when discussing the capacity for self-deception (including his own) as it meets ideas of middle-class aid. He tells the audience:

> You've all come. It's all very nice and it's a benefit and it's the acme of middle-class charity really. This is what middle-class people are prepared to do. This is the sacrifice you're prepared to make... middle-class people like us – all giving money to people less fortunate than ourselves, living our beautiful lives before we go home to our own lovely tiles.[10]

Moran goes on to make some incisive remarks about how middle-class people view and judge types of poverty before abruptly saying goodnight. The crowd seem generous (as you might expect at a benefit night) and Moran does not look back. There is a definite feeling of his being impatient to be gone, although it could well be a performance of intolerance. Middle-class views on charity and poverty may act as one means through which to speak of deception. Another is Moran's discussion

on the intimate relationship between self-deception and wasted potential. In reviewing Moran's live show *What It Is* in 2009, Veronica Lee suggests that much of his work reflects on the "idea of a life unlived [and quotes Moran] 'Some people watch their lives fly by... and hold the door open.'"[11] Ideas of failure, of the potential and deceptive self, do echo through Moran's performances. Moran begins this section of the performance by discussing the stresses of modern living, which makes normally sensible people go to the gym, do yoga, or worse, read moronic self-help books. Books written by toss pots that you would normally cross the road to avoid.[12] Releasing your inner potential is nothing short of dangerous to your health. Leave your potential alone, is Moran's second ominous warning of the evening so far, coming at the beginning of the first scenario under discussion here, which is named... well... *Potential*. Moran believes that releasing the inner 'you' is a very, very bad idea:

Potential

...Or release your potential – that's another one
Now, that's a very, very dangerous idea
You should stay away from your potential
I mean that is something you should leave absolutely alone
Don't... you'll mess it up... it's potential
LEAVE IT!
And anyway it's like your bank balance
You know you always have a lot less than you think
Don't look at it... No
Leave it as a kind of... it's the locked door within yourself
And that's how it should be, because then at least in your mind
The interior will be always be palatial
You know, wonderful gleaming marbled floors
Brocaded drapes, mullioned windows covered in mullions, whatever
 they are
And flamingos serving drinks, pianos shooting out canapés into
 the mouths of elegant men and women, who are exchanging
 witticisms
"Yes this reminds me of the time I was in Budapest with Binky"
"We were trying to steal a goose from the casino ha ha," WHAM!
 Vol-au-Vent
Doooon't open the door, 'cause it won't be like that
All you're going to see will be one tiny grey starveling little cat with
 diarrhoea

Sitting on a mattressless iron sprung bed
With it's huge eyes mewing at you... Meweeoww
Smoking as well probably
As an emphysemic landlady untangles her pop socks in the
 background
And some terrible guy, the colour of an aubergine rounds the corner
Holding a mug of beef tea wearing a string vest and says Mahaa
 Mhaa? Mhaaa (*Moran makes kissing sounds*)
THAT'S YOUR POTENTIAL!
But look at people who use it
Who do actually give it everything, you know?
Like great athletes, you know the 'Beckhams' or 'Roy Keanes' of this
 world
People charging, running up and down the field swearing and shout-
 ing at each other
Are they happy?
NO! They're destroying themselves
Who's happy? YOU!
The fat fucks watching them
With a beer can, balanced on your ninth belly
Roaring advice at the best athletes in the world
"YOU WANKER"!...
It's not going to make you happy
It'll depress you when you find out how little you've got, you know?
You don't want to find out that the most you could possibly achieve
If you gave it your all
If you harvested every screed of energy within you
And devoted yourself to improving yourself
That all you would get to would be maybe eating less cheesy snacks.[13]

In the main, Moran's performance style is not inflected with that
play of submission and dominance, which inhabits Tiernan's more
overtly engaged relationship with the audience. Rather, Moran's style
is characterised, at times, by his adoption of the higher status position.
His physicality too is very different from that of Tiernan; it is more self-
contained. He occupies downstage centre and although he paces to and
fro, he does not deviate very much from that spot. His stance is relaxed
and confident. At times his physicality becomes more animated and his
tone more aggressive or sardonic when he wants to place emphasis, but
he never strays far from his controlled physicality and position onstage.
Even at his most animated, there is no expectation that this man is

about to go tearing up and down the stage, one that is often met by Tiernan. While there is little sense of spectacle or exaggeration, neither is there any overriding impression of Moran's being deadpan or expressionless. Rather there is a strong focus on connecting directly with the audience, and Moran rarely takes his eyes off them. The focused and unhurried power that Moran possesses holds the spectators and Moran's measured gaze does consistently sweep the room. He can look weary, determined or plain pissed off and at times he attempts the odd smile. It is here, with a microphone in one hand and a lit cigarette in the other, that Moran engages with the intricacies of human potential. His tone is conversational, edged with his trademark languid antagonism, like being hit over the head with a firm feather pillow. The audience are being warned about their inabilities. This is followed by Moran's elaborate, visual and starkly poetic *Potential* imagery before he returns to the land of derisory observations and the harsh realities of (un)lived potentials. *Potential*, warns Moran, usually falls way, way short of fantasy castles (with mullioned windows) in the sky.

The *Potential* scenario does not build in the conventional sense, in which the audience are cued for their place of laughter. Rather the audience follow Moran, and the laughter is apparent throughout but at a level that the performer firmly controls. At times, Moran does pause momentarily – as, for example, when the audience applauds spontaneously. However, there is little sense of his wanting to be unduly interrupted here and the clapping dissipates before too long. Moran's personifications of being with "Binky in Budapest" or the "fat fucks" screaming "wanker" at the television set produce small explosions of laughter and some scattered applause, but these 'snapshot characterisations' are brief and last no longer than the line or two it has taken to create them. Moran builds the tension in the last section of the scenario and the audience follow along willingly and expectantly so that when the line comes, "Who's happy? YOU! The fat fucks watching them," the tension breaks and the audience experience laughter. That laughter is elicited by their recognition at the incongruous notion, that it is *they* that are happy and not those who are supposedly at the peak of their *Potential*. Moran nose-dives the scenario toward the extreme deflation of the last line. He tells the audience that the most they might achieve if pushed to the limits of their *Potential* is scoffing less dairy in their diet. While he may not dally too much for audience reaction that is not to suggest that he does not care about the crowd. There is certain warmth about Moran's performance style, even if this particular scenario has something of a monological quality about it. It feels quite reflective at

times with something like a stream-of-consciousness about his delivery. However, he has dispelled any notion of his work as monological, observing that his style is a conversational one, "you can have a conversation with somebody's reactions and expectations to what you've just said."[14] That sense of connection with the audience is vital to the work, despite the curmudgeonly persona and the series of soft hammer blows dealt out. There is, of course, a tacit understanding that this is a performance of misanthropy, even if he might mean it just a little bit. However underplayed his performance style, that sense of inclusivity with the audience is integral to Moran's style of stand-up.

The American comic Jerry Seinfeld once compared telling a joke to:

> attempting to leap a metaphorical canyon, taking the audience with you. The set up of the joke is the nearside cliff, and the punch line is the far side. If they're too far apart the listeners don't make it to the other side. And if they're too close together the audience just steps across the gap and doesn't experience an exhilarating leap of any kind. The joke hearer gets far more pleasure from the joke if they have to do a little work.[15]

That leap, where the set-up for the joke is on the nearside and the punchline is on the far side, and where the audience experience the exhilaration of making that jump is very close to the structure of the *Potential* routine. And in this scenario, that metaphorical canyon is working in tandem with a classic storytelling structure, commonly known as the 'shaggy dog' story. Not unlike the 'cock and bull' story of which I spoke in the previous chapter, a 'shaggy dog' story is a joke, which can be described as the telling of a long-winded, repetitive and overly embellished story. The difference if you can split the hairs between aspects of a 'cock and bull' and a 'shaggy dog', is that and mainly, with a 'shaggy dog' story, the punch line, when it finally arrives is wholly inadequate or anticlimactic.[16] In many respects the art of the 'shaggy dog' story is entirely dependent on the "personality of the teller and his or her skill at embellishment... which is a masterpiece of storytelling even if the punch line is unsatisfactory or entirely absent."[17] This does seem to be the case here. Moran weaves the story slowly, scaffolding the 'shaggy dog' story with elaborate imagery, embellished poetics, personifications and dark dreams of *Potential*. The audience do laugh throughout these elaborations, albeit not uproariously, and they do laugh when Moran seems to have reached some punchlines, as on the "THAT'S YOUR POTENTIAL!" or Who's happy? lines. So too, the "eating less cheesy snacks" line is

recognisable as a punchline in so far as it ends the *Potential* story, and, if it operates at all, it certainly does not operate in the more conventional sense. There is a sense that the audience are amused and entertained, but at the same time there lurks a slight bemusement as Moran subverts the convention of joke expectations and cues to laughter. Jimmy Carr fears a 'fatal metaphor pile up' when grafting 'shaggy dogs' and 'metaphorical canyons' to discuss the mechanics of joke structure. However, there is a combination of both these formulations at work in the *Potential* scenario. The skill in 'shaggy dog' joke telling is "leading [the audience] up the garden path and right to the cliff edge, setting carefully judged leaps of imagination for the audience to follow... across. The triggers for laughter are in the gaps between the words."[18] Those carefully judged leaps of imagination are what, more generally, Seinfeld is talking about with metaphorical cliffs and canyons, and in this 'shaggy dog' story there are several due to the scale of the scenario. The audience are carried along through verbose feats and flights of poeticism as Moran describes *Potential*, before careening down the bathetic cliffside toward cheesy failure. The small gaps as triggers for laughter in the 'shaggy dog' is the work of enjoyment that Seinfeld describes while following Moran across the *Potential* landscape. However, while Seinfeld does not go further to describe the types of punchline he may be referring to (and I am not sure that he had a 'shaggy' dog structure in mind), a 'shaggy dog' is most definitely defined by dissatisfaction as ending. Moran's punchline is classic, and the deflation razes the 'shaggy dog' to the ground, its scaffolding lying in ruins all around.

The *Potential* scenario could be understood as blind hope in the face of cold-faced reality, of surreal dreams pulled under by dark actuality. In that respect the scenario resembles Simon Critchley's discussion of Samuel Beckett's work, *Molloy* (1979). Critchley describes what Beckett called the 'syntax of weakness,' in his works:

> This is a syntax that can be found throughout Beckett's work in a whole series of wonderfully self-undoing, self-weakening phrases: 'Live and invent. I have tried, Invent. It is not the word. Neither is live. No Matter. I have tried.'[19]

Borrowing from Beckett, Critchley proposes his own formulation as "humour as a syntax of weakness, as a comic syntax."[20] The *Potential* piece is inhabited by a series of self-undoing, self-weakening phrases as Moran gears down through the story. There may be some unease in the audience, as Moran is self-reflexively playing with the potential

self and the potential for self-deception. Ideas of possibility are embedded in ambivalence; in people's fantasises of greatness and in their fear of failure, which may either spur or paralyse. There may also be some pleasure in denying one's potential or accepting perceived failings and it is within these shifting ambivalences that Moran has placed the *Potential* tale for the audience. Perhaps then it is something of a relief when the story comes to rest on the 'cheesy snack' line. It seems a soft landing. However, that sense of relief dissolves into realisation as the joke begins to flicker out. That tiny silence exists as the last line evaporates. Here, there may well be a Beckettian moment of weakness when the audience realise that "humour rebounds upon the subject... [and that the] object of laughter is the subject who laughs."[21] As the last laugh still sounds, the audience can, on one level, acknowledge and recognise themselves in the narrative. There is also a darker concomitant moment of self-doubt and discomfort, when the audience recognise that Moran is playing with the audience's ambivalent and personal perceptions of the potential self. Those ambivalent narratives exist in the dialectic tensions between fantasies of desire, "I could have been a contender" and the denial of that desire "Who wants to be a contender anyway?" and all the variations in-between. I suggest that in the *Potential* routine, Moran creates a self-reflexive critical space, wherein he questions how people may map (or trap) themselves in conflicting narratives of possibility. He interrogates that potential matrix, those self-constituting stories which are continually being written and rewritten to accommodate, justify or validate potential narratives of the self. Inscribed within those self-constituting stories there always lurks the potential for self-deception embedded in those multiple narratives of desire, fantasy, escape and failure.

4.2 'Sorry? Ha! – You make me sick – Put some clothes on'[22]

Moran likes to talk about love, romance, and relationships and the topic appears frequently in his material. At the Apollo Theatre in London as part of the *like totally...* tour in 2006, Moran spends considerable time discussing the nature of relationships. He talks about the very real dangers of close living over long, long years. He tells the audience about a young couple that fall in love, and who, after many years of living together, find that they have, at last, achieved real depth:

> They go to bed one night, years and years later, where they do achieve a kind of real intimacy. You have to know somebody very

well to be able to say 'I hate the way you breathe, I would stab you
to death, but I can't afford to take the two weeks off work.'[23]

Aah, romance. Again, and for openers, Moran deals with the topic
of couples in love. The scenario, entitled *What We Say*, was filmed at
Sydney's State Theatre in Australia in May 2009, as part of the *What It
Is* international tour. It deals with ideas of language play as powerful
weapons of choice, deployed in everyday situations by those in loving
relationships. Moran also makes some scathing critical commentary on
the limbo state of adolescence occupied by certain middle-class, middle-
aged men.

What We Say

But before any of that can happen...[24]
The couple get a chance to celebrate
Their... their... togetherness in the... in the new life
Which they've chosen to be together
And one of the big ways... people do that is by torturing each other
With the English language
Because it's cheap and available or indeed any language that they
 know how to speak
And people will kill you – over time
They will shave out every last morsel of fun in you with little harm-
 less sounding phrases, that people use everyday
Like "be realistic, can't you just for half a second be realistic?"
Now what that means is,
See reality my way or DIE (*Laughter*)
Which is why you end up in a warehouse choosing a toilet for the
 entire weekend (*Laughter*)
Nobody ever said to anybody, be realistic; let me oil you (*Laughter*)
Sometimes it's just... you know... insulting
"It's all sex with you isn't it, eh?"
"No, no, it's not, no, I resent that"
"Sometimes I want a snack... during" (*Laughter*)
Sometimes it is fffiendishly clever
Like "Why are you in a bad mood?"
See that's genius – you have to break that down to understand it
Somebody has said to you
"Why have you chosen to feel awful, thereby making me aware of you?"
"Because I have no choice in the matter"

"And why do I continue to live with you?"
"Even though you're so gravely mentally ill"
"And I don't get any government money"
First thing in the morning when nobody should be speaking
My wife says things like "You look terrible – what"?
"Am I sick?"
"No, no you just look old and terrible – Morning, Morning" (*Laughter*)
That's an awful thing to say to somebody
"It's because I care about you, don't say hello to the children, you'll frighten them"
"Sort yourself out upstairs" (*Laughter*)
But you get to say really good things as well
Like em... you know the phrases that would just have died out otherwise
Like aaah – "How dare you!" straight from Victorian theatre
People love talking like that
They feel 12 feet tall
"HOW DARE YOU!"
Running home from work to find the other person and go,
"Where are you? I know you're here somewhere – there you are"
"How dare you!" (*Laughter*)
"What the fuck do you mean how dare I?"
"Have you got a ray gun in your pocket or something – shut up"
My favourite one is "I know what you're thinking"
"Oh do you – do you really?"
"Well done, I know what you're thinking too"
I know what everybody's thinking
They're thinking I'd like to be lying face down in a cushion
With my mouth full of chocolate
And something lovely happening to my lower half (*Laughter and clapping*)
"Do you want your prize now or later?"
But there is something going on right now... in the world
Which means that... I think ah – you know things...
Guys are changing – men
Now they don't want... basically... and there's loads of it here
I've noticed loads of it in this country
And there's loads of it where I live
And you look at them and it just hit me one day very forcefully
They don't want to grow up
'Cause they're wearing children's clothes

You know you see loads of guys
And they're in their thirties and forties
Shuffling around in T-shirts with you know, *Zap* or **Pow** or whatever
 on it
And they've got ambiguous length trousers
They're not shorts, they're not trousers
They're just these things that say
"I don't want an executive position anytime soon OK!"
"I'm having a milkshake for about the next ten years"
"Stay the fuck away from me" (*Laughter*)
And they hang around together... with another guy
And they're not romantically involved
And they stay inside – these are men remember
Inside the house... playing video games!
I think this is amazing
You know what I mean
Bip Bip... Bip Bip... I don't understand the names of the... but you know
World of ***Bip***
Bip Bip Bip – Sluurp – Milkshake
Bip Zap Bip Bip Bip Bip
A few generations ago at this age they would have been dead by now
And they're going ***Bip*** – "Dude you got more ***Bips*** than me"
"I am so gay" (*Laughter*)
So women are having children much later
Do you know – do you know the average age of a woman having a
 child in this country?
Do ya?
Eighty-nine years old, that's right! (*Laughter*)
Waiting for these fucks to grow up
'Cause what have they got to pass on to their children
Apart from "Watch out for the snakes on level six."[25] (*Laughter*)

'Comic tears from the brain' (again)

In contrast to the *Potential* routine, this scenario positions itself firmly in
the world, not of what is unsaid, but of what many of us do say on a daily
basis. Moran is dressed casually, jeans, black shirt and jacket, wearing shoes
that look suspiciously like orthopaedic footwear. He is wearing an edge of
haggardness that perhaps comes from the stresses of an international tour,
which is well underway at this point. The *What We Say* routine works as a
game of two halves. In the first half, Moran is telling the audience about
the language-driven ins and outs of a couple's relationship. Lines such

as the belligerent "**See reality my way or DIE,**" or "HOW DARE YOU!" work to strip bare the war of words in a couple's world. At times, the work takes on something of a more personal feel as he touches on discussions with his wife and the 'Wreck of the Hesperus' view that he presents to his family in the mornings. Moran's imagery of being face down on a cushion, with a mouth full of chocolate and "something lovely happening to my lower half", brings one of the biggest laughs in the scenario. The audience, perhaps, recognise aspects of their own behaviour and inclinations, or indeed the erotic charge of fantasy wish fulfilment evoked by Moran's desire for chocolate and sex. Throughout this scenario, the work is inflected with some stereotypical male gendering; however, overall it is not reduced to a more traditional binary of who's dragging whom to look at toilets for the weekend. There is no sense of Moran's defaulting to "reactionary humour... [which] seeks to confirm the status quo... by denigrating a certain sector of society, as in sexist humour."[26] The structure of the *What We Say* scenario is punctuated by a series of questions, which are connected to a sequence of small surprises or punchlines that pepper the scenario. Moran has built in around nine of them in the first half, which key the laughter within the structure of the joke. Questions like; 'Can't you just for half a second be realistic?' 'It's all sex with you isn't it, eh?' 'Why have you chosen to feel awful, thereby making me aware of you?' 'And why do I continue to live with you?' 'What the fuck do you mean how dare I?' 'Have you got a ray gun in your pocket or something?' 'Oh, do you, do you really?' As mentioned above, this reply results in sustained laughter and, in effect, works to bring the first half of the scenario to a close. Each substructure of question and answer, then, as a succession of minor punchlines, works in a more truncated and perhaps even conventional sense than the 'shaggy dog' technique, in that the 'shaggy dog' is based on long-winded stories with an 'unsatisfactory or absent' punch line. Here, Moran is brisk by comparison, signalling to the audience that; "I've got a surprise for you in thirty seconds... here it comes... wait for it... BOO!' And despite being warned, we're still surprised. We laugh delightedly and settle back to wait for the next surprise."[27] Those series of small incongruities are structured to travel the length of the first section of the scenario. And Moran does not spend too much time loitering around any of these punchlines or their responses. That said, the audience's laughter as it works in convoy with the joke structure here, again resembles Moran's thoughts on his conversational style:

It's such a great feeling when you discover that other people are thinking about the things you're discussing. Nothing beats it when the

material really flies… When you catch a wave with an audience, you get such a buzz. It's not like sounding off through a megaphone. Despite appearances, it's a genuine conversation. If you're the lead singer, then the audience is the rhythm section. There's nothing like it.[28]

If Moran is the lead singer here, then the audience are certainly the rhythm section throughout the whole of this first section, making the joke structure work for both comic and audience.

The second half of the scenario moves away from brandishing language firearms in the world of relationships to the world of middle-aged men, specifically those who have an aversion to the maturation processes of life. As with aspects of Tiernan's work in the previous chapter, this second section works within a 'rule of three' structure; that is the classic comic rhythm of incongruity, defined in stand-up as "Establish, Reinforce, Surprise!"[29] The comic establishes the comic pattern within the joke structure, continues to reinforce that pattern for a time, before finally subverting it. Moran establishes this scenario by being flabbergasted at some aspects of contemporary male behaviour, at those who inhabit the world of **Bip.** This world is peopled by men who, in Moran's opinion, 'do not want to grow up' and who do not 'want an executive position anytime soon, OK!' He reinforces his continuing sense of bafflement by detailing their daily patterns. Men who are 'having a milkshake for about the next ten years… [so] stay the fuck away.' Men, who hang around the house all day with other men and they are not romantically involved. Men, who enjoy wearing apparel that includes **ZAP** and **POW!** T-shirts paired with the sartorial elegance of short-long trousers. But most of all, Moran is amazed by men whose daily concerns centre on 'Dude you got more **Bips** than me' and who are deploying virtual tactics in avoidance of the grown-up world. He also points out that a few generations ago these men would have been dead by now, which heightens the absurdity of their '**Bip Bip Bip** – Sluurp – Milkshake – **Bip Zap Bip Bip**' behaviour. The surprise element of the 'rule of three' structure again comes in the form of a question; Moran asks the audience about the childbearing age of women in Australia in 2009. He reveals the shocking statistics, 'Eighty-nine years old, that's right!' The behaviour of men from the world of **Bip** has resulted in octogenarian motherhood, waiting for "these fucks" to grow up. The extraordinary verbal imagery of 89-year-old expectant mothers, along with Moran's insulting the menfolk (in this instance) of Australia, elicits an outbreak of laughter. That laughter travels until he pops his next surprise. Moran implies that women are right to

wait. Why? Because what have these men to pass onto their children? Nothing apart from 'watch out for the snakes on level six.' It's hard to build a legacy from that. Miracles of birth notwithstanding, in this half of the scenario, Moran's observations about fairly uninspiring adult male behaviour do hit on some recognisable truths for the audience. Those observations, and that audience recognition, keep the laughter wave rolling until Moran calls half time for the interval. Throughout the *What We Say* scenario, those steady rounds of laughter, which Moran creates throughout the bi-part structure as described, have propelled along the audience. The laughter journeys the length of the joking structure, not in an uproarious fashion, but as a sustained and consistent accompaniment to the scenario as a whole.

Earlier in the work, I discussed the fact that Jerry Seinfeld believes that a certain ironic detachment is integral to the craft of stand-up comedy. Broadly speaking, he is not alone. In fact he is keeping some very good company. On one level, what Seinfeld is describing may well be considered as running parallel to de-familiarisation processes. Brechtian concepts of de-familiarisation have been linked to the per-formance form of stand-up comedy. And not only because stand-up comedians speak directly to the audience, thereby acknowledging the performance context, but because of stand-up comedy's ability to make that which seems familiar, strange or dislocated. Such processes can be described in various ways. Oliver Double and Michael Wilson examine Brecht's *Verfremdungseffekt* when analysing the works of Karl Valentin during the Second World War.[30] Double and Wilson make argument for Valentin's comedy as having an effect akin to Brecht's own definition of *Verfremdungseffekt*; that is "turning the object of which one is to be made aware, to which one's attention is to be drawn, from something ordinary, familiar, immediately accessible, into something peculiar, striking, and unexpected."[31] In his discussion of ideas of the comic and religious experience, Peter Berger also points to Brecht's technique of *Verfremdung* and Eugène Ionesco's concept of *depaysement,* which liter-ally means 'losing one's country.' He argues that the comic transcends the reality of the familiar world, transforms reality into something strange and unfamiliar, in other words, "it relativizes paramount real-ity."[32] An interesting formulation, which is related to these ideas of de-familiarisation, is Simon Critchley's notion of humour as *sensus* and *dissensus communis.* Building on the works of the Earl of Shaftsbury, Immanuel Kant, with Wittgensteinian influences, Critchley proposes his formulation, which has its provenance in Roman culture; of a *sensus communis* as that which:[33]

Makes explicit the enormous commonality that is implicit in [our] social life... this is what Shaftsbury had in mind... when he spoke of humour as a form of *sensus communis*. So, humour reveals the depth of what we share. Humour is an exemplary practice because it is a universal human activity that invites us to become philosophical spectators upon our lives. It is practically enacted theory. I think this is why Wittgenstein once said that he could imagine a book of philosophy that would be written entirely in the form of jokes.[34]

Critchley's formulation does fly in the face somewhat of other theorists who feel that modern relativism has taken the arguments of Shaftsbury (and others) out of their original contexts, using 'bits and pieces' of the original in order to celebrate the positive aspects of humour over and above the negative.[35] That said, Critchley argues that humour *returns* (my emphasis) people to a certain common sense. But it does so by creating a temporary distance, by de-familiarising the world before returning us to that familiarity.[36] The *sensus communis* is returned by temporarily estranging the world, or by creating moments of what Critchley terms *dissensus communis*, 'distinct from the dominant common sense', which throws light on everyday practices. By doing so the *dissensus communis* may hint at or signify how 'things might be otherwise.'[37] In this scenario Moran makes that which seems familiar both strange and dislocated. He does so in order to cast a cold and critical eye over everyday behaviour. By doing so he exposes the power play masked behind everyday phraseology in relationships. He does so in order to critique adolescent behaviour in certain middle-class, middle-aged men. Critchley's *sensus communis* and Brecht's comic 'tears of the brain' (again) find their place here, and, in many respects, they both work equally well. Having said that, Moran's comedy troubles both. Critchley and Brecht propose models that, either implicitly or explicitly, hint at or offer another common sense or a new awareness. This could be seen as the diverging of paths between Moran's comedy and the models advanced by both Critchley and Brecht. Moran's opinion on the subject (and it is something shared by many comics) can be encapsulated in his comment that "I don't think you should ever be improved by comedy."[38] Explicitly then, Moran eschews any sort of qualification that makes unambiguous meaning in his works. The work certainly points up the absurdities that hide behind everyday patterns of language and behaviour; it does not, however, overtly at least, point to perceiving the common practices of ordinary life any differently. In the end, I suggest that gifting Moran's comedy with hues of a different colour is in the

hands of the audience or viewer, and Moran certainly is not going to enlighten anyone on that score. Throughout this scenario he injects the proceedings with his trademark undertow. Indeed throughout all of Moran's routines under discussion here, there is that concomitant sense of pointlessness to temper even the most hardened of comedy's transformative and celebratory advocates. Any suggestion that Moran is attempting to improve that which he critiques through his stand-up comedy would perhaps be met by Moran with as much weary disdain as he could possibly muster.

4.3 'Death needs you'[39]

In the final scenario under discussion here, the central themes of language and relationships are once again considered. Moran's personal reflections on the brevity of youth, mid-life redundancy and the inevitability of death are wound into the narrative. As I have already discussed, reviewers and critics alike have pegged Moran as the acme of the middle-aged crank. Commentary and analysis of his stand-up invariably refer to Moran's trademark tirades on the state of the world, his disdainful and bitter rants at the aging process and the inevitable shuffle off this mortal coil. Moran's stories of personal angst and his tormented worldview have come to define his stand-up material in recent years. This scenario is again typical of that style and subject matter. Entitled AWESOME! – it too was filmed in Sydney's State Theatre, Australia as part of the *What It Is: Live* international tour in 2009.

AWESOME!

Because youth vanishes on you
It's such a surprise, that's what people say
It seems like yesterday – it dies
It seems like yesterday to me
I was out drinking tequila with my friends
I mean tequila – it's not even a drink
It's just a way of getting the police around without using a phone
Now I'm on the phone to those same friends asking them for recipes
"How do you make breadcrumbs"?
Ya think Jesus, what's happened to me?
Please don't let me die in a gardening centre
Don't let me turn into one of those people

Who begins every single fucking conversation with the words...
I'm not a racist but...
You see 'cause you have this illusion all the time that you're cool
People do – not just younger people – everybody thinks that
All men do
Ninety nine point nine percent of men are convinced that they have
to live silently
With the bitter irony of the twist of fate that means nobody knows
they're really a spy
And an amazing guitarist
Men give serious time and thought to... how would I deal with it
If a rocket came out of that alley right now... would I?
Yea I think I'd handle the situation pretty well
Ahem... A spy who plays guitar at night
And the... I basically think, you know, that I'm what would have
happened
If James Dean had lived and discovered carbohydrates and orthopae-
dic shoes
You have to tell yourself this bullshit just to keep going
'Cause you're constantly being reminded how redundant you are
How am I supposed to feel in the swim of what's current
When I don't understand what's going on
Because younger people – my children steal the future
By changing language
Everything I relied on
You walk outside and you expect to feel you know what's going on
When you walk down the street and your children say
"Oh, ho look at that church... it's so random"
"What? Is it moving? What do you mean? What are you talking
about?"
"It's a perfectly ordinary church where people go to get married"
"Marriage. Uugh, that's so gay"
"Look... just... can we just have some quiet time?"
"Here's some crisps – there you go"
"Crisps. Awesome!"
"They're not awesome"
"They're crunchy"
"If I opened them and haggard shafts of light and cherub women and
angelic music comes out they would be awesome OK"?
**"Mountains and rivers and the fact that I'm still breathing are
awesome..."**[40]

Moran follows this piece by means of a loose association of ideas and dialogue with the audience. He discusses his views on honesty, old people, young doctors, women, children, drink and gender divides in a seemingly random order, which has come to represent Moran's "modernist scattergun approach."[41] Before too long, however, Moran does find his way back, reconnecting to his earlier conversation on the aging process and its implications for Moran's body:

> What's really odd is what ehm... is what gets taken away from you
> It's not what you expect – you know
> People, people talk about old age and the twinkly-eyed pictures of...
> You know grandmothers in pink smiling fondly at children
> And dogs and wheat fields and so on
> They're probably fucking out of their minds; they don't know where they are
> But they... that's why they look so serene
> But – you know the weirdest things get taken away from you
> Like I used to have toenails
> I remember them
> I took pictures
> And now I have the sheeting they put on battle ships
> My family are afraid of me
> They make me clip them in the garden
> I brought down three seagulls last week
> Eyebrows – I had eyebrows
> People used to come from nearby just to touch them
> Nowadays I have these fucking things, I get short wave radio signals on them in the evening
> I wake up in the morning; it looks like giant spiders are trying to eat my eyes Aaaahh...
> And you try all the old tricks you know because
> You walk into a crowded room
> And you suck in your gut and you see the other one underneath
> "Hello I'm Jeff, your pointless second stomach"
> You don't need to feed me or anything"
> **"I'm a gift from death"**
> Cause death is like the Don saying
> **"Send him a message"**
> The other morning, I woke up
> I was frightened – I'm always frightened in the morning
> I don't ever know where I am

And... but I heard this beautiful reassuring sound
It sounded like my childhood
I thought what's that?
It's... there's church bells behind the hill or
No, it's an ice-cream van in the rain...
It was me...
Breathing.[42]

The *Awesome!* scenario again starts out as a series of direct observations concerning how many may feel about the rapid disappearance of youth. Observational comedy is clearly at work and is peppered throughout the *Awesome!* narrative. Moran's pleas to God to not end up like the person 'who begins every single fucking conversation with I'm not a racist but...' is something that the audience identifies with, in any case it elicits a lot of laughter. Moran continues in a conversational vein through men's everyday fantasies of rockets, spies and guitars, the truth of which anyone who has witnessed a late night air guitar solo of Led Zeppelin, or the obsessive replaying of Bond movies will readily attest to. With a grimace on his face Moran tells the audience that you have to tell yourself this bullshit just to keep going, to stave off feelings of redundancy, inflecting Moran's story with that trademark undertow, that darker shadow, perhaps about the relentless and unforgiving nature of just being in the world. These feelings of redundancy continue as Moran ratchets up his misanthropic persona and, Victor Meldrew-like, he rails at the injustice of having language stolen from him by his children. No longer current, no longer in the swim of things, outmoded and left behind. Moran belligerently tells his children and the audience that mountains and rivers and the fact that he is still **breathing** is truly something *Awesome!* (Rather than, as the children would have it, eating a packet of crisps.) The cantankerous father alienated by his confident and self-assured children, in a language that he no longer recognises is punctuated by the audience's laughter. Perhaps they connect to their own thoughts of worth and aging and the lurking fear of becoming anachronistic within a lifetime. In the last section of the story, Moran again muses on the things that are taken away from people as winter creeps into the garden. Moran briefly evokes some lyrical and poetic "Werther's Originals" imagery of wisdom and serenity, the gifts of experience that enrich the final 'act' of life. He marks the downward spiral by telling the audience that this imagery of twinkly-eyed tranquillity and sense of contentment can only be the result of insanity or drugs. The bathetic shift gathers pace as Moran recounts his own body's slow

betrayal over time. Time's plan of attack on Moran's physicality takes its shape in battleship sheets of metal toenails, eyebrows that receive short wave radio in the evenings, and the icing on the cake, that redundant second belly which suggest that Death has (no surprise here) a black sense of humour. As the story and the evening (this is the last section of the performance) begin to draw to a close, Moran adopts something of an outsider stance. What I mean here is that in this scenario, Moran is playing the insider/outsider game with the audience. Playing the insider and the outsider game is one that many comedians (including Tiernan and Higgins) often indulge in. The insider effectively threads the observational through the dialogue, saying, 'Look, this is me sharing with you, the many familiar threads of common experience.' The build to the line about turning into an old bigot near the top of the scenario certainly maintains an insider status, creating a temporary bond with the spectators.[43] On the other hand, the outsider is the comedian who puts himself or herself somewhat at odds with the audience. This aspect of a performance style is favoured by many of the more absurdist comics, since "surreal comedians have a natural tendency for the outsider role, portraying themselves as exotic aliens with a skewed outlook on the world."[44] This sense of a shift to the outside position becomes more apparent as this scenario moves on toward the end of this evening's performance. The work moves into more surrealistic and poetic imagery, before the cold plunge into a crabby last word, masquerading as a punchline. Moran tells the audience that he is always frightened in the mornings. He wakes up and he never knows where he is. He elaborates into a 'piece' of whimsy, a flight of nostalgic imagination; of the reassurance of church bells ringing and ice cream vans in the rain (a very common occurrence, if you happened to have grown up in Ireland). Images of childhood, or of peace, or of innocence or comfort, all of these feelings are evoked through his brief poetic fancy. There is a single beat before the steep decline. Moran abruptly tells the audience in that sort of feigned belligerence of his, that those evocative, wistful, nostalgic and reassuring sounds, were in fact coming from within, they were echoes of his '**Breathing.**'

Homo risibilis

In an earlier chapter I referred to the work of Johan Huizinga. Here I would like to discuss him again briefly as a way of beginning to examine the *Awesome!* scenario. Huizinga's argument on humanity's capacity for play, as *homo ludens*, is taken up and extended by Simon Critchley. Critchley takes Huizinga's argument one step further by suggesting that

humans can also be described as *"'homo risibilis'* which suggests both 'the risible or ridiculous being,' and 'the being gifted with laughter.'"[45] Critchley continues his hypothesis to suggest (borrowing from Peter Berger's use of Max Scheler's arguments) that the strangeness of the human being lies in the fact that we are our bodies, but we also have our bodies, and in this way we have the ability to position ourselves critically in relation to it. As Berger recognises we are back in the domain of Plessner's "ex-centric" human as discussed in the last chapter. In what Berger describes as an anthropological hypothesis, Plessner proposed, "man is the only animal capable of somehow standing outside himself, man is incongruent with himself. Human existence is an ongoing balancing act between *being* a body and *having* a body."[46] Berger also recognises that Plessner rejects the notion that his work strays into the traditional philosophical argument surrounding the mind/body dichotomy. However, Berger also suggests that Plessner's analysis does come very close to those philosophical arguments, which deal with what Berger terms the mind/body problem. That said the sense of being able to stand outside oneself, the ability to position ourselves critically in relation to our bodies can be allied to certain functions of humour:

> Humour functions by exploiting the gap between being a body and having a body... the physical and the metaphysical... what makes us laugh... is the return of the physical into the metaphysical where the pretended tragical sublimity of the human collapses into a more comic ridiculousness which is perhaps even more tragic.[47]

There is that sense here that Moran is distancing himself from his own body and in that space of critical reflection, of finding himself and his own body ridiculous. This is what Critchley means when he talks about humour exploiting the gap between being a body and having a body to produce humour. Moran's comic exploitation of that gap is expressed in the distress he feels at the betrayals of his own aging body. Moran's realisation is stark, that the body he once had, the attributes he once possessed are being slowly eroded away. He cannot escape what has taken place and been replaced in his own body. He cannot escape the notion that the potential of the sublime (even in our own heads) has indeed collapsed into comic ridiculousness. Yet Moran may harbour ambivalent feelings toward his own body, and he is not alone, many more are helped along the ambivalent highway with lashings of denial or ever-increasing efforts to arrest the inevitable. And in ways the body itself could be said to possess ambivalent qualities. For what is the

body if not alive yet dying, giving pleasure and pain, capable and yet incapable, the body as both a gift and a burden.

That said, the audience laugh at Moran's metamorphoses and at the morning intimacies of Moran's mortal frame. The '**Breathing**' line as a finale for the scenario may also bring a bemused realisation of sorts; some insight in the wake of Moran's corporeal quakes that "if we laugh with the body, then what we often laugh at is the body, the strange fact that we *have* a body."[48] Here then lies that curse of critical distance that I spoke of above, that inescapable grasp of consciousness, even as the self attempts to deceive itself, even as the self tries and fails to escape the comi-tragic body. Moran has once again ended the *Awesome!* scenario and the evening on a surreal note, which suggests a deliberate playing with the anti-climax of the '**Breathing**' line and with the ensuing silence. Throughout this scenario, Moran is concerned with youth, the aging body, and with childhood memory and nostalgia, perhaps even happiness. On the '**Breathing**' line Moran is made aware of his morning (mourning) body, perhaps he hears a rattle, emanating from within. But with that there is something else. Breathing is, of course, an unconscious rhythm. To give thought to it, to become aware of it, strangely makes the act of breathing much more difficult, it seems breathing becomes laboured at the very thought. That said, as breathing functions on a fundamental level to remind us all that we live, that we are here, it also reminds us that we only have so many intakes of breath left. Breath is a clock-watcher. So we breathe. Do we not also *breathe in* our lives, our experiences, our suffering, our hope, our disappointment, and our joy? We breathe on the windowpane and know we are alive, and we remember those other times when breath frosted glass. To my mind at least '**Breathing**', as Moran speaks of it here, talks of memory; perhaps as hiding place and stronghold, as retreat or escape or even of past reassurance in the face of present uncertainty, it's impossible to really know. Moran evokes something of memory as comfort or salve before being swept away and replaced by the body in the bed, in the material here and now, back, as they say to the thing itself. Moran may well let the word hang in the air as an insufficient end to the evening, but to me, it does seem to speak of the sustenance and succour (here at least) of memory, even as time erodes the ground beneath our feet. A safe hiding place is no bad thing I feel, as the sands keep running through Moran's hourglass.

After the '**Breathing**' line, Moran walks slowly across the stage. He retrieves the microphone stand and returns to where he began, putting the microphone back in place. During this time the audience are

laughing with a mixture of bemusement and expectation. The laughing splutters, but does not extinguish fully, and it is here in the almost silence that Moran says, "I'm going." The crowd rally with some cries for more, to which Moran replies "Yes you say that, cake, cake, where are the cakes?" He smiles a warm smile, thanks the audience for coming and more or less exits stage left. Clearly, and although Moran has acknowledged the crowd in an affirmative way, this means of ending a performance and exiting the arena is somewhat unconventional and low key. On one level it is a very high status exit in the game play of dominance and submission that Moran would seem to enjoy playing with the audience, of which I have already spoken. Nor is there anything very new in the way that Moran leaves the stage here. According to Double, Moran once said at the end of the first half of a show in Brighton, "comedians are supposed to end on a big laugh, but brazenly admitted, 'I can't be bothered.'"[49] He does play with silence and at times seems to enjoy subverting traditional stand-up conventions, including garnering the 'big laughs' at the end of an evening's performance. And Moran does show something of a predilection for the deflated last line, as reflected in both the *Potential* and the *Awesome!* scenarios. Moran's subverting of the more conventional aspects of stand-up comedy is something that the audience may well be keyed to as integral to Moran's overall performance style. Certainly those who are familiar with his stand-up or his persona through *Black Books* (and indeed some of his other film roles carry whispers of the disgruntled persona) may little expect him to look for or indeed gift any overt notion of affirmation in the comic–audience exchange. In that sense, I believe that there is a certain licence from the audience that allows Moran to play the game of belligerence, which for the most part is enjoyed by both comic and audience. That is not to say that the status game of dominance and submission becomes neutralised in any way; rather there exists something of a tacit agreement between Moran and the audience which loosely bounds the rules of the game. Paradoxically, then, and not unlike the discussion about Tiernan's licence and relationship with his audiences in the previous chapter, perhaps here too the audience give a certain permission of sorts to Moran within the complex terms of status play that informs a comic–audience exchange. After some moments, Moran does return to the stage. He berates the audience for not supplying any cakes, even though he asked for them specifically. To cries for the encore, he tells the audience, "Words, words, you give me words, don't you think I have enough of those fucking things, ehm?" An audience member shouts something inaudible to Moran. He replies with arm

outstretched in an effort to still the voice, "Be quiet and I'll tell you something else, you know, this is what you came for... well I think it is, I'm really glad when people like you come out because I feel good for the people at home."[50] Again, not exactly the response one expects to calls for an encore, but not entirely surprising either. Clearly, Moran is deliberately subverting how he arrives on stage, just as he subverted the conventional exit moments before. The opening remarks eschew any notion that Moran will allow things to get too celebratory. He bursts the bubble, here at least of that sense of intersubjective affirmation more normally associated with an encore. An encore, which adds to some earlier in the performance material before leaving the audience with the wisdom of his grandmother; "Listen. I'm off to Peru. Don't tell a soul. There's money in it and maybe and early Matisse. Don't breath a fuckin word Kimosabe. You got me?... Bless her."[51] Another surreal 'bite' in the dying moments is no surprise, and speaks to Moran's trademark performance style, his relationship with the audience and his control of the performance space. Moran continues to play out the belligerent poetics that constitute his comic persona for the audience, and the audience (to various degrees) agree to licence that poetics.

4.4 The comic 'i'

Poetic belligerence constitutes one means of describing Moran's stand-up persona. Earlier in this work, I spoke of Tiernan's onstage self also, as that which is neither the whole truth nor fully a lie – an apt way to describe the blurred boundaries between the self and the performed self on a stand-up stage. Tiernan has been quite open in the media about his creative and performance processes. In the past, Moran has been recalcitrant; however, in more recent years he has softened his approach. Speaking of his influences, Moran observes, "There's always... a host of voices you're inspired by, I love Don DeLillo, and I love Isaac Bashevis Singer, and I love Beckett, and I love Pinter."[52] Interestingly, Tiernan also speaks of an aspiration to be "a cross between Billy Connolly and Samuel Beckett."[53] Tiernan goes on to suggest that the possibilities for stand-up have not yet been fully explored, and that the theatrical traditions of clown and of one-man shows are a source of inspiration and exploration in his work. Again in interview, Tiernan evokes Beckett, "'I want to leave a record behind of what it was like to be alive', and later, 'I want to write because it helps me put a stain on the silence,' so I guess, I hope that the stains I leave, leaves people laughing."[54] Interestingly, both Tiernan and Moran cite Beckett among other writers

and playwrights, as well as the Irish and British theatrical tradition as having inspired the ways in which they construct their material for performance. Perhaps too, Moran's alter ego Bernard of *Black Books*, as the doomed bookseller, who so lovingly drapes himself in all the colours of failure, may have something of the Beckettian voice. That being said, Moran rightly rebuffs any notion that his miserabilist comic persona likened so often to the shambles that was Bernard is anything like his offstage self, stating "I'd be in jail or hospital if I was, that much should be obvious."[55] Moran's comic persona may be instantly recognisable and associated with his complaining counterpart; however, what drives Moran's onstage self is not as easy to capture. He guards the perimeter of his offstage self vigilantly. While Moran has become more up-front, there still resides something of the vague, the offhand, and, at times, deliberate contradiction when he speaks about his drive to perform, his performance processes and his feelings about stand-up comedy itself. A miserabilist cover up if you will, so that it's not much of a surprise when Moran, in response to a question about the function of his stand-up replies, "It's the idea of sharing. So repulsive."[56]

At this point the association of ideas that are held loosely together by the formula of the comic 'i' come into focus. As discussed, the comic 'i' is that which constitutes 'me,' as aspects or fragments of the self, selected and projected outward from within, by means of a comic persona, and bounded by the comic frame.[57] In this reading that which constitutes 'me' is rooted in the thinking that "narrative and self are inseparable in that narrative is simultaneously born out of experience and gives shape to experience."[58] In addition, *the* self, as Paul Eakin argues, is an entity that suggests "something too fixed and unified to represent the complexity of subjectivity. 'The self' describes an awareness of subjectivity in process;"[59] subjectivity which does not predate representation but is born of cultural, material and socioeconomic inscriptions. That fragmented, provisional and ongoing construction of the self as performed on the stand-up stage is filtered through the construct of the comic persona. A comic persona can be described in various ways, beginning perhaps with, "you are you plus fifteen percent,"[60] moving along the "personality spectrum,"[61] up the scale to character comedians at the other end.[62] Comic personae act as the means through which an audience connects, bonds and identifies with the comic on stage. In this reading it also acts, whatever the degree of fabrication, as that which carries fragments of the self from within to without. There can be no doubt that stand-up is a practised art, which actively manipulates the raw 'material' of performance in

its relentless pursuit of laugher. This is why Jimmy Carr calls most comedians flagrant liars who are constantly on the lookout for a punch line. On the other hand, the power of stand-up is deeply connected to versions of truthful telling and ideas of authenticity. In addition, the performance of the self in stand-up comedy is contained within the rules of the comic frame. Those rules are enshrined in the premise that the stand-up stage fundamentally treats the world playfully, enacting the non-serious mode. That said, and as discussed earlier, a comic heterotopic space is that which can incorporate the non-serious mode within its borders. As such, the playful mode becomes one of the characteristics that demarcate the comic heterotopic site. With this in mind the parameters of a comic heterotopic space can be understood as that space which is linked to but separate from all the other spaces in society, and in a way that simultaneously symbolises, challenges or inverts those spaces. Smith and Watson argue for the enacted self that claims the 'I' in autobiographical performance.[63] In the previous chapter I suggested that this notion also holds true in stand-up. The performed self can also connect to the comic 'i,' in stand-up performance as provisional, multiple and fragmented, as 'subjectivity in process.' The 'i' that is situated at the centre of Moran's comic world speaks to his feelings and opinions of everyday experience and ordinary life staged by means of his curmudgeonly persona, as a process of shared experience with an audience. Bounded by the comic frame, and at play with ideas of comic ambivalence, which always transmits the comic sign, Moran projects aspects of the self on the stand-up stage as comic performance, sharing his own battles with everyday existence. Moran does defamiliarise the world to point up familiar (mostly) taken-for-granted behaviour, states of being and feeling, and patterns of daily life. He does, to certain extents, critique what Mintz describes as the "gap between what is and what we believe should be."[64] Whether he does so to return us to another *sensus communis* or somehow changed in a Brechtian way is problematic. As discussed, any real sense of Moran's work as comedy which "liberates the will and the desire, [which] change[s] the situation"[65] cuts across the grain of the performance works, and is also undercut by Moran's own scepticism. The comic shuns the notion that comedy should improve anything. Whatever the play on style, Moran's comic worlds turn on acts of everyday as communication with an audience, yet darker and deeper impulses continue to pull at the surfaces of the work. It somehow feels as though Moran has his head above the water and is swimming for the shore, but the darkness is on its way up to swallow him whole.

Gardening, gardening, gardening... death

Moran is very critical of those who dismiss stories of daily experience in stand-up as "offering saccharine to the audience."[66] In his view they are completely missing the point. He observes, "life is very cheap right now. There's an undervaluing of the human and of human essentials like community.[67] He talks about, "Family life. Community life. Ordinary life... [b]ecause you have to talk about these things that are the stuff of everyday."[68] In the selected work for discussion here, and in the comic heterotopic space, Moran dissects people's narratives of potential and the potential for self-deception. Those stories of possibility exist in dialectic tension between desires for the best potential self, and narrative that accommodates a turning away from that self. The potential self and the potential for self-deception are inexorably linked to the story making that shapes a life, for both interior and exterior worlds. Moran estranges the world to take a long hard look at everyday behaviour. In doing so he exposes the game of language power play in a couples world and critiques the exploits of middle-aged men who refuse to grow up. He discusses the passing of time and feelings of redundancy as his children steal language and the future from him. His personal torment is evidenced in his tirades at the inevitability of impending death and the slow betrayal of his aging body. That which once held such potential now a reducing shadow of its former self. Moran's comedy works to pull the ordinary asunder, exposing the absurdities hidden in everyday life. Understanding Moran's comedy is bound up within conflicting sets of tensions in the work. On one level, Moran's comedy can be described as that which "ridicule[s] a lack of self-knowledge."[69] It also inhabits a state of feeling, which describes the condition of black humour, as "subversive... disruptive of accepted values and systems, an aggressive weapon... a defence strategy... containing a strongly satirical element [with] subject matter which would normally be considered taboo."[70] Within and without these pages Moran does make mockery of people's (including his own) proclivity for deception and for attitudes and behaviour that exhibit the want of self-understanding. The work does question and subvert accepted social values and ways of life, and is always cut through with a belligerent, if not fully aggressive attitude of attack. At times, too, Moran can play with taboo subjects. As mentioned above, his 'lost in translation' discussions of homosexuality in St Petersburg is a most recent case in point. However, the idea of black humour as defence weapon is of particular interest. At times, Moran's outbursts feels something like a Beckettian character, trapped

in an ongoing battle with death, "engaged in a hopeless rearguard action against annihilation, [his] prayers, tirades and imprecations are futile – and the more futile, the more verbose they become."[71] Moran is acutely conscious of his reducing bank balance of time. His riches are slowly depleting, feeding into his deep uncertainty about purpose and the prospect of a vanishing point as a future horizon. That keenly felt consciousness fuels his futile and verbose tirades; through the work, Moran takes up the rearguard position against those forces of annihilation. In that way, Moran's work is very much embedded in the *risus purus* of Beckett's *Watt* (1970) as, "the mirthless laugh... down the snout – haw!... the laugh laughing at the laugh... in a word the laugh that laughs – silence please – at that which is unhappy."[72] For me, the *risus purus* comes very close to the darkest heart of Moran's comic worlds. As a nadir point, Moran shrugs his shoulders, snorts down his nose, looks you squarely in the eye and asks, "What's the bloody point"?[73] It's hard to muster an answer when Moran hovers near the thin end of the existential wedge.

Moran talks himself down from the ledge by trying to "assert the truth about things, as if... authoritativeness alone might, however temporarily, still the chaos and confusion."[74] He stills the turmoil by discussing what matters, "all the important subjects are familiar... the eternal subjects are the eternal subjects. It's hard work to understand it. At times it's easier to try and understand yourself."[75] Moran's comedy speaks of the important subjects, the 'familiar,' comedy of recognition, even if made strange, shot through with darker sharper surrealism, signalling to the blacker humour of profound doubt and existential uncertainty. In a way Moran's comedy describes the ultimate incongruence of absurdity. This is what Albert Camus had in mind when he identified absurdity that arises from the "'collision within ourselves'" which Bob Plant elucidates as "when our own death, loves losses and passions strike us as being of epic (subjective) importance *and simultaneously* of trivial (objective) significance."[76] Plant suggests that fundamental conflict within us invites questions, which are unanswerable. Questions such as '"What is the meaning of life?' and 'Does life matter?"' are "irresistible *and* futile [however, they] can legitimately be met with comic laughter rather then existential bemoaning or revolt."[77] Further he suggests that laughter offers a way of living with that 'experience of absurdity.' Exposing and articulating the way we are and the way we live is Moran's gift and it is one that audiences recognise and enjoy. The darker undertow speaks to an existential angst and feelings of doubt and disorientation, a sort of "metaphysical anguish at the absurdity of the human condition."[78]

Moran struggles to make sense and to give meaning to the everyday in the face of understanding our inevitable "destiny and its cosmic 'uselessness.'"[79] However, the awareness of that 'experience of absurdity' can also elicit comic laughter as well as deep anxiety. In that sense, the comic message remains a hopeful one. Moran's stand-up is keyed to national and international audiences, and in that way he connects his performed comic 'i' as 'subjectivity in process' to the broader community. Unlike Tiernan and as discussed, however ambiguous, Moran's comedy is not performance as "promissory act... because it catches participants in a contract with possibility... with imagining what might be, could be, should be."[80] And despite the curmudgeonly and the darker shadows lurking, the work is deeply involved in ideas of sharing, telling stories that give a sense of "a *shareable* world."[81] For all his obfuscations Moran's comedy is essentially about the collaborative. As previously discussed, this is what Bert O. States meant when he talked about the fundamental importance of the collaborative in performance, that sense of "Why should we pretend that all this is an illusion? We are in this together."[82] For me Moran's work is deeply connected to sharing, and the act of sharing is almost as important as that which is shared. His work constitutes the communicative *act* of surviving the everyday, and the indelible scoring on all of us. If anything that is the message that Moran's comedy signals out into the world, when we struggle to give meaning, when we struggle to make sense, when we struggle to simply not give in. We are all in it together. Right up to our necks. And one way or another and however scathingly or belligerently, Moran is charting the story for all of us. As we are all faced in the same direction. Perhaps, then, Moran's work, like that of Tiernan, is indicative of comic identity as incomplete, as the self, estranged from society.[83] Yet in the end here, too, it seems to me that Moran talks into that estrangement, connecting the common threads of existence to larger pools of individualistic and communal selves. Surely that speaks to rupture in some way? There is more to be said here. But for now there is a certain comfort in knowing that. And there is hope in that too, not of expecting the situation to change but of realising that we are not alone. I am consoled.

5
Revenge of the Buckteeth Girl

5.1 Revenge

Maeve Higgins: Live at Vicar Street, 2010

Maeve Higgins walks onto a minimal stage set in Vicar Street, Dublin. The stage is flanked by floor-length black curtains and little else. A microphone and stand are centre stage, and a stool is obscured in the curtains on the right. In keeping with this setting, her entrance is also understated, she greets the audience and immediately starts to talk about her habit of over-ordering food in restaurants. She is dressed in a Laura Ashley-style floral print dress, a green cardigan, and I cannot see her shoes from my seat at the back of the venue, where I am attempting to film the performance. The delivery of her material in this performance is low-key and conversational. At times and in similar style to elements of the performance works of both Tiernan and Moran, the material can inflect into mimicry and 'instant' or 'snapshot' characterisations. Her tones are always playful, and the pace and rhythm is rapid. Higgins speaks quite quickly and at times her tempo is such that it is difficult to catch everything she says. Furthermore, some of her lines tend to be delivered quietly and in a 'throwaway' manner, meaning that the audience have to listen carefully to catch every word. So too, her physicality is quite contained. There is little movement about the stage and her gestures, facial expressions and personifications are animated, if not particularly flamboyant or exaggerated. In other words they flow, but they never flow too far from her centred physicality, at least in this performance. After talking about how she overeats in restaurants (throughout the show Higgins returns to issues related to food and weight loss), Higgins begins to share memories of her earliest years. Ideas of family and of childhood recur throughout Higgins's material and interestingly,

they change very little when she tours abroad. By way of example, at the *Comedy Gala Festival* in Auckland, New Zealand in 2009, Higgins spent a section of her performance talking about familial features, including a part in which she focused on two aspects of her mother's personality: her fixation with the length of her own arms and the other of her amazing facility to count up random noises very quickly:

> [My mother], she always shows off about her arms... she always says 'haven't I lovely arms, they're a good length aren't they... they're great, they're perfect,' [and on counting quickly] she's super cool because if there are loud noises made in rapid succession, she can count them quite quickly in her mind. So like if there's a knock on the door... she's like (*mimes counting*) 'four, four, definitely, Dave get that.' And only because my dad is such a kind man, he sometimes takes, like a fake minute to pretend to count up the noises himself... (*feigned amazement*) 'How do you do that? That's incredible, what is that, like a photographic sound memory or something'?[1]

The minutiae of 'life' in the Higgins household received a strong audience response in New Zealand, in recognition perhaps of those eccentricities that pervade all domestic existence when no one is looking. Broadly, Higgins's material works very well as the comedy of identification and a good way to explore her use of that comic style is to consider the (self-entitled) *Bullies from Cobh* scenario. In this piece of work (filmed by the author at Vicar Street) Higgins shares with the audience her memories of a "chubster" youth and of having been bullied as a child:

Bullies from Cobh

But the tables turned in secondary school
That's for sure
Then the bullies emerged
I can understand why I was bullied, 'cause I was very confident
Which is the worst gift you can give a child
And my parents had six daughters
And they would tell us all the time
Like my mother handled the brain side of things
And she'd be like (*Mother's voice*)
"You're brilliant – Look at this – Look at this maths"
"Look at this, you're a genius"

"Watch out, you're powerful"
"You've a powerful mind"
"Mind it" (*Laughter*)
And then my Dad would handle the physical side
He'd be like (*Daddy voice*)
"You're gorgeous"
"Oh, you're so stunning"
"You'd take the sight out of any man's eyes"
"That's what you do girl – be careful"
"Be careful... break hearts"
I'd be (*Buckteeth expression, girly voice*)
"I know Daddy"
"I know"
"Shut up about it" (*Sustained laughter and applause*)
Because at the time I hadn't learned about hair products
And I had braces
I know a lot of you are probably like
Oh, we had braces and frizzy hair
But I had braces and headgear and an allergic reaction to the headgear
Two rosy patches by the mouth
And also my weight matched my age
And I thought that was really cool
Like my weight used to match my years in age
And I remember thinking
That was really handy
When I was thirteen I was thirteen stone
I was like cool, I only have to remember one number
Cool Maeve...
So ahm, you can imagine my teens...
And sometimes I do imagine going back to Cobh
And you know... like showing them
Ahm... and I do imagine arriving in Cobh
All my old bullies lined up by the pier
At the deepwater quay in Cobh
And ahm...
They'd be like (*Deep, slightly imbecilic Cork accent*)
"Who are you beautiful elegant woman?"
"It's me... Maeve" (*Smug satisfied expression*)
"Oh, you've gone away to nothing girl"
"Jesus Christ Almighty"
"You're so stunning"

"And Maeve how did you get your car under the water like that?"
"Oh that's not a car, that's a submarine"
"Subra... suma?"
And then they'd be like
"Who's that fella drivin it? – he's only gorgeous"
"That's Jake Gyllenhall or Jyllenhall"
And they'd say, "How come you can't pronounce your own husband's name?"
And I'd say 'cause I didn't take his name"
And they'd be like, "what a sexy feminist"
"You're allowed to say that" (*Smug expression*)
PUSH PUSH PUSH PUSH PUSH PUSH (*Hand gestures pushing bullies into water*)
Fall – throw rocks... rocks
Heavy rocks... Heavy rocks (*Whistles*)
Whale... Come in (*Posh lady voice, beckoning*)
Thrash... Thrash... Bang
Die So Scared (*Sustained laugher and applause*)
I read somewhere that you suffer from low self-esteem if you imagine killing your bullies, but ah I don't know (*Dismissive little shrug*)[2]

In this scenario, Higgins's takes us back to her childhood in Cobh, telling the audience that confidence is the worst gift you can give a child. Her cartoonish depictions of her former self, complete with buckteeth and braces, weight and hair issues, elicits a lot of laughter, and something like compassion for the childhood Higgins. An ideal candidate for parochial persecution. Accounts of the actual bullying are left to the audience's imagination and it is no stretch; this is shared and familiar territory in one way or another for many survivors of secondary-level education. Before too long, Higgins turns the story towards fantasy wish fulfilment. Her dark dream is to return to the place of her tormentors, lined up at the deepwater quay in Cobh. She plays out the scene for us replete with imbecilic yokels in awe of the now svelte, confident and 'married-to-a-film-star' Higgins. They call her a 'sexy feminist' because she refuses to take her husband's name. Higgins condescendingly concedes the point before casually pushing them (one by one) from the pier, gleefully sending them to their watery graves. She throws heavy rocks from a height and in a posh lady voice (one which she utilises often during the performance), she summons a whale (of all things) to ensure a cruel and violent death. It seems as if this part of her routine offers a strange combination. Higgins plays out her revenge

vision on the Cobh bullies in an understated way. There are no dramatic scenes or histrionics. However, and almost because of the low-key style, her intent feels deeper and darker, so that the way of telling sits in stark contrast to what is being told. There is certainly some dark determination as on the line "Die So Scared", which leaves the audience in little doubt as to Higgins's intentions. In addition, the audience respond to her almost childish and mischievous facial expressions and body language as much as the line itself. Higgins would seem to suggest a certain embarrassment about a grown woman having such a detailed revenge fantasy, but the material clearly suggests that there is some depth of feeling about the 'victims' of that fantasy. To prove the point, Higgins suggests, but shrugs off the idea that fantasising about killing childhood bullies may indicate low self-esteem. She dismisses the thought, and the audience (or at least I was) are left with the distinct impression that bullies from Cobh should be on their guard if approaching the edge of any convenient precipice. She knows where you live.

In interview with Higgins I asked her how she understood the comic–audience relationship in her own work:

> On a good night I think they're like my best friends. I feel that's when I could tell them anything and they would just accept it. And that does happen quite a lot. I have to remind myself all the time; it's not your diary, keep to the funny stuff. And I often say to the audience, don't let this degenerate into a conversation. Because sometimes I ask them questions and then they answer me and then I get... talking to one person and we have quite a boring conversation. So sometimes I have to say... don't let me get chatting to one of you because it will be the end of the show. On a bad night, (if there are walk outs, or very drunk people)... It's hard, but on those nights I feel like that the audience is nearly my enemy. Generally I can't seem to just have a middle ground... I'm just like, oh you're the best and never want to get off the stage or else just be like really spiteful.[3]

Higgins described how she saw herself in performance: "It's only in the last year that I've gotten closer to who I am in real life... I try really really hard to not change when I go onstage... that is quite scary. If I read things on the internet saying how much they hate me, it does feel like me."[4] She seems to involve herself with the audience at an almost personal level, and she admits that she is bad at the middle ground; rather, she seems to operate within the polar opposites of audience as friend or foe. This sense of wanting to cultivate personal relationships

with the audience echoes some aspects of private joke telling. Private and professional joke telling are, of course, very different phenomena; in private joke telling, the purpose is not to judge "the quality of the performance but rather for everyone to laugh together, signalling how much they're enjoying each other's company."[5] Another professional comedian who seems to work in a similar vein is the Bolton stand-up comic Peter Kay. His style of joke telling, described as the comedy of intimate recognition, runs alongside aspects of private joke telling in that it is "comedy as a bonding exercise... it's inclusive and warm, a conversation with the audience that at times feels like some kind of community therapy. It's more than just local, it's parochial."[6] In that sense Higgins's comedy as bonding exercise echoes aspects of Kay's performance style. With Higgins, it feels almost like a deliberate attempt to close the gap between public Maeve and private Maeve. In addition, Higgins does acknowledge that there is a certain risk to adopting such a personal approach to the material and to the comic–audience exchange. She admits to feeling more exposed to the public's whims of approbation, disapproval or even apathy, which, ironically, may also account for Higgins' highly personalised perceptions of her audience.

That said, Higgins's use of the local, even the parochial is immediately apparent in the *Bullies from Cobh* scenario.[7] Here again, as was the case for both Tiernan and Moran, the social congruity/incongruity dynamic is at work, that agreement between comic and audience on the shared social world as background to the joke. Referencing local place names and areas emphasises communal culture and remembering. Cobh is referred to throughout, as is the very specific naming of the deepwater quay and here again is the sense of creating a bond with an audience based on local knowledge. The audience may not be familiar with the deepwater quay in Cobh, or indeed Cobh (or Cork) itself, but the place imagery evoked in the story is familiar enough to allow the audience to imagine a neighbouring copy. This story could be read as having something of a nostalgic quality. On the one hand, connection is made with the audience through a shared sense of sentimental feeling about past experience and the vanished world of youth. On the other hand, Higgins's comedy is not about overtly hankering for the values of the past. It is not the nostalgic longing of other comedians, such as the Liverpudlian comedian Tom O'Connor's "Wasn't it good, when we didn't 'ave any problems like the modern people've got?"[8] Nonetheless it is an important element of Higgins's comedy to create a "strong warm bond with the audience, identifying [herself] very much as one of them."[9] Recounting her childhood memories resonates with the

audience as that comedy of intimate recognition. Allied to such specifics is the question of accent. Double states one of the reasons why British comedian Frank Skinner was so successful in working men's clubs in Birmingham was because of his knowledge of the local area along with "his authentic Brummie accent."[10] On a somewhat related, but more general note, Carr and Greeves make the point that "one of the reasons that Ireland has produced so many great comics is undoubtedly that Irish people have a rhythm to their language that goes beyond accent, a rhythm that seems somehow made for telling funny stories," and they reflect that the "sing-song rhythms of the Gaelic tongue persist as a powerful undertow that tugs at the formal surface of the language."[11] However true or otherwise, I would suggest that Higgins's distinctly Cork accent, her rhythms and intonations, does add to the comic effect of the story. Interestingly and again in terms of what could be described as differing local politics, there exists a certain rivalry between Cork and Dublin. Apart from Cork's relationship with the capital city, there is also something of a national perception that Cork sees itself as somehow different from the rest of Ireland. Cork's perception of itself as being perhaps somewhat apart, as its own republic and as the real capital of Ireland is subverted to some extent here, as Higgins mocks her very local bullies from Cobh. That being said, all of these elements combine to create a rapport with the audience based on shared history, shared understanding and cultural and social familiarity.

Higgins's recounting of her youth, fixed in place, time and language, do emphasise that sense of cultural bonding with the audience. Her material lays a strong emphasis on the minutiae of her personal life, grounded in honesty and also a desire to tell the truth of her experiences, however they are transposed into the performative arena. Parochial bonding with an audience, however, is also undercut by Higgins's play with darker thoughts. This story is constructed around the idea of wish fulfilment and revenge fantasy. At first blush, vengeance is not a theme that you would particularly associate with the comic material presented by someone like Higgins. Yet the underlying pattern through the *Bullies from Cobh* scenario speaks to unforgiving depths of feeling about her childhood bullies. And although she does acknowledge her issues of low self-esteem, she never lets go of the vengeful dream. Visions of death (even by rocks and whales) speak to the darkness that lurks in the material. Here, somehow, it almost feels genuine and very personal, as though she were recounting something of the feelings she has toward real bullies in her past life. In that sense, Higgins's comedy is something of a double-edged sword because there

is a subversive undertow that tricks the audience to darker places. This is where the work takes on a more aggressive and layered quality, where the blacker edges ripple and knock against the edges of her 'girl next door-style' of comedy. This means that even as the audience feel pity for Higgins's overweight, bucktoothed, frizzy-haired childhood self and even as they empathise with her vengeful fantasies, they are aware that Higgins's work is not all about whimsy and charm. Her comedy has the ability to cut across the surfaces of her humour, producing incisive comedy that subverts her 'chatterbox' persona. Her handling of the light and dark in her comedy is something that I am going to focus on throughout the rest of the chapter. One way in which to deepen that discussion here is to fix on a recurrent theme in her performance works, which speaks to her issues with and anxiety about her body size. This is something that Higgins returns to time and again, and she does not disappoint on this night in Vicar Street.

5.2 'If you're fat, just like be fat and shut up.
And if you're thin, – fuck you!'[12]

During interview, I asked Higgins how she defined her style of stand-up comedy. She responded:

> Definitely low key, observational... and as truthful as I can make it... I still have one short thing about flirting but I say to the audience, 'oh this is an old bit' because I just enjoy doing it and I like '*do*' some funny voices in it, but mainly yea, mainly... like this current show, it's stuff that's happened to me in the last few months and trying to see the funny side... it's just part of being, of trying to be honest like, say when it happened and it's usually... like this show is like from the fifteenth of December [2009] on, stuff that happened to me and I started doing it on the seventh of January, so you can imagine the seventh of January show was not that great (*laughs*) Yea, Yea, (*laughs again*) poor old Waterford.[13]

Higgins's liking for telling 'truthful' tales involving recent events in her life is evident in the next scenario under discussion. Her life stories get a good airing in Higgins's TV programme *Fancy Vittles*, which the comic has described as 'stand-up to camera.'[14] The show received some very good critical feedback when it aired on Irish television in 2009. Patrick Freyne of the *Tribune* gave something of a glowing review, stating, "Maeve Higgins rocks. And RTÉ has a new, genuinely original, very

funny observational comedy programme. [Higgins] and her sister Lilly make dinner for a bunch of their lady friends. Actually Lilly makes the dinner; Maeve mainly waffles away to the camera."[15] Over the course of this series Higgins speaks directly to camera about her neuroses, obsessions and anxieties that come of living in this 'modern world.' She talks about body image, about sex, about boyfriends, girlfriends, dead pets and family. She talks about how she would really like to know what normal might actually be. All the while, Lilly is silently directing operations and cooking up a (quiet) storm in the background. The show is also punctuated with a selection of footage from the RTÉ archives, scenes from the 1940s to the 1970s, which continually punctuate the programme with nostalgic reminders of the way Irish cultural life used to be. *Fancy Vittles* has been described as a "whimsical and quirky look at relationships and social behaviour,"[16] set against a visual backdrop of 'simpler' times. The juxtaposition of Higgins's discussions to camera whilst cooking and baking, cutting to and from the archive footage poignantly illustrates the comedy, suggesting that Higgins may not be quite ready for 'modern life.' In the first episode of the series she speaks to what she conceives as current cultural obsessions with a sexualised body image:

> I find in these modern times (*laughs*) I have a problem with this... that everything has to be sexy all the time now. I think... like call me old fashioned... that the most amount of people I would want to have sex with me at one time is one person. I don't want everybody thinking that I'm sexy. That's creepy.[17]

She tells the story of turning up to a Halloween party where everybody was dressed in very sexy costumes. Unsurprisingly Higgins talks in irritated tones about the situation she found herself in, as she had shown up wearing a 'medley of winter vegetables.'

The next scenario is also concerned with cultural perceptions of female body size. I have called this *Thin Means Good Person*. This scenario is based on Higgins's (presumably) experience of attending a Weight Watchers meeting. It explores her body image anxieties and her ongoing attempts to conform to acceptable standards of physical beauty.

Thin Means Good Person

And I mean – I did go to
I've been to... I joined Weight Watchers three times you know
Most people you talk to have been to more than one Weight
 Watchers meeting

It's 'cause we're so sneaky
We just go to the other one and say
"Oh, what's this?"
"Oh, points, is it?" (*Looking at imaginary Weight Watchers points information*)
"Oh that's interesting"
"Hee Hee Hee"
"Got my points chart six months ago, bitch"
And when you go to Weight Watchers you get a leader
Which is quite sinister in itself, isn't it?
And my last leader
She was a thin woman...
Means good person in Weight Watchers (*Sustained laughter*)
And... but some of my friends
They said that their leaders
Are like quite actually fat... actually
So, but they said it's too awkward to bring it up (*Laughter*)
You know?
'Cause I'd imagine it is
It's the woman's job and everything
But... ahem... I do think she's got it all sewn up
'Cause she's just like
"Don't eat that, give it to me" (*Mimics the leader eating food*)
But I didn't like the vibe in Weight Watchers
Because everyone is very quiet and mortified because they're fat you know (*Sustained laughter*)
So everyone's like (*Makes sad fat face... looks at ground and sighs*)
Then you can understand the expression 'bovine'
Everyone has big eyes looking at the ground
And then someone needs to stand over there
To herd us over to the weighing scales
They'd bang into each other and not say excuse me and stuff
So that would drive me mad
So I would always try and be like a human
And answer questions and talk and stuff, you know?
Our leader would always ask us questions
And everybody would just be like (*Mortified fat face expression*)
I would always try and answer you know?
That's how I found out I was bad at Weight Watchers
Because one day our leader was like
"Ok ladies were gonna talk about the seven deadly c's"

"What would they be for us girls?" (*Dublin accent*)
"And I was like" (*Hand goes up, getting leader's attention*)
"Pss Pss"
"Crime... Car-Jacking?"
And she was like
"No, No. Crisps Chocolate"... I don't remember the other ones
Pretty sure cake's totally fine
'Cause they're tiny
You eat them in the dark.[18] (*Sustained laughter and applause*)

In the *Thin Means Good Person* routine, Higgins takes the audience into the duplicitous world of Weight Watchers as she describes (after presumably falling off the wagon), returning to a meeting under the pretence of a first-timer. She warns the audience of the ominous notion of having a 'leader', which is Weight Watcher practice. Higgins also signals that Weight Watchers is possessed of an ethos which allegedly believes that '*thin* naturally means a good person,' which results in sustained and hearty laughter from the crowd. The idea that the leader may often be as fat as those attending, but that it's simply too awkward to bring the subject up also has the intended comic effect. Her 'instant' characterisations of the leader who eats everything and of the 'herd' of embarrassed and ashamed pupils also add to the audience's enjoyment of the scenario. Higgins reveals that she is bad at Weight Watchers. She is bad because she attempts to behave like a human and not stare at the floor in shame. By answering the leader's questions incorrectly, Higgins deliberately points up her failure. The last two lines of the story attest to her guilty enjoyment of eating 'tiny' cakes in the dark and this observation brings another round of sustained laughter and applause from the audience. Throughout the scenario Higgins's pace and tone remain conversational and her personifications do yield big laughs. Her illustrations of the phenomena of weight loss programs and her personal failure would seem to create a direct connection and rapport with the audience. The strength of the scenario would seem to lie with audience recognition of the validity of her observations. They may well empathise with Higgins' story of personal anxiety around her body size and of her subversive failures to become a successful Weight Watcher.

The politics of self-deprecation

Higgins's comedy as keyed toward the personal minutiae of her life is mirrored in many ways to other performing women who make stand-up comedy. In interview, the Perrier Award-winning British comic Jenny Eclair describes her sense of the personal in terms of gender. She asserts,

"I think that when comediennes do write and perform from the heart, they have a sort of consciousness of their lines, whereas men tend to be much more surreal or physical, and not so personal."[19] The high-profile British comic Jo Brand responded to Alison Oddey's observation that several famous male comics (such as Jack Dee, Lee Evans and Harry Hill, for example) tend toward the surreal rather than the personal as comic material. Brand observed:

> Yes. Well I think that's men and women all over. I think women are very talented at knowing what they need and expressing their emotions, whereas men are absolutely hopeless at it. I think just because there are more male comics you do get more variety of comedy, but none of it is particularly emotionally expressive. It tends to be played sort of far away from the person really.[20]

Stylistically, the notion of female stand-up as invested in ideas of emotional truth and of a more personalised expressivity than their male counterparts connects in ways to the comedy of self-deprecation. The tactic of self-deprecation is by no means limited to women or comedy, however, as Danielle Russell states in her study on female stand-up, "the variety of comedic approaches are as varied as the comedians themselves, [however] one form of humour continues to be identified with women in particular: self-deprecation."[21] Philip Auslander's work on American comedy is useful here. He argues that traditional female comics of the 1950s and the 1960s:

> Tended to work within self-imposed restrictions that reflected the social stigma attached to aggressively funny women. The traditional female comic's chief strategy was to render herself apparently unthreatening to male dominance by making herself the object of her own comic derision in what is usually referred to as self-deprecatory comedy.[22]

In order to attain and maintain success in a more traditional and patriarchal culture industry, female comics such as Joan Rivers and Phyllis Diller deployed the comedy of self-deprecation. Their comic material was marked by a style that looked "inward onto the female subject herself, rather than outward onto the social conditions that [made] it necessary for Diller and Rivers to personify themselves in this way."[23]

Lisa Merrill discusses women and comedy by defining feminist humour as that which speaks *to* the value of female experience, as that which does not underpin or normalise a male perspective. What Merrill

terms as a "strong rebellious humour" is that in which women *self-critically* examine those stereotypical roles, and the degrees to which, as Merrill argues, "we have been led to perpetuate this objectification."[24] If the humour traditionally associated with American comics such as Phyllis Diller and Joan Rivers has been named as self-deprecatory, the American comic Lily Tomlin's work is indicative of what Merrill terms "celebratory women's humour."[25] Tomlin's one-woman show, entitled *The Search for Intelligent Life in the Universe* (1986), involved Tomlin becoming 12 different characters, from prostitutes to middle-class housewives. Merrill argues that all Tomlin's characters "display integrity and insight, which allows them to be self-critical without being self deprecating."[26] More recently Jenny Eclair has talked about her self-deprecatory attitude in the material, "I admit to things I'm not good at, I admit to being a bit desperate – aging stuff: the make up and the hair."[27] So too Jo Brand talks about her comedy, as inhabiting the world of self-deprecation at times; her thinking around the subject is "I might as well get it all out, say it before someone else says it and say it worse than someone else would say it... If someone heckles you with 'Fuck off you fat cow', I just say, 'I think we've covered that already', have you not been listening?"[28] Higgins takes on the quality of self-deprecation as she deals with issues of her body image to produce comic material. Higgins calls herself a *chubster*, she apologises to the thin people in the audience because they're like 'what's the problem... apple.' She mimes eating an apple and then shakes her fist at all the thin people who enjoy fruit more than cakes. At another point in the evening she tells the audience that "when you are trying to lose weight you really will do anything else, so before Christmas I was buying shelves, most important thing, need to get shelves or I won't lose weight."[29] There is the sense that the whole set is punctuated and peppered with comic disapproval of her own body size. On one level Brand, Eclair and Higgins all perform the act of 'making herself the object of her own comic derision' which bears the hallmark of classic self-deprecation as female comedy. Whilst there is not the room here to give a deeper reading of Brand and Eclair's work, I would argue that Higgins's work also makes serious game play with Merrill's ideas of 'strong rebellious humour,' and that it is also possible to examine the work from this related, but more liberating perspective.

Thin Means Good Woman

Higgins's *Thin Means Good Person* scenario reflects current critical arguments on the phenomena of slimming programmes in Ireland.

Jacqueline O'Toole's essay on group slimming classes is relevant here.[30] O'Toole frames her discussion by arguing that weight loss programmes are principally targeted at women. She cites the work of Chris Shilling, who argues that whereas societies of late modernity may no longer believe in political or religious grand narratives, they now increasingly regard the body as constituting a firm foundation through which to construct a dependable sense of self-identity. Shilling goes on to state that "it is the exterior territories or surfaces of the body that symbolise the self at a time when unprecedented value is placed on the youthful, trim and sensual body."[31] Presently, social discourse surrounding the body is framed in part by current public health concerns in Ireland. Contemporary lifestyles have become increasingly sedentary, resulting in health-related concerns about body weight and obesity. As such, medically sanctioned definitions of correct body weight have come to constitute the standards which define a healthy body. And, as O'Toole points out, a healthy body is also part of the active discourse feeding society's obsessions with well-being, beauty, youth and the pursuit of an ideal body. In this way, as O'Toole argues, motivational talks in slimming classes are embedded in messaging two dominant storylines:

...to achieve such a body, much emphasis is directed toward the responsible citizen, invoking notions of self-control, self-discipline and competency in the production and presentation of the self in everyday life... overweight people are profoundly 'othered' in this context and depicted as irresponsible, unfocused and out of control. But they are encouraged to learn from the habits of normal (code = slim) people. A blame storyline permeates the control narrative with the clear invocation of the need to be responsible.[32]

O'Toole acknowledges that analyses of people's participation in weight loss programmes are complex. Her work centres on the performance power of motivational talks in slimming classes which "articulates a narrative of individualism and agency where self control and personal transformation are central features... in order to improve... individual bodies' minds and selves."[33] However, O'Toole also argues that motivational talks in slimming programmes focus strongly on placing overweight women within simplistic narratives of blame. Those talks fail to take any account of what links there may be between social, psychological or material conditions and issues surrounding body weight.

Historically, women have been viewed as emotional and illogical, as out of control and insatiable. The contemporary manifestation of

seeing women in this way can be understood through women's appe-
tites, which must be kept under surveillance so that women do not
lose control of themselves through under- or over-eating.[34] Insatiable
desires for food and overeating represent women within a narrative
(both as narrators and receivers of the blame storyline) that defines
them as irresponsible. Further, those narratives are deeply layered with
moralistic overtones. Food and eating behaviour are discussed in terms
of 'good food' and 'bad food' and members are encouraged to recount
their eating 'sins' before the weekly class. And, as O'Toole notes, there
is a definite sense of this moral discourse around eating behaviour as
being gendered: "women must try very hard to be good when it comes
to food and avoid temptation and being a temptress."[35] So the narra-
tives offered may suggest the potential for self-transformation; how-
ever, they also perpetuate gendered narratives, which depict overweight
women as being negligent, uncontrolled and even dangerous. Higgins
begins her story of Weight Watchers by returning to the programme
(albeit it in a deceitful fashion), which signals her belief in the poten-
tial for self-transformation narratives that are offered by weight loss
programmes. Nonetheless it is clear that by staging her personal experi-
ences and failures, Higgins points up her frustrations and even anger at
social expectations of physical beauty, which are imposed upon women,
and of viewing those who fail or refuse to conform as being deviant
in some way. I suggest that through the comedy of self-deprecation
Higgins points up her failure at losing weight and at Weight Watchers.
However, the story is also heavily laced with self-critical commentary
which both exposes and ridicules weight loss programmes. The *Thin
Means Good Person* scenario accommodates Higgins's desire to believe in
narratives of transformation through dieting. However, she simultane-
ously resists, by ridiculing social standards of attractiveness perpetuated
by slimming groups, which shape and influence women's personal nar-
ratives of identity in society. In this way I would argue that Higgins's
Weight Watchers scenario could just as easily mean *Thin Means Good
Woman*. In attending slimming classes women are caught in a double
bind. Currently, overweight people are deemed as irresponsible citizens,
and women as the chief targets of slimming class narratives are not
only labelled irresponsible citizens, but are also caught in a gendered
blame narrative, which reinforces negative historical and contempo-
rary stereotypes about women's identity. In my view, women, either
willingly or otherwise, continue to be caught up in a web of discourses
which seek to police the ongoing negative storyline of what it means to
be 'good' woman. That said, and as with Tiernan and Moran, Higgins's

style and delivery of the story is ambivalent, she does not inflect the work with any particular editorial comment and in the end it is really in the hands of the audience to decide for themselves. In the empathic impulse they may laugh with Higgins as she describes her situation of personal failure. Equally, the audience may laugh in recognition at Higgins's subversive ridicule of a cultural coda which works hard to connect ideas of an idealised body size to a 'responsible and in control' gendered self and with personal and professional success in life. A cultural coda which also has the power to relegate those profoundly 'othered' overweight and 'out of control' women into a position which constitutes an element of risk to a community; where 'othered' women are conceived as dangerous to themselves, their families and to a society for refusing or failing to 'act' like a responsible woman.

5.3 Maeve Higgins does not scare men

If much of Higgins's stand-up comedy is concerned with ideas of body image and size, then the subject of sexual relations also feature prominently. The next scenario to be considered here is called *Flirting as an Art Form*, and takes on the subject of sexual politics in the dating world. Higgins makes some incisive commentary on a culture industry that is determined to keep hackneyed gendered roles alive on a 'periodical' basis. Higgins prefaces the *Flirting as an Art Form* scenario by telling the audience that she has performed this 'bit' on her TV show *Fancy Vittles*. She dolefully suggests that not many people may have actually seen the programme. The comment is something of a play at self-deprecation, considering the relative success of the show. Higgins's stories of her failure in relationships with the opposite sex feature prominently in a number of *Fancy Vittles* episodes. It seems that Higgins likes to tells stories of fantasy, failure and even revenge, when it comes to the men in her life. This scenario begins as a telling of different dating techniques in New York and in Ireland:

Flirting as an Art Form

So, anyway I was in New York
And I was having dinner with a man
Because he asked me out to dinner
Because in the States it's very, very different than here
Like over there, if they like you they ask you on a date
And it's all very like... It's like an interview (*Laughter*)
And... but here, here you like sleep with someone three times

And then you're like
"Sorry you don't have a mobile phone number or something…"
 (*Extended laughter*)
"No… No… You're grand … You're grand No… No"
"Sorry I don't want to be pushy – Sorry" (*Sustained laughter*)
"Ah, I'll see ya when I see ya"
"I'll see ya when I see ya"
"No, take anything you want" (*Extended laughter*)
"Yea… No… Yea… OK."[36]

…And later

Flirting is when you're subconsciously letting somebody know
That you want to lob it into them (*Loud and extended laughter*)
So it's an art form
I read about it in a woman's magazine
Our Bible (*Lots of laughter*)
And this is what it said
It said flirting…
If you're like a woman, flirting with a man
Then… if you're that way inclined
Then…
These are the three rules that you have to obey ok?
If you want him to be like **Boing Boing** (*Higgins attempts male pelvic thrusts*)
Then you have to be like three things
First of all
Wait until he stops talking
Then you do a little laugh
Then…for encouragement…
And then…ahm…bite your lip and touch your neck (*Puts her hand around her throat*)
To be "you could kill me that's how much…"
"I don't know…"
"I'm nervous… you could kill me"
"Now wanna do me?" (*Laughter*)
Ahem… So it wasn't specific enough for me
It didn't say what he should be talking about or not
I mean I know obviously
Some things you shouldn't do a laugh after
But other things… anything else is fine

He could be just be like (*Holds up a talking hand as 'boyfriend' with a Cork accent*)
"Listen I found out"
"It's not just gluten that I'm intolerant to"
"I'm completely allergic to wheat actually"
"Yea...Yea" (*intakes of breath*) "Yea..."
"In fact ahem... actually... couscous, couscous is actually basically pasta"
"So I couldn't have couscous or anything like that now"
And then when you're sure he's finished talking you'd be like
"Ha ha ha" (*Cartoon buckteeth expression, biting lip with hand around her neck*)
And he'd be like **Doinng** (*Laughter*)
Boh Boh Boh (*Pelvic thrusts*)
And he'd be delighted
And he'd be like
"You're the one"
"Or one of the ones"
And you'd be like
"Hm... take it or leave it"
But that's not how I flirt
I tell... I tell people
Amazing facts from the natural world
Like if I hear myself
Telling people this one
Then I know I've got it bad
If I hear myself saying
"And every scallop has got thirty five blue eyes"
"Did you know that?"
Well, good night... good night
And ah... to be honest with you girls
I walk away at that point
Because I know he'll follow.[37]

The subject of sexual politics would seem to be the intended target in the *Flirting as Art Form* scenario. Higgins begins by recounting her American 'interview'-styled date, before comparing it to the vagaries of the Irish equivalent, or rather the lack thereof. She tells the audience that after sleeping with a man three times, she attempts to get a mobile phone number, and is turned down. She apologises for being pushy. Making meek enquiries and behaving submissively in the face of her

rejection result in sustained laughter from the audience. They can perhaps recognise (both men and women) the situation in which Higgins finds herself. In the game play of sex and dating Higgins's apologetic semi-jilted Irish woman is inflected with a more scathing critique of Irish men, who come across in her descriptions as boorish, selfish and bordering on cruel. Higgins then moves away from 'flirting' for some time, returning to the subject matter later in the performance. When she does, she suggests that flirting is 'when you're subconsciously letting somebody know that you want to lob it into them.' The line is met with loud laughter, signalling the audience's enjoyment of the line's bawdiness. Her subtle mockery of women's magazines as 'our Bible' also gets a lot of laughs and speaks back in some ways to the work of (among others) the American feminist publication *Titters*. The magazine, which was published throughout the 1970s, contained "parodies of advertisements for women such as schools for nurse's aides so they can meet and marry a doctor [and] Magna Vibe earrings that ring when 'Mr Right' comes along."[38] The audience also react with laughter throughout the whole of the Cork 'boyfriend' as hand puppet 'spot.' However, the biggest response comes during Higgins's self-parody, following the rules for flirting, biting her lip and grinning inanely. All the while she has her hand to her throat, which, according to the Bible, should result in peaking (piquing) male sexual desire. Her approximations of sexy male pelvic thrusts that naturally result from her foreplay also produce lots of laughter. Those pelvic thrusts have a sort of comic charm, in part because the audience do not really expect too much vulgarity from Higgins. The comic effect may also be heightened by the fact that she is wearing a floral print dress. There is a stark contrast between the dress and the thrusts; frankly, it's not what you'd imagine from a woman wearing a Laura Ashley frock. In addition, there is no aggression behind them, they seem to be almost oddly polite. The incongruity between Higgins's 'charming persona' and her ability to plunge straight into edgier material is a game that Higgins plays very well with the audience. The sights and sounds of Higgins in 'full flirting' mode are very funny and the audience laugh at her self-caricature, a sort of comic grotesque of bizarre sexual relations. However, embedded within this scenario there is also a critique of contemporary women's magazines, some of whose stock in trade is to sell the ten best ways to catch, keep and only very occasionally (on a case-by-case basis) get rid of your man. Critiquing advice and articles in women's magazines allows Higgins to construct a very funny piece of physical comedy while highlighting the power of the print (and other) media to

speak directly to a female readership on the best ways to attract men. However seriously women may take these magazines (and it may well be that many take them with a pound of salt), the idea still exists that some magazine content can place women in a subordinate light and, further, that women continue to invest themselves within that storyline.

Higgins soon returns to the familiar territory of her own dating failures. Her predilection for stories from the natural world as a dating technique is highlighted as being comically ineffective as a method of seduction. The lines "and every scallop has thirty five blue eyes, did you know that... well good... good night" does bring some laughter. However, that laughter is not as wholehearted as for previous lines and there is a sense that Higgins may have lost the audience somewhat during the more surrealistic 'wonders of the natural world' dialogue. The final lines suggest that Higgins has been successful in her bizarre dating rituals and, not unlike Moran's deflated endings in the previous chapter, those lines feel unsatisfactory as conventional punchlines. Higgins would seem to be talking to the female audience when she states 'to be honest with you girls, I walk away at that point, because I know he'll follow.' However, implicitly Higgins is including the whole room in this conclusion since the vagaries of the dating game are familiar (at times excruciatingly so) for both men and women. Auslander suggests that in feminist humour, female comics speak directly to the women in their audiences. Perhaps in an inverted sense Higgins is also "attempting to stress the commonality of women's experiences with men."[39] That said, Higgins's surreal dating techniques fall a little short of their comedic intent because of the somewhat surreal nature of the closing lines.

However, I suggest that deflation as ending is stylistically in keeping with her failure throughout. This whole scenario does feel low key. Higgins's story of sexual politics is best described as implicit critique on the social conventions and expectations that are imposed on women. She involves the audience in her stories of personal disappointment and her performance of those stories works as ambivalent game play. As in the *Thin Means Good Person* scenario, Higgins' 'deceptively charming' comic persona accommodates that interplay between self-deprecation and self-criticism. It is the duality of that construction which allows her to fire off some critical rounds of ammunition and satirical commentary from within her foxhole camouflaged by the colours of self-deprecation. Those critical and satirical rounds do hit their mark, but they may still only be flesh wounds. As I discussed above, in the 1970s, feminist magazines were parodying along similar lines, with 'Magna

Vibe earrings that ring when Mr Right comes along.' Lisa Merrill has referred to a rebellious humour in the 1980s, working between the lines of self-deprecating and self-critical comedy. Higgins does attempt to point up something like the commonality of experience of both the men and women in her audience. By sharing her failures, she involves the whole room, making them complicit in identifying with their own disappointments. As stated earlier, she does mock those magazines, which continue to sing (however glossily) the same old tune. To my mind, from within her own comic construct Higgins is making something like the same social commentary and critique as those feminist writers and performers in the 1970s and 1980s. The object of attack on which Higgins trains her weapons toward is a very deserving one; however, the very fact that Higgins's intended targets for satire still so richly merit that attention beggars belief.

5.4 Male periods

If Higgins plays actively with the boundaries of self-deprecation, self-criticism and social critique in order to subversively challenge the female (body) politic, the next scenario also works within a similar dynamic. In the *Male Periods* routine Higgins interrogates ideas surrounding the traditional segregated notions of 'male' and 'female' humour. Throughout this scenario, Higgins deconstructs pervasive cultural thinking, which continue to pigeonhole the subject matter and performance style of female stand-up comedy. In so doing Higgins exposes the gendered politics embedded in the performance form of stand-up, and undercuts the normalised comic stereotypes grafted onto conventional conceptions of the female comic.

Male Periods

But first I wanna say
I'm a female comedian
I'm wearing this to prove it
And I don't think it's a very big deal
I don't even think about it actually
But then sometimes journalists say to me
"What's it like being a female comedian?"
And I always say to them
"Sometimes I'm hungry other times then I'm tired" (*Laughter*)
I don't know what it's like for the men
I've never been actually one of the men ones... so

I don't know... and they'd be raging
And then I wouldn't bring it up but
Three different people have asked me
"What's it like for the men when you do a joke about periods?"
"Does that isolate the men?"
And I always think like, actually...
I beg your pardon
First of all I don't actually **do** any period jokes
And if you'd caught my set you'd know that
We call it set...
Caught, I mean like seen... actually
Actually... if you caught my set
And second of all I don't think it would be that bad
If I did a period joke
You know, the men in the audience would be like (*Upset and distressed*)
"Hang on a minute"
"What's she actually saying?"
"Ooooh give me that candle" (*Mock attack on her own body with a candle*)
"Oh my God... Give me a knife"
Wsssshhh (*Slits stomach*)
I think you'd be like probably totally cool about it
So then to check
I was trying to think of a joke about periods
But I couldn't think of one
And then I was thinking
Oh my God you are an OK comedian
Why can't you think of a joke about periods?
I can think of a joke about nearly everything else
And why is it?
Is it because I'm mortified?
I hope not
'Cause I shouldn't be
Ahem... but I know I am a bit
'Cause I still get embarrassed if someone sees the tampons near me
I'm just like
"Oh no that... I don't know"
"That's my dickey bow"
"Oh ho ho ho" (*Operatic voice*)
"Casual... Formal" (*Moves tampon to and away from her neck*)
"Casual... Formal"

I'll pretend it's anything else
"Oh you found my bomb"
"That's my bomb"
"I'm a bomber"
"There you go"
"And what of it?"
"To each his own"
"I bomb – you sew"
Actually I'm not the only one because a lot...
There was a whole marketing campaign
A few years ago
That made tampons look like sweets
Yea... and like... so like... if
Your boyfriend was like
"Oh, can I have a sweet?"
You'd be like – "no give that to me"
Gulp (*Swallows tampon*)
Drink of water
Oooooooh (*Stomach explosion*)...
I feel like... I'm not sure
But I feel like... that the men
You'd be more cool about it
You wouldn't be so embarrassed
You'd be like (*In a shop*)
"The purple ones there and the paper"
And be just walking down the road (*Tampons in hand*)
La La La La La (*Carefree male lilt*)
Which is your song
And hopefully you'd be able to have more craic with it than women
Do you know?
Like if you're in the pub and you want to make your friends laugh
You could just be like
"Watch this... Watch this"
"Here... Michael!" (*Throws imaginary used tampon*)
Michael would be like
"Oh, ya got me boy"
"You got me" (*Wiping face*)
"I'll get you back in two weeks' time I will" (*Laughter and applause*)
Sorry... I hope that wasn't too gross
But remember... it's just an idea.[40]

This scenario is focused on Higgins's treatment of what is understood as some hackneyed territory of female stand-up. Notions of the binaries that have formed and continue to inform discourse on the nature of male and female stand-up comedy are centred on the idea of the male as paramount. As previously discussed, the tradition of male dominance in stand-up is allied to the notion that the form itself has, certainly from an historical point of view, centred on the male. Issues of phallic authority, with observations such as "holding a microphone is like holding a penis"[41] and the comic Jerry Seinfeld's assertions that "to laugh is to be dominated",[42] make for a strong argument on the historical and formal power of the male stand-up comic. So much so that Auslander has contended, "women comics who choose to remain within the conventional form and performance contexts of stand-up comedy are essentially appropriating a cultural form traditionally associated with and still dominated by, male practitioners."[43] From this reading, then, it would seem that the historical and formal constraints inherent for women comics in comedy clubs (and also other live settings) are self-evident. However, the issue is more complex. Within the live performance context both male and female comics do maintain at least a measure of licence and control over their material. In this sense live performance may well differ from the power held in mass cultural media, which can act as a powerful tool to neutralise the female comic.[44] Therefore any discussion of situating female comics within the patriarchal arena must "remain open-ended, for comedy's potential for empowering women is always accompanied by the potential for patriarchal recuperation; both can take place simultaneously, in fact."[45] While it is important, on the one hand, to acknowledge the historical and formal frame of stand-up comedy as a male form of discourse, on the other hand it is also important to acknowledge that perspectives on female stand-up comedy are continuing to change. Again Danielle Russell's study of self-deprecation in female stand-up comedy is useful here. While Russell also acknowledges the problematic nature of stand-up comedy and male dominance she asserts that female comics are, in general, moving away from a more traditional and overtly negative self-deprecatory style of performance. Russell states that "all women in comedy challenge the validity of separate spheres based upon gender – male space is public, female space is private... by seizing what has traditionally been male territory, women in comedy are staking a claim to the power that accompanies that realm."[46] Russell suggests that both male and female comics use self-deprecatory tactics as performance. However, she also asserts that while it may seem that a female comic is ceding control to the audience

in a series of self-putdowns, in fact the real authority always remains with the (female) comic as "the comic retains the microphone... and centre stage. The surrender of power is an illusion."[47] It's important to contextualise female comic's experiences within the power relations of the stand-up stage. While gendered negativity and odious behaviour directed at women in the stand-up industry cannot be discounted and do distort the argument, within those tensions, women are continuing to stake a claim to the power of the stand-up space. That assumption of the power dynamic in female stand-up comedy is significant. Female comics are continuing to exert increasing power and control over live and media formats – for instance, Higgins controlled the editing process on her TV show *Fancy Vittles*. Importantly, in recent years there has been a continuing sense of agency over female comic material and that agency is invested with the power to identify what *is in fact* funny. Frances Gray puts it very well when she suggests that "to define a joke, to be the class that decides what is funny... is to make a massive assumption of power... that of defining and thus controlling the immediate area of discourse."[48] Controlling the discourse is vital and, as Russell states, "power dynamics are interwoven in comedy, by pursuing their personal agenda's female comics expose the politics behind definitions of who and what is funny."[49] So then, Higgins (and others) finds herself situated within the series of relations that shape the stand up form, and in this way, the *Male Periods* scenario is very well poised to test those series of tensions.

Higgins begins this scenario by articulating her frustrations at being asked about being a female comic. She makes this clear by mocking the offending journalists. Higgins initially frames the scenario by stating that she does not do period jokes, which positions her rejection of what is conceived as stereotypical female comic material. She tells the audience that she keeps being asked about what effect period jokes might have on the men in the audience. Her depiction of male mutilation at the mention of periods openly criticises the notion that some men cannot handle the subject matter. There is also an underplayed critique of tampon manufacturers who mask the product to look like sweets. Higgins's portrayal of tampons as dickie bows, bombs and sweets is very funny and also suggests a conspiracy of silence by producers and a sort of acquiescence by consumers such as Higgins. Despite her better judgement, she is aware that she is to an extent complicit in perpetuating that silence. In what is a deftly manipulated and incongruous comic turn of events Higgins then positions the story firmly back in the male sphere. Rather than isolate the men in the audience Higgins suggests

that men (with a generous pinch of ego boost) might be far cooler about the whole period thing. Her descriptions of unashamed men buying tampons openly, as well as the graphics of throwing period products around the pub elicits sustained laughter from the audience. In what may have felt like a stretching of comic permission here for some, Higgins succeeds in making the scenario work without any sense of offending or isolating any section of the audience.

Higgins's tactic of suggesting that men could handle having periods better than women is indicative of the tried-and-tested formula of self-deprecation. Higgins would seem to cede authority to section(s) of the audience here and, further, she would seem to be expressing her own inadequacies and insecurities in relation to the topic. Again, and not unlike Tiernan and Moran before her, Higgins plays something of a status game with the audience. By ceding control as self-deprecatory comedy, Higgins skilfully manoeuvres the whole audience into a position where they remain receptive to the story. This is why ideas of self-deprecation in comedy are complex. Higgins's comic persona would seem to be in the act of disclosure about her failings. However drawn upon Higgins's personal feelings on the subject I would suggest that this *act* of self-disclosure is an illusion of sorts. Higgins may couch her messages in stories of personal failure, yet this is a mastered technique, which packs a powerful and subversive message. If the *Thin Means Good Person* and implicitly the *Flirting as an Art Form* scenarios work within gendered narratives of blame, here the storyline is embedded in a gendered narrative of shame. By citing her own menstrual mortification and will to secrecy as comic material in a public sphere, Higgins self-critically points up the stubbornly persistent patriarchal and moral discourses surrounding sexual difference and cultural gender bias. Those discourses, which in the past have insisted "the female body's moisture, secretions, and productions [constituted] shameful tokens of uncontrol."[50] By locating the comic discourse squarely on the story of her own body, Higgins exposes ossified cultural and social assumptions, embarrassment and even disgust about the functions of the female body. Further, patriarchal and moral discourses continue to manifest themselves within the stand-up comic form itself. The presence of a female comic on the traditionally male-dominated stand-up stage can be read as an aggressive act. To assume the power available in that formal and, at times, hostile space disconcerts persistent cultural definitions of 'femininity'. Danielle Russell argues that "conventional definitions of "femininity" and "lady-like" behaviour render the stance of superiority inherent in stand-up comedy "inappropriate" for women." She cites

Beth Littleford, who states, "Society gyps women", because comedy is seen as boys' territory... Women have to undo society's "lady-izing."[51] By telling the story of her own body, Higgins reveals something of the story of the *communal* female body, which has been so tightly held within a stranglehold of customary discourses. And although attitudes are changing, those discourses prove difficult to rout. Higgins's 'act' of disclosure highlights broader societal complicity, which continue to locate cultural views of women's identity onto redundant moral, and gender-biased notions of sexual difference. Higgins subversively points up the absurdity of those narratives of shame, which continue, lichen-like, to graft themselves onto contemporary conceptions and expectations of women's identity.

The *Male Periods* routine is also layered with a critical commentary on gendered notions of male and female humour. Higgins chooses a subject, which has been traditionally conceived of as appealing to female laughter. She usurps that notion and, by controlling the discourse, makes a significant claim to the power of the performance space. That assumption of power allows Higgins to transform a topic as engaging only to a female sense of humour, into comic material with broader audience appeal. In this way Higgins challenges the notion that the subject matter of menstruation will not be found to be funny by men, or that jokes on menstruation belong solely to what can be understood as more politically overt comedy. So while her comic style may be subtle, nonetheless, Higgins challenges assumptions on what men, and, in fact, the broader audience, will reject as the subject of humour. She criticises the media who continue to differentiate the female comic from the male, placing emphasis on gender over and above comic material. She subverts the formally clichéd idea of the period joke, in order to critique conservative notions of difference between male and female humour. In this way the comedy works to expose gendered prejudice around what constitutes female comic material, and further it asks questions of why those differences continue to be sustained. Politically, comic women's voices must do battle to be heard above the cacophony of male comics and that imbalance can, at times, result in reductive value assumptions and stereotypical attitudes toward female comic material. Higgins's comedy subtly mocks those who relegate women's comedy as speaking primarily to their own sex and without the power that male comics possess, that of mainstream appeal. Additionally, from a broader perspective Higgins's use of this material is timely, as it taps into shifting cultural attitudes which are beginning to move away from making value assumptions about comic material based solely on the gender of

the comic.[52] That being said, there still exists an imbalance between the sexes in the stand-up performance form; historically, formally and in terms of numbers, men still significantly outweigh women comics. In this sense the claim to power of the performance space still reflects the influential male voice. However, Higgins, by taking control of the discourse and defining what is and what is not funny, is making her own claim to the power of that stand-up space, a space that is becoming more attractive and open to women wishing to pursue a comic career. In this way, stand-up comedy continues to move away from the idea of the male as paramount and the growing presence of the female comic will, in her turn, continue to alter and influence the power structures of a traditionally male-dominated form.

5.5 The comic 'i'

As already discussed, one way among many of looking at subjectivity in stand-up performance is to look at the loose association of ideas inherent in the formulation of the comic 'i.' As with Tiernan and Moran, the comic 'i' is described as that which constitutes 'me,' as aspects or fragments of the self, selected and projected outward from within, by means of a comic persona, and bounded by the comic frame. In this model, narrative and the self are synonymous, with the self being grounded in the "phenomenological assumption that entities are given meaning through being experienced... narrative is an essential resource in the struggle to bring experience to conscious awareness."[53] In addition, the self is understood, not in a simplistic or essentialist way but as an ongoing subjective process; discursive, provisional, multiple and inscribed by cultural, socio-economic and material relations. Aspects of Higgins's subjectivity are filtered through the construct of her comic persona on the stand-up stage. As discussed, Higgins has said that she 'tries really really hard to not change when [she] goes onstage, which she finds frightening at times. It could be said that she works to the formula of stage persona as discussed; that is "you are you plus fifteen percent,"[54] or Oliver Double's notion of naked selves, where the comic on stage "appears unaffected by the process of performance."[55] Jo Brand works in this way, she has said that her offstage self changes "hardly at all to be honest," when onstage, "I mean hardly at all in public anyway."[56] A comic persona is vital to the form in that it functions as a mode of connection, context and identification, which marks the relationship between the comic and the audience. I have also argued that a comic persona functions as an artefact that corresponds to aspects of the '*me*'

that 'i' want to project from within to without on the stand-up stage. That said, there is no doubt that stand-up comedy is a constructed, revised and honed performance of the self, with nightly shows of oft-repeated material as the subject of laughter. The fact is that stand-up material operates within a very fluid structure that oscillates between versions of truth and outright fiction. Yet one way or another, and to a greater or lesser degree, there is an assumption that what is presented on stage by the stand-up comic has more than a ring of telling the truth for the audience. It is recognised as an art form that deals in authenticity, and in handling the truth of things, despite the apparent difficulties, and in whatever form that might come. However, stand-up comedy is bound to the rules of the comic frame, which refuses the serious mode, as Mintz suggests, "the essence of the art [of stand-up] is creative distortion... treating that which is usually respected disrespectfully and vice versa."[57] In this reading the comic frame is also working within the set of relations that bound the comic heterotopic space. Comic heterotopias as discussed treat the world in the non-serious mode, and can be described as countersites, in which all the other sites in a culture can be contested, rehearsed or reversed. As with Moran in the last chapter and Tiernan before him, I have employed Smith and Watson's argument for the performed self that claims the 'I' in autobiographical performance.[58] I maintain that the idea equates to stand-up, in that the enacted self can claim the 'i' in stand-up performance in something like the same way; as provisional, multiple and fragmented, as an ongoing subjective process. The 'i' that is situated at the centre of Higgins's world speaks to descriptions of the minutiae of her life, about trying to be honest, about telling stories about things that happen to her and trying to see the funny side. Her persona is carefully crafted – sweet, awkward and delightful – yet Higgins subverts the surface of her whimsical persona by going into the darker territories of retribution, censure and disgrace. Higgins's comedy resembles a cork in the water; every so often she submerges it, but it always ends up back on the surface. Bobbing.

'I'm barren, but I have comedy'[59]

In interview, Higgins recounted a story that was then still fresh in her mind. During a gig the previous week, she had noticed that a man in the audience was glaring at her:

> And him and his wife were hating [the show], so I said, because what I do is tell long-winded stories about things that have happened to me that are not important at all. So I think he wanted me to do

something more sensational, with a punchline and routines and things like that, whereas I don't really do that. So in the end I said it to him. I said if you're not happy you can go. I can see you're not enjoying yourself.[60]

And they did.

It is safe to say that Higgins's 'long-winded stories' fill a lot of show time, and they suit more than most. In these pages and in the comic heterotopic space, Higgins deploys the comedy of intimate recognition, which seeks to make connection through evoking a sense of shared experience and ideas of the collective with an audience. In the *Bullies from Cobh* scenario Higgins takes to heart the old saying that 'revenge is a dish best served cold,' as she fantasises about visiting vengeance on adolescent tormenters in her hometown of Cobh, Co. Cork. The story works as a series of exaggerated self-caricatures and highly improbable revenge strategies, which are very funny. However, the vengeance motif gives a clue to the darker themes at work in Higgins's style of comedy. In the *Thin Means Good Person* routine, Higgins deals with her anxieties around body image. Utilising the comic technique of self-deprecation, Higgins focuses the comedy onto her own body size. By staging her personal experiences and failures at weight loss, Higgins offers some self-critical commentary of those social expectations defining physical beauty imposed upon women by cultural and commercial forces. Forces that continue to cast women in the starring role of a gendered blame narrative for failing to achieve those standards, for failing to *act* as a responsible woman. In the *Flirting as an Art Form* scenario Higgins takes us on a journey of sexual politics and her own experiences of dating failure. Dancing on the head of a pin between self-deprecation and self-critical commentary, she mocks women's magazines within which all the secrets on how to get and keep a man are plastic wrapped. She makes some satire of the male sex, marking out some sharp parody for the condition of the Irish male. Again Higgins would seem to be critiquing conventional commercial forces, which continue to place women in a subordinate light, even as women continue to have a hand in perpetuating the stereotype. Finally, in the *Male Periods* scenario, Higgins takes on the subject of the female comic in stand-up comedy itself. In this way *Male Periods* becomes connected to the earlier work, here instead of *gendered narratives of blame*, the work is pointing up *gendered narratives of shame*. Higgins resurrects the female period joke and again the comedy is written onto Higgins's body. By divulging her insecurities surrounding her periods, Higgins again exposes the outmoded cultural,

moral and patriarchal discourses that stubbornly graft themselves onto the loci of the female body and gendered identity construction. Throughout all of this material Higgins, however self-deprecatingly, is controlling the discourse on the stand-up stage. She does critique those who insist on placing the gender of the comedian above the comic material. In doing so, she manages to punch holes in some well-built conventional walls differentiating male and female humour and reflects the growing influence of the female comic in the male-dominated world of stand-up comedy.

Higgins continues to enjoy a high profile in Ireland. *Fancy Vittles* was depicted as a relief to RTE's hit-and-miss comedy; "she is rarer than a blessing of unicorns... alluring, original pithy and deftly honest.[61] For the Edinburgh Festival in 2007, Ashley Davis described Higgins's comedy as, "sweet stories, domestic references and endearingly crap Halloween-based recycling ideas. Thanks to enough well-told dark material – such as a surprise rape gag or descriptions of her mother as pet terminator, only an eejit would dismiss her style as saccharine."[62] Higgins's comedy constitutes something of a balancing act. Perched on a high wire, and driven by an empathetic impulse, she plays with the boundaries of her own comic work. She has placed herself within a genre and a tradition that is male dominated. Her power lies in that realisation, and the framing of her material operates as performance that is carefully worked toward that empathetic laugh as mutual reward. But this is not to say that Higgins is a "girlie, faffing around, skipping on and skipping off."[63] Although Higgins does not push comic permissions as overtly as Tiernan does, or as Moran can when the humour takes him, throughout all her performance works, Higgins plays darkly with subversion and the power to immerse her comedy into deeper waters, negotiating narratives of revenge, narratives of blame and narratives of shame. Perhaps the fact that she is a female comic has something to do with those comic permissions. That's a very good question and I cannot answer for it here. That said, Higgins plays very well with failure. And anxiety. She can talk about cakes and rape, of being barren, of having comedy to soothe the pain. The darker seams are stealth bombs that quietly implode in the middle of her comedy. It is through the prism of her 'deceptively charming' comic persona that Higgins plays at the darker edges without seeming to change her 'girl next door' comic style. As Russell suggests, "scepticism about women's comic abilities lingers, [and this] stymies the attempts of those women who venture into stand-up."[64] Higgins's style of comedy is not overtly challenging or aggressive; I suggest that Higgins's comic persona is constructed in

a way which allows her to accommodate her subversive discourse and her stories of social satire. In this way Higgins manipulates the more traditional format of the comedy of self-deprecation; however, that manipulation comes not from any sense of self-loathing but rather from a certain self-confidence, which speaks to her control over the performance form. It also speaks to Higgins's stories as a discursive power in the comic space, which works to expose and satirise contemporary cultural assumptions and the stereotyping of women's identity. In addition, Higgins's work exposes the gendered politics inherent in stand-up comedy, challenging historical assumptions and formal segregations of funny women, while opening up broader questions of audience reception in contemporary society. Russell states that comedy can act as "more than simply entertaining, comedy can serve as a coping mechanism. It can inspire an alternative vision even if it cannot alter power structures."[65] Higgins sells her "Irish cake baking, tea cosy loving chatterbox' version very well."[66] The work is, simultaneously, signalling to the experiences and expectations that frame her everyday life. The negotiation is well handled. To my mind Higgins's subjectivity, her social, cultural, political 'inscription' as woman, masked in the camouflage of self-deprecation and self-critical commentary, works to subvert the male-dominated comic form. It speaks into those power structures of which Russell speaks, creating clearly female comic narratives, which continue to challenge societal expectations of women's identity in contemporary society.

In discussing Tiernan's work I borrowed a leaf from Dee Heddon's thinking on autobiographical performance. She suggested that taking the self(selves) as the subject in communication with the other self(selves) in the audience makes the form appealing to "marginalized" (author's emphasis) subjects.[67] I suggested that this thinking could apply equally well to stand-up comedy as mainstream performance. Here, I propose that Higgins's work encompasses the two concepts. Higgins's stand-up is, like that of Moran and Tiernan before her, keyed to national and international stages; in this way her comic 'i' as the enacted self in stand-up is connected to the broader community. Women's comic voices are still marginalised on the stand-up stage. If the goal of autobiographical performance should not be "to tell stories about yourself, but, instead, to use the details of your own life to illuminate or explore something more universal;"[68] then Higgins's stand-up, operating as popular comic performance, allows her to illuminate her experiences of being a woman living in the twenty-fist century. Jill Dolan believes that women standing alone onstage and telling stories to

an audience still represents a political act. She speaks of the performer Holly Hughes describing the "utter need to tell a story, balanced by a hunger to listen."[69] Hughes thanks God for the audience:

> ...I stumble through the story (stories) of my life (lives). And they're paying attention... not in an Orwellian sort of way but watched in the sense of being watched over, guarded. Having an audience is a form of protection. It's like having the light of a hundred tiny private suns helping me find my way from one side of the story to the next.[70]

Higgins's work operates in a similar manner. Stories told in pursuit of laughter, yes, but also as maps, as negotiations with our own self(selves) and with others as we attempt to find our way 'from one side of the story to the next.' For too long, women have been in the act of disappearance from too many stages to number. I have spoken through the work of 'comic humans as being incomplete;' of the concept that one modern evocation of comic identity speaks of its being increasingly individualistic, symbolic of the comic self as being estranged from society.[71] As with Moran and Tiernan, Higgins also connects to the idea. Her position is more complex. Occupying the marginal position of a successful mainstream female comic speaks into that rupture between the self and society in a fundamentally different way. For her voice must do battle with historicised scant or outmoded ideas of female comic identity, as well as refiguring contemporary understanding of what it is to be a funny woman. For her part, Higgins adds her comic voice to the store of communal knowledge about comic women, which clashes with some dominant discourses stacked on those shelves. She tells her stories of *her* life into larger stores of communal identity, and encourages other tellings, between other selves. Women's comic voices have suffered in silence or struggled to be heard, a condition of malaise that has debilitated, misshapen or threatened to extinguish the very sound. Someone get a megaphone; it really is time to be heard.

Final Remarks

The world of stand-up is very tricky. Through this book, I have made some efforts to take its inherent contradictions into account. My formulation of the comic 'i' as a way to look at ideas of subjectivity and identity represents my best attempt. One of the central contradictions is, of course, the idea that stand-up material can inhabit an autobiographical nature or quality. On the other hand, I have tried to show that the storied self is also radically contextualised as comic material, which can easily transform into invention and outright lies. Whatever the scale, there is always an active degree of manipulation involved in comic material within the stand-up frame, where the pursuit of laughter is all. I believe that the construction of comic personae is vital to the accommodation of those manipulations. A comic persona acts as a means of connection and communication with an audience. A comic persona as device also serves another very useful function as part of the loose association of ideas involved in the comic 'i.' As I have tried to illustrate, the comic 'i' suggests that which constitutes 'me,' as fragments or aspects of the self, selected and projected outward from within by means of a comic persona, and bound by the comic frame. This construct of the comic 'i' allows one means among many to speak of identity in stand-up performance, of subjectivity and the comic self. Tiernan's comic persona is that of the controversial comic, Moran resides within the depths of the misanthrope, and Higgins is at home with her double vision of quirky deception. These identifiable comic personae also act as conduit, through which to project subjective interpretations of experience. They embody points of view which are not objective, rather they represent understanding as particular and personal versions of reality.[1] Those versions of reality are channelled through the temporal 'here and now' of stand-up performance. Working within the comic heterotopic space, along with the conventions of the form, all three comics express and impress those subjective fragments, as acts of connection and communication with those 'other' fragmented selves of the audience. This company of ideas have formed the central driving force through the totality of the work. I have tried to suggest that these ideas can act as a useful analytical tool in stand-up performance. There is much more to be said on the subject; in that sense this book

represents a scratch in the paintwork. That said, I hope that it has been of some value to the reader.

Watch(wo)men

Looking across the three case studies there are some similarities. Comparatively, Tiernan, Moran and Higgins work with the cultural contexts and specifics within which comedy is positioned. All three recognise that comic practice is underpinned by a tacit *social contract* between the audience and the performer so that joking may be understood as "a game that players only play successfully when they both understand and follow the rules."[2] To various degrees all three play with the technique of de-familiarisation, comedy that works to distance the practices and assumptions of ordinary life. In doing so the works can constitute acts of 'everyday anamnesis' that remind us what we already know in a new way, reminders of "who 'we' are, who 'we' have been, and of who 'we' might come to be."[3] And all three couch their work in comic ambivalence; they make scant editorial comment and it is left to the audience to make up their own minds. All three are very well aware that the job of being a stand-up is actually about making people laugh and that "a joke that does not get a laugh is not a joke – end of story."[4] That Tiernan, Moran and Higgins have carved out successful careers both in Ireland and on the international stage speaks to their skill as comics. It also speaks to their comic material, which is grounded in the communicative act of stand-up, and of their particular and subjective experiences of contemporary life. All three commit acts of transgression when their material seeks to critique cultural mores, prejudices and behaviours, gendered inequalities, ideologies and systems of belief. At times their material can run into deep pools, which are framed, in existential or philosophical inquiry; questions of faith, of what it is to be human, of value and gender, of memory, of death. It's also safe to assume that their success outside Ireland is influenced by the growth of a global culture informed and shaped by the ongoing and exponential flow of our mediatised world. That growth is reflected in a well-established international stand-up touring circuit across Europe, Australia, New Zealand, Britain, America, and beyond. The influence of ideas surrounding global and 'glocal' culture is also perhaps responsible in part for current discourse as to the nature and meaning of the form itself. Currently, stand-up is immensely successful as a genre of popular culture. Staging the comic self makes claim to the power and control of the stand-up space. In that spotlight, the performed comic self can act as a means to interrogate the

social, political and cultural relations that shape everyday experience on national and international stages. In that sense stand-up as performance is relatively undocumented in critical discourse. I suggest that the creation of a stand-up archive of performance DVDs as a research tool for analysis may illuminate discourse in many directions. There is much more room for investigation into a form so heavily invested in narrative, and the complex relationship between the comic and the audience as part of that discourse. Investigation into stand-up comedy as dialogue with an audience may also illuminate notions of subjectivity, of community and of national identities, perhaps specifically in the light of the seismic cultural shifts both here and abroad in the recent past. An archive would be a very useful resource through which to investigate the provisional self as embedded within that mesh of social, political and cultural relations, on national and international stages.

Rebecca Emlinger Roberts suggests that comic routines are not art. However, for Roberts, comic material symbolises a central concern in critical discourse on the differences between the prerogative of art and popular culture. Roberts argues that:

> the comic plays at the edges of our consciousness as Duchamp did, as Acconci and Shermen do, as Ashbery and Kristeva do. The comic plays at our suspicions that life is scarcely more than sky and ground, that, like the horizon, one's orientation not to mention systems of values, even one's *self* is perpetually being made and interpreted. The stand-up comic, like the artist becomes a kind of simulacrum of disease with the status quo – endlessly shifting notions of what humour is, what art is, and what as humans we think we are all doing here.[5]

The comic interrogates and plays with a society's cultural values in comic heterotopias, those spaces related to, but distinct from all the other spaces in society. The comic can perpetuate and question those values, structures and systems of belief in a culture, which may at times expose the comic to challenge and censure. The comic expresses conflicting and fragmented selves in narratives born of experience, shaped through those experiences, submitting those self(selves) to the scrutiny of 'other' fragmented selves. The drive to entertain and to make people laugh does not lessen the value of stand-up comedy as *acts* of contact, between the self and the selves in a culture. Tiernan, Moran and Higgins project and subject their performative identities to the vagaries of the public appetite, which are rooted in the comic's particular performative subjectivities. The comic works under discussion here are bound up

fundamentally in the subjectivity of personal and collective memory. For me, Tommy Tiernan, Dylan Moran and Maeve Higgins, as stand-up comics, remember and narrate experience which is rooted in individual and collective perceptions and interpretations of cultural values, traditions, systems of belief and ways of being in everyday life.

In her discussion on collective memory and art, the poet Heather McHugh likened the artist to the watchman in Aeschylus's *Agamemnon.* She observes, "If we don't participate with the watchman, with the reader and conveyor of signs, he will forget the art of relaying, relating, he will forget for all of us."[6] Stand-up comedy as a performance form may lie in circles of thought, which continue to argue about art, about value and meaning-making, and what popular culture has (or has not) got to offer. Questions of value and popular culture continue to divide. Those conflicting rationales aside, it is the function of the watchman/woman to read and relay the signs of cultural signification. For me, this is what Tiernan, Moran and Higgins do best, on national and international stages; they interpret and relay their subjective perceptions of daily experience. In doing so they actively read and convey those multiplex symbols and signs of cultural meaning and memory in contemporary society. This is where those ideas of comic identity that I have spoken of on a number of occasions through the work come back into focus. I use one particular evocation; that of comic identity as increasingly individualistic, as estranged from society in order to make a particular point.[7] Identity performed on the comic stage may well be divided, multiple, fragmented, gendered and political, but in the end, I am not so sure about estranged. For me the stand-up comics who populate stages through the pages of this book are in ongoing *acts* of communication; if comic identity can be defined by its sense of dividedness or incompleteness, then those comics surely speak to that idea of rupture in some way. They are signalling into the breach as a series of navigations and negotiations between the self and selves, between self and society. As a final word, I look to Tim Etchells of the well-known performance group *Forced Entertainment*, who suggests that an "art work that turns us into witnesses leaves us, above all, unable to stop thinking, talking, and reporting what we've seen."[8] The extent to which any given audience, as witness, assigns value or purpose to the work, and assigns value to the watch(wo)man, cannot be really known here. For my part, I am drawn to Roberts's final point on cultural and aesthetic anxieties around popular culture: "perhaps we need to believe that art lies elsewhere, *of* popular culture yes, if we must, but not *in* it."[9] Look closer. The watchwoman is signalling.

Appendix: Biographies

Tommy Tiernan

Tommy Tiernan was born in Navan, in Co. Meath, in Ireland in 1969. He attended the same school as both Dylan Moran and the Irish television presenter Hector O' hEochagáin. He began his career in the early 1990s, playing pubs and performance venues around Ireland. In 1996, Tiernan won the Channel 4 "So You Think You're Funny" Award, and two years later, he was awarded the Perrier Comedy Award at the 1998 Edinburgh Fringe Festival. Tiernan is currently highly successful in Ireland, and he has produced several DVDs of his performance works, including *Tommy Tiernan: Live* (2002), *Cracked: Live at Vicar Street* (2004), *Loose* (2005), *Jokerman* (2006), *OK Baby* (2007), *Something Mental* (2008) and *Bovinity* (2008). Throughout his career, Tiernan has toured extensively, both in Ireland and in Australia, New Zealand, Britain, Canada and America. In 2010, Tiernan headlined the *Michael McIntyre Comedy Roadshow* in Britain and has performed at the Royal Albert Hall in London, as well as performing on *Live at the Apollo* in 2011. His latest performance DVD, entitled *Crooked Man*, was released in 2011, after a successful national and international live tour. Tiernan is currently touring the show *Stray Sod* with Irish and international dates, as well as continuing his 'world tours' of the Irish Counties. Tommy Tiernan lives in Galway in the West of Ireland, with his wife Yvonne and his five children.

Dylan Moran

Dylan Moran was born in Navan, Co. Meath in 1971. He began his career in the Comedy Cellar in the International Bar in 1992. In 1993 he was awarded the 'So You Think You're Funny' Award at the Edinburgh Fringe Festival, and three years later he was the youngest comedian to win that festival's most prestigious honour, the Perrier Award for Comedy. His first tour, entitled *Gurgling for Money*, toured the UK in 1997. His move into acting began with a lead role in the sitcom *How Do You Want Me?* (1998) and his vehicle *Black Books* established Moran as a successful writer as well as performer of comedy. His stand-up comedy tours have also been very successful and include *Ready, Steady, Cough* (2000), *Monster I* (2004), *Monster II* (2004), *like, totally ...* (2006) and

What It Is (2008). Moran has toured extensively with his performance works across Europe, America, New Zealand, Britain and Ireland, and has produced DVDs of his live shows, including *Monster* (2004), *like, totally ...* (2006), *What It Is* (2008) and a 'best of' DVD entitled *Aim Low* (2010). Moran's film career is substantial, including roles in *Shaun of the Dead* (2004), *Run Fat Boy Run* (2006), *Tristram Shandy: A Cock and Bull Story* (2006), *A Film with Me In It* (2008), *The Decoy Bride* (2011), *Good Vibrations* (2012) and *Calvary* (2014). In recent times, Moran has been touring with his live performance tour, *Yeah, Yeah*, both nationally and internationally. Moran also brought out a DVD of the London leg, aptly entitled *Yeah, Yeah: Filmed in London* (UK: Universal Pictures, 2011). Currently, he lives in Edinburgh with his wife and family.

Maeve Higgins

Maeve Higgins was born in 1981 in Cobh, Co Cork. After studying photography in Colaiste Dhulaigh, she began her stand-up career in 2004 by performing "Once on a bus outside a hotel in Cork and once in a room over a pub in Dublin." Higgins came to recognition through the very popular series of *Naked Camera*, a hidden camera-style of entertainment programming broadcast on RTÉ for three years up to 2007. Higgins performs regularly on the Irish comedy and festival circuit as well as internationally, including appearances at the Edinburgh Fringe Festival, the Melbourne International Festival, the Adelaide Fringe Festival, the Kilkenny Comedy Festival, and the New Zealand International Festival. She had a regular slot on the Ray D'Arcy show on Today FM entitled "What would Maeve do?", where Maeve gave advice to listener's questions. In 2009, Higgins's RTÉ One television series *Fancy Vittles*, which she wrote and performed with her sister Lilly, was very well received and enjoyed healthy ratings. Her stand-up comedy shows include *Ha Ha Yum* (with her sister Lilly, 2006–07), *Slightly Amazing* (2007), *My News* (2007), *Kitten Brides* (2008–09), *I Can't Sleep* (2009), *Blabbing Away* (2010) and *Personal Best* (2010). In 2011 Higgins toured her stand-up and recorded her first stand-up comedy album (*Can't Stop Doing Comedy*) at the International Bar in Dublin. In the same year Higgins began writing for the *Irish Independent*, and she also contributes a column to the *Irish Times* where she conjures ideal dreams. In 2012 Higgins wrote a book entitled *We Have a Good Time... Don't We?*, a series of essays which reflects Higgins's absurdist worldview. Maeve Higgins currently divides her time between London, Dublin and New York.

Notes

Introduction

1. Della Pollock quoted in Dee Heddon, 'Beyond the Self: Autobiography as Dialogue', in *Monologues: Theatre, Performance Subjectivity*, ed. by Clare Wallace (Czech Republic: Litteraria Pragensia, 2006), pp. 157–84 (p. 183).
2. Dylan Moran, *Aim Low* (UK: Universal, 2010).
3. Christina Patterson, 'Dylan Moran: I Am a Bit of a Bumbling Man As You Can Tell', *Independent*, 16 October 2009, www.independent.co.uk/arts-entertainment/interviews/dylanmoran (accessed 16 October 2009).
4. Patrick O'Neill, 'The Comedy of Entropy: The Contexts of Black Humour', *Canadian Review of Comparative Literature*, 10:2 (1983), 145–66 (p. 166).
5. Dee Custance, 'Profile of a Serial Kidder', *The Skinny*, 8 September 2007, http://www.the skinny.co.uk/40232-profile-of-a-serial-kidder (accessed 7 June 2010).
6. Joanna Hunkin, 'Review: Maeve Higgins at Basement Theatre', 14 May 2009, http://www.nzherald.co.nz/entertainment/news/article/cfm?_id+1501119&objectid=10572098 (accessed 14 May 2010).
7. Peggy Phelan quoted in Philip Auslander, 'Liveness: Performance and the Anxiety of Simulation', in *Performance and Cultural Politics*, ed. by Elin Diamond (London: Routledge, 1996), pp. 196–213. (p.196).
8. Peggy Phelan quoted in Philip Auslander, Liveness', p. 196.
9. Philip Auslander, Liveness', p. 197.
10. Philip Auslander, Liveness', p. 197.
11. Philip Auslander, 'Going with the Flow: Performance Art and Mass Culture', *TDR*, 33:2 (1989), 119–36 (p.125).
12. Auslander, 'Going with the Flow', p.128.
13. Auslander, 'Going with the Flow,' p.128.
14. Philip Auslander, 'Comedy about the Failure of Comedy: Stand-up Comedy and Postmodernism', in *Critical Theory and Performance* (Michigan: University of Michigan Press, 1992), p.199.
15. Philip Auslander, 'Going with the Flow', p. 128.
16. Philip Auslander, 'Liveness', p. 197.
17. Patrice Pavis, *Analysing Performance: Theater, Dance and Film*, trans. by David Williams (Michigan: The University of Michigan Press, 2003), p. 11.
18. Henri Bergson, *Laughter: An Essay on the Meaning of the Comic*, trans. by Cloudesley Brereton and Fred Rothwell B.A (UK: Kessinger Publishing), [n.d.], pp. 5–6.
19. Eric Weitz, 'Who's Laughing Now? Comic Currents for a New Irish Audience', *in Crossroads: Performance Studies and Irish Culture*, ed. by Sara Brady and Fintan Walsh (Hampshire: Palgrave Macmillan, 2009) pp. 225–36 (p. 225).
20. Eric Weitz, 'Who's Laughing Now?', p. 225.
21. Eric Weitz, 'Who's Laughing Now?', p. 225.

22. Michael Billig, *Laughter and Ridicule: Towards a Social Critique of Humour* (London: Sage Publications, 2005), pp. 178–9.
23. Michael Billig, *Laughter and Ridicule*, p. 194.
24. Jimmy Carr and Lucy Greeves, *The Naked Jape: Uncovering The Hidden World of Jokes*, (London: Penguin, 2006) p. 194.

Chapter 1: The Trailblazers: Vaudeville, Music Hall and Hibernian Varieties

1. Richard Butsch, *The Making of American Audiences: From Stage to Television, 1750–1990* (New York: Cambridge University Press, 2000), p. 95.
2. Richard Butsch, *The Making of American Audiences*, p. 95.
3. Richard Butsch, *The Making of American Audiences*, p. 96.
4. In fact, there were others such as Charley White and R.W. Butler who were also in the act of sanitising variety in search of new and broader audiences. Pastor outdid his competitors somewhat by being better organised and more systematic in his efforts. Richard Butsch, *The Making of American Audiences*, p. 105
5. Richard Butsch, *The Making of American Audiences*, p. 105.
6. Edward Franklin Albee was the grandfather of the noted American playwright Edward Albee.
7. Lawrence J. Epstein, *The Haunted Smile: The Story of Jewish Comedians in America* (New York: Perseus Books Group, 2001), p. 28. pp. 105–7. The sanitising project from 'improper' to 'proper' entertainments in variety and vaudeville did not obliterate older styles of performance at that time. They continued to exist as music hall "dives" and saloons attracting their clientele with the time-honoured inducements of alcohol and sex.
8. Richard Butsch, *The Making of American Audiences*, p. 111.
9. See Lawrence J. Epstein, *The Haunted Smile*, pp. 28–30.
10. Lawrence J. Epstein, *The Haunted Smile*, p. 30. Oliver Double also describes a typical vaudevillian evening, as consisting of a large variety of different acts including "singers, dancers, speciality acts and comedy quartets." Dr Oliver Double was a practicing stand-up comic for many years before entering academia. He currently lectures in stand-up at the University of Kent. See Oliver Double, *Getting the Joke: The Inner Workings of Stand-up Comedy*, (London: Methuen Publishing, 2005), p. 21.
11. Richard Butsch, *The Making of American Audiences*, pp. 115–17.
12. Richard Butsch, *The Making of American Audiences*, p. 118.
13. Epstein makes the point that Jewish comedians born of vaudeville and who have passed into comic legend are those who "provided an assimilationist model... Jewish comedians, more specifically male comedians... developed a 'double consciousness,' a sense of being Jewish but having to hide it to win approval and a sense of being American, but not fully so." See Lawrence J. Epstein, *The Haunted Smile*, pp. 50–1.
14. Oliver Double, *Getting the Joke*, p. 22.
15. Milton Berle interview with Vernon Scott, cited in Oliver Double *Getting the Joke*, p. 22.
16. Oliver Double *Getting the Joke*, p. 22.

17. Richard Butsch, *The Making of American Audiences*, p. 150.
18. Lawrence J. Epstein, *The Haunted Smile*, p. 51.
19. While the popular entertainments of film and radio materially threatened vaudeville, Joseph P. Kennedy delivered the real deathblow. The father of John Fitzgerald Kennedy (JFK), Joseph Kennedy bought 200,000 shares from the Keith-Albee Orpheum circuit, by then the largest and most powerful chain of theatres in America. Mr Kennedy had connections to the movie business and little interest in live performance. He sold his shares to the Radio Corporation of America, which became RKO (Radio Keith Orpheum), who certainly had no interest in competition with their movie interests. For further discussion see Oliver Double, *Getting the Joke*, pp. 22–3.
20. Oliver Double, *Getting the Joke*, pp. 22–3.
21. Richard Butsch, *The Making of American Audiences*, p. 169.
22. Lawrence J. Epstein, *The Haunted Smile*, pp. 112–22.
23. Lawrence J. Epstein, *The Haunted Smile*, pp. 111–12.
24. Air-conditioning meant not having to leave the city during the sweltering heat of the summer and the television meant that comedians playing the 'Belt' were beamed directly into people's front rooms. See Lawrence J. Epstein, *The Haunted Smile*, pp. 111–12.
25. Oliver Double, *Getting the Joke*, p. 24.
26. Phil Berger, *The Last Laugh: The World of Stand-Up Comics* (New York: Cooper Square Press, 2000), p. 65.
27. Phil Berger, *The Last Laugh*, pp. 64–7.
28. For a more detailed discussion on the 'sick comics', see Lawrence J. Epstein, *The Haunted Smile* pp. 155–91; Phil Berger, *The Last Laugh*, pp. 65–98; and Ronald K.L. Collins and David M. Skover, *The Trials of Lenny Bruce: The Fall and Rise of an American Icon* (Illinois: Sourcebooks, 2002), pp. 11–23.
29. Oliver Double, *Getting the Joke*, p. 25.
30. Phil Berger, *The Last Laugh*, p. 82. Bruce was unafraid to tackle taboo subject areas such as race, religion and drugs, "are there any niggers out there tonight?" was an intro he used in order to expose the absurdity of racial slurs.
31. Oliver Double, *Getting the Joke*, p. 26.
32. By the late 1970s, stand-up comedians went on strike over (the lack of) wages, and Mitzi Shore (Sammy Shore's ex-wife to whom the club was handed over on their divorce in 1974) had to submit. She eventually began paying her acts. See Oliver Double, *Getting the Joke*, pp. 27–8.
33. Philip Auslander, 'Comedy about the Failure of Comedy: Stand-up Comedy and Postmodernism', in *Critical Theory and Performance* (Michigan: University of Michigan Press, 1992), pp. 196–207 (pp. 196–7) and Oliver Double, *Getting the Joke* pp. 46–7.
34. Comedians had been making successful transitions to television from the 1940s. Among them, Milton Berle was hosting his own variety television show by 1948, and Phil Silvers' creation (along with writer Nat Hiken) "Sergeant Bilko" (1955–9) was also very popular. Comedians George Burns and Gracie Allen also transitioned to television with their popular radio show, *The George Burns and Gracie Allen Show* (1950–8). Groucho Marx also took his radio show *You Bet Your Life* (1950–61) to television and Jack

Benny was similarly successful with his programme *The Jack Benny Program* (1950–64). The 1960s also featured television stand-up appearances on the *Ed Sullivan Show* and *The Steve Allen Show* among many others. By the 1970s American stand-up was again transformed by the advent of cable TV. Stand-up 'comedy concert films' were very popular with cable companies as they were cheap to produce and were popular with viewers. See Lawrence J. Epstein, *The Haunted Smile*, pp. 129–30, 147, 152–4. Philip Auslander, 'Comedy about the Failure of Comedy: Stand-up Comedy and Postmodernism', p. 196.

35. Oliver Double, *Getting the Joke*, p. 29.
36. Oliver Double, *Getting the Joke*, p. 40.
37. Roger Wilmut, *Kindly Leave the Stage: The Story of Variety 1919–1960* (London: Methuen, 1985), p. 14.
38. Roger Wilmut, *Kindly Leave the Stage*, p. 14
39. Tony Allen, *Attitude: Wanna Make Something of it? The Secret of Stand-up Comedy* (Glastonbury: Gothic Image Publications, 2002), p. 62.
40. Roger Wilmut, *Kindly Leave the Stage*, p. 14.
41. Roger Wilmut, *Kindly Leave the Stage*, p. 15.
42. Roger Wilmut, *Kindly Leave the Stage*, pp. 14–15.
43. Oliver Double, *Getting the Joke*, p. 31.
44. Tony Allen, *Attitude: Wanna Make Something of It?*, p. 65.
45. Roger Wilmut, *Kindly Leave the Stage*, p. 17.
46. Oliver Double, *Getting the Joke*, p. 34. Ted Ray stands out during this period as a gifted comic who in the 1930s was "one of the earliest stand-up comics to wear an ordinary suit and tell unlinked gags… he was more relaxed in his delivery than most comics – a style he had perhaps developed as a result of watching visiting American comics." See Roger Wilmut, *Kindly Leave the Stage*, pp 118–19.
47. Oliver Double, *Stand-Up: On Being a Comedian* (London: Methuen Publishing, 1997), p. 34.
48. Roger Wilmut, *Kindly Leave the Stage* p. 125.
49. Oliver Double, *Getting the Joke*, pp. 35–7.
50. Roger Wilmut, *Kindly Leave the Stage*, p. 215.
51. See Roger Wilmut, *Kindly Leave the Stage*, pp. 208–14. See also Oliver Double, *Britain Had Talent: A History of Variety Theatre* (Hampshire: Palgrave Macmillan, 2012), pp. 69–94.
52. Roger Wilmut, *Kindly Leave the Stage*, p. 125.
53. From about 1960 on, what was known as the 'satire boom' produced television shows, including *That Was The Week That Was*, *Steptoe and Son*, *Till Death Do Us Part*, *Monty Python's Flying Circus* and *Yes Minister* as setting the standard for exemplary television programming in the period.
54. Roger Wilmut, *Kindly Leave the Stage*, p. 214, pp. 220–5.
55. Oliver Double, *Getting the Joke*, p. 36.
56. Andrew Stott, *Comedy: The New Critical Idiom* (Oxon: Routledge, 2005), p. 114.
57. Bernard Manning quoted in Andrew Stott, *Comedy*, p. 114.
58. Tony Allen, *Attitude: Wanna Make Something of It?*, p. 81.
59. Some of the most successful comedians of recent years were already emerging through different formats including the folk music clubs and venues

of the time. Billy Connolly, Jasper Carrott and Mike Harding among others began their professional stand-up careers as folk singers that would converse with the audience, and do 'bits' by way of introduction to the songs. Over time, the comic aspect became a larger characteristic of the work than the songs themselves. Another major figure also came through different ranks. Victoria Wood started her career by predominately singing her own cabaret style songs, increasingly interspersed with stand-up 'patter,' Wood went on to forge a stellar stand-up, acting and writing career.

60. Oliver Double, *Stand-Up*, p. 165; Wilmot and Rosengard, *Didn't You Kill My Mother-in Law?*, p. 30.
61. Wilmot and Rosengard, *Didn't You Kill My Mother-in Law?*, p. 10.
62. See Wilmot and Rosengard, *Didn't You Kill My Mother-in Law?*, p. 10.
63. Wilmot and Rosengard, *Didn't You Kill My Mother-in Law?*, pp. 55–6.
64. They also did Samuel Beckett skits, which were funny if you knew Beckett's work, so for the most part they went down abysmally; Mayall and Edmondson usually stuck to the same two routines each week. Comedians Mike Redfern, Mark Dewison and Lloyd Peters completed the line up for *20th Century Coyote*. Rik Mayall and Adrian Edmondson along with Nigel Planer and Alexei Sayle were among the first to break into mainstream television with the anarchic TV series, written by Ben Elton, entitled *The Young Ones*. The sit-com, which ran on BBC from 1982 to 1985, made household names of these five early Comedy Store regulars.
65. Alexei Sayle, *Alexei Sayle Live at the Comic Strip* (MCI: Spoken Word, 1988).
66. The Comic Strip ran until July 1981, when the troupe embarked on a tour. The show and tour was instrumental in "bringing the performers to a wider audience, and for creating the team that would later make the *Comic Strip Presents…* programmes for Channel Four." See Wilmot and Rosengard, *Didn't You Kill My Mother-in Law?*, p. 77.
67. Tony Allen, *Attitude: Wanna Make Something of It?*, p. 98.
68. Wilmot and Rosengard, *Didn't You Kill My Mother-in Law?*, p. 66.
69. Andrew Stott, *Comedy*, p. 119.
70. Oliver Double, *Stand Up*, p. 242.
71. William Cook, *Ha Bloody Ha: Comedians Talking* (London: Fourth Estate, 1994), p. 6.
72. Tony Allen, *Attitude: Wanna Make Something of It?*, p. 119.
73. William Cook, *Ha Bloody Ha*, p. 16.
74. Oliver Double, *Getting the Joke,* p. 39.
75. Tony Allen, *Attitude: Wanna Make Something of It?*, p. 61.
76. Christopher Morash, *A History of Irish Theatre: 1601–2000* (Cambridge: Cambridge University Press, 2002), p. 107.
77. The Queens Royal was situated on Great Brunswick Street (now Pearse Street and on the site of what is now Pearse House), the Theatre Royal was situated on Hawkins Street (now Hawkins House) and the Gaiety Theatre is still situated on South King Street, in Dublin's city centre.
78. Christopher Morash, *A History of Irish Theatre*, pp. 104–8.
79. Joseph Holloway cited in Ben Levitas, *The Theatre of Nation: Irish Drama and Cultural Nationalism 1890–1916* (New York: Oxford University Press, 2002), p. 15.
80. Christopher Morash, *A History of Irish Theatre*, p. 106.

81. Christopher Morash, *A History of Irish Theatre*, p. 109.
82. Ben Levitas, *The Theatre of Nation*, p. 15.
83. Christopher Fitz-Simon, *'Buffoonery and Easy Sentiment': Popular Irish Plays in the Decade Prior to the Opening of The Abbey Theatre* (Dublin: Carysfort Press, 2011), p. 41.
84. Philip B. Ryan, *The Lost Theatres of Dublin* (Wiltshire: Badger Press, 1998), p. 13.
85. Christopher Fitz-Simon, *'Buffoonery and Easy Sentiment'*, p. 41.
86. Eugene Matthews and Matthew Murtagh, *Infinite Variety: Dan Lowrey's Music Hall 1879–97* (Dublin, Gill and Macmillan, 1975), p. 17.
87. Matthews and Murtagh, *Infinite Variety*, p. 37.
88. Matthews and Murtagh, *Infinite Variety*, p. 35.
89. Christopher Morash, *A History of Irish Theatre*, p. 106. There are some small differences in details here, also see Matthews and Murtagh, p. 160, p. 78.
90. The theatre was attached to the Mechanics Institute, popular in the early to mid-nineteenth century; their "aim was to provide educational, and cultural facilities for craftsmen, skilled workers and mechanics many of whom were illiterate." See Philip B. Ryan, *The Lost Theatres of Dublin*, p. 157.
91. The Irish playwright Sean O Casey once performed there in Boucicault's *The Shaughraun* in 1895.
92. See Philip B. Ryan, *The Lost Theatres of Dublin*, p. 147.
93. Philip B. Ryan, *The Lost Theatres of Dublin*, p. 201.
94. Christopher Morash, *A History of Irish Theatre*, p. 126. See Roger Wilmut, *Kindly Leave the Stage*, pp. 14–15. For a discussion on patents, and the illegitimate and the legitimate stage in Dublin, see Matthews and Murtagh, pp. 37–8.
95. Sir Edward Moss founded the chain of 'Empires,' as music halls, which were large, ornate and very well run. See Roger Wilmut, *Kindly Leave the Stage*, p. 15.
96. Philip B. Ryan, *The Lost Theatres of Dublin*, p. 206.
97. Philip B. Ryan, *The Lost Theatres of Dublin*, p. 203.
98. Philip B. Ryan, *The Lost Theatres of Dublin*, pp. 201–8.
99. Philip B. Ryan, *The Lost Theatres of Dublin*, p. 25.
100. Christopher Fitz-Simon, *The Irish Theatre* (London: Thames and Hudson, 1983), p. 84.
101. Philip B. Ryan, *The Lost Theatres of Dublin*, pp. 148–9.
102. Philip B. Ryan, *The Lost Theatres of Dublin*, p. 32.
103. Patrick F. Byrne, 'Fifty Years of Gaiety: Dublin's Gaiety Theatre 1871–1921', *Dublin Historical Record*, Vol. 38:1 (1984), pp. 37–44 (p. 43).
104. Philip B. Ryan, *The Lost Theatres of Dublin*, p. 150.
105. Christopher Morash, *A History of Irish Theatre*, p. 176.
106. One Tony Reddin worked this reputation. When Paramount took over in 1927, changes were made to how the theatre operated. The hybrid entertainment form of cine-variety had arrived, where a stage show and a film were included in the price of the ticket. Paramount created a stage show to accompany important new films; the show would travel with the film to Paramount theatres. As Paramount had one screening outlet in Ireland at the Capitol, Reddin was often charged with having to produce a show a week. He was successful in his ventures and the theatre was a popular venue, see Philip B. Ryan, *The Lost Theatres of Dublin*, p. 181.

107. Philip B. Ryan, *The Lost Theatres of Dublin*, p. 47.
108. David Devitt, 'The Theatre Royal: A Place of Cine-Variety', *History Ireland* (Dublin: History Publications Ltd, 2013), p. 36.
109. Christopher Morash, *A History of Irish Theatre*, p. 176.
110. Christopher Morash, *A History of Irish Theatre*, pp. 156, 176.
111. Philip B. Ryan, *The Lost Theatres of Dublin*, p. 32.
112. Philip B. Ryan, *The Lost Theatres of Dublin*, p. 141.
113. Philip B. Ryan, *Jimmy O'Dea: The Pride of the Coombe* (Dublin: Poolbeg, 1990), pp. 233–4.
114. Philip B. Ryan, *The Lost Theatres of Dublin*, pp. 210–12.
115. Philip B. Ryan, *The Lost Theatres of Dublin*, pp. 210–12.
116. David Devitt, 'The Theatre Royal: A Place of Cine-Variety', p. 36.
117. Philip B. Ryan, *Jimmy O'Dea*, p. 234.
118. Philip B. Ryan, *The Lost Theatres of Dublin*, p. 143.
119. Philip B. Ryan, *The Lost Theatres of Dublin*, p. 213.
120. Philip B. Ryan, *The Lost Theatres of Dublin*, p. x.
121. Oliver Double, *Britain Had Talent: A History of Variety Theatre* (Hampshire: Palgrave Macmillan, 2012), p. 2.
122. Paul Whittington, 'Just for Laughs', *Irish Independent*, 12 September 2009, http://www.independent.ie/entertainment/tv-radio/just-for-laughs-1884916.html> [accessed 19 December 2010].
123. Paul Whittington, 'Just for Laughs'.
124. The Gaeltacht comprises of areas in Ireland where Gaelic is the first language, see http://<www.rte.ie/inthenameofthefada (accessed 6 October 2010).
125. Philip B. Ryan, *The Lost Theatres of Dublin*, p. 187.
126. Stephen Dixon and Deirdre Falvey, *Gift of the Gag: The Explosion in Irish Comedy* (Belfast: Blackstaff Press Limited, 1999), p. 63.
127. Stephen Dixon and Deirdre Falvey, *Gift of the Gag*, p. 62.
128. Paul Whittington, 'Just for Laughs'.
129. Ed Caesar, 'Dylan Moran: Sourpuss Supreme', *Independent*, 25 April 2006, http://www.independent.co.uk/news/people/profiles/dylan-moran-sourpuss-supreme-475554.html (accessed 1 January 2010).
130. Stephen Dixon and Deirdre Falvey, *Gift of the Gag*, p. 69.
131. Stephen Dixon and Deirdre Falvey, *Gift of the Gag*, p. 70.
132. Kate Holmquist, 'The Comedy Don', *Irish Times*, 1 January 2010, http://www.irishtimes.com/newspaper/newsfeatures/2010/0102/1224261521677.html (accessed 1 January 2010).
133. Kernan Andrews, 'Ardal O'Hanlon – Seeing the World Through a Comedy Lens', *Galway Advertiser*, 19 November 2009, http://www.advertiser.ie/galway/article/19296 (accessed 12 December 2010).
134. Ardal O'Hanlon quoted in Stephen Dixon and Deirdre Falvey, *Gift of the Gag*, p. 87.
135. Kate Holmquist, 'The Comedy Don'.
136. William Cook, *Ha Bloody Ha*, p. 15.
137. Stephen Dixon and Deirdre Falvey, *Gift of the Gag*, pp. 76–7.
138. Stephen Dixon and Deirdre Falvey, *Gift of the Gag*, p. 186.
139. Hughes was the youngest-ever winner of the Perrier Award in 1989, he has written poetry (*Sean's Book*) and had a successful television series on

Channel 4, entitled *Sean's Show*. He followed up with *Sean's Shorts*, where Hughes travelled Britain in search of interesting places and people. He was also a team captain alongside Mark Lamarr and Phil Jupitus for the BBC series *Never Mind the Buzzcocks*. In addition, Hughes can boast of a very successful stand-up, film and television career in Britain, Ireland and beyond.

140. Dylan Moran quoted in Stephen Dixon and Deirdre Falvey, *Gift of the Gag*, pp. 97–8.

141. In Ireland, comedy festivals have also grown in size and number over the last number of years. Established in 1994, the Kilkenny Cat Laughs festival is the longest-running and arguably the best-known. *The Guardian* newspaper included Cat Laughs in their top five comedy festivals, stating that the festival has "earned a cult status and discerning comedy fans head to Kilkenny when the corporate world of Edinburgh becomes too much". Smaller comedy festivals include the Carlsberg Comedy Carnival in Iveagh Gardens in Dublin, the Bulmer's Comedy Festival in Dublin and Waterford, the Galway Comedy Festival, the Big Tickle Comedy Festival in Derry, the Kells Comedy Festival in Meath and the Halloween Howls Comedy Festival in Portlaoise, Co. Laois. Comedy tents have increasingly become popular and a regular feature at music festivals, including the Electric Picnic in Co. Laois and to a lesser extent, Oxygen in Co. Kildare. both of which are running since 2004. See Georgia Brown, 'Five Top Comedy Festivals Around the World', *Guardian*, 16 March 2007, http://www.guardian.co.uk/travel/2007/mar/16/scotland.canada.australia.html (accessed 6 October 2010).

142. Brian Boyd quoted in Stephen Dixon and Deirdre Falvey, *Gift of the Gag*, p. 100.

143. Alex Lyons quoted in Stephen Dixon and Deirdre Falvey, *Gift of the Gag*, p. 100.

144. Ardal O'Hanlon quoted in Stephen Dixon and Deirdre Falvey, *Gift of the Gag*, p. 100.

145. Stephen Dixon and Deirdre Falvey, *Gift of the Gag*, p. 124.

146. Kate Holmquist, 'The Comedy Don'.

147. Brian Boyd, 'The tiers of Ireland's clowns', *Irish Times*, 9 August 2010, http://irishtimes.com/newspaper/features/2010/0809/1224276415315.html (accessed 20 December 2010).

148. See Philip Auslander, 'Comedy about the Failure of Comedy: Stand-up Comedy and Postmodernism', in *Critical Theory and Performance* (Michigan: University of Michigan Press, 1992), pp. 196–207.

149. Paul Whittington, 'Just for Laughs'.

150. Tommy Tiernan's tour, *Loose* (2004–2005) is to date the longest-running show at Vicar Street having played for 166 performances.

Chapter 2: The Comic 'i'

1. Jimmy Carr and Lucy Greeves, *The Naked Jape: Uncovering The Hidden World of Jokes* (London: Penguin, 2006), p. 113.

2. Mort Sahl, quoted in Oliver Double, *Getting the Joke: The Inner Workings of Stand-Up Comedy* (UK: Methuen Drama, 2005), p. 70.

3. Frank Skinner, *Frank Skinner* (London: Century, 2001), p. 80.
4. Oliver Double, Interview with Shazia Mirza by telephone, 28 June 2004, in Oliver Double, *Getting the Joke*, p. 71.
5. Oliver Double, *Getting the Joke*, pp. 70–1.
6. Oliver Double, *Getting the Joke*, p. 19.
7. Oliver Double, *Getting the Joke*, p. 19.
8. Paul Ricoeur, 'Life In Quest Of Narrative', in *On Paul Ricoeur: Narrative and Interpretation*, ed. by David Wood (London: Routledge, 1991), p. 20.
9. Paul Ricoeur describes Aristotle's concept of emplotment as that which 'in Greek is *muthos* and which signifies both fable (in the sense of an imaginary story) and plot (in the sense of a well-constructed story). It is the second aspect of Aristotle's *muthos* [which Ricoeur takes] to reformulate the relations between life and narrative.' Paul Ricoeur, 'Life In Quest Of Narrative', p. 21, p. 24.
10. Paul Ricoeur, 'Life In Quest Of Narrative', p. 24.
11. Paul Ricoeur, 'Life In Quest Of Narrative', p. 25.
12. In order to discount the comment that life is lived and not told, Ricoeur suggests a thesis, which is twofold. First, on the side of the narrative text or that of fiction Ricoeur contends that the meanings in narrative operate only in the crosshairs between the text and the reader, and in so doing centres the very act of reading as the primary focus of analysis and its ability to transform the reader's experience. Acknowledging the world of linguistics in analysis of the narrative streams, Ricoeur suggests that a hermeneutical analysis begins where linguistic investigation ends. A hermeneutical interpretation of the literary text must be understood as a negotiation between "man and the world (referentiality), between men, (communicability) between man and himself (self-understanding)." In this analysis Ricoeur reiterates that the *act of reading* (his emphasis) is the most determining factor for the totality of the work and that the act of reading has the capacity to transfigure the reading into a *guide for reading*. In other words, what Ricoeur may be suggesting here is that by the very act of reading, the reader discovers how to navigate the narrative in terms of the work's indeterminacies, its interpretations and finally reinterpretations within different or contemporaneous social, cultural or historical contexts. Stories are open-ended, capable of myriad interpretation and it is the reader finally who imaginatively fills in the blanks missing from the oral or written narrative, but needed by that narrative in order to interpret fully its meanings. See Paul Ricoeur, 'Life In Quest Of Narrative', pp. 26–7.
13. Paul Ricoeur, 'Life In Quest Of Narrative', p.28.
14. Paul Ricoeur, 'Life In Quest Of Narrative', p.28.
15. Paul Ricoeur, 'Life In Quest Of Narrative', p. 29.
16. Paul Ricoeur, 'Life In Quest Of Narrative', pp. 29–30.
17. Paul Ricoeur, 'Life In Quest Of Narrative', p. 30.
18. Paul Ricoeur, 'Life In Quest Of Narrative', p. 32.
19. Paul Ricoeur, 'Life In Quest Of Narrative', p. 32.
20. Ciarán Benson, *The Cultural Psychology of Self: Place, Morality and Art in Human Worlds* (London: Routledge, 2001), p. 45.
21. Ciarán Benson, *The Cultural Psychology of Self*, p.45.

22. Ciarán Benson, *The Cultural Psychology of Self*, p. 45.
23. Elinor Ochs and Lisa Capps, 'Narrating the Self', *Annual Review of Anthropology*, 25 (1996), 19–43 (p. 21).
24. Elinor Ochs and Lisa Capps', 'Narrating the Self', p. 21.
25. Ciarán Benson, *The Cultural Psychology of Self*, p. 45.
26. Erving Goffman, cited in Eelka Lampe, 'Rachel Rosenthal Creating Her Selves', in *Acting (Re)Considered: A Theoretical and Practical Guide*, 2nd edn, ed. by Phillip B. Zarrilli (Oxon: Routledge, 2002), pp. 291–304 (p. 299).
27. Henry Bial, 'What is Performance'? in *The Performance Studies Reader: Second Edition*, ed. by Henry Bial (Oxon: Routledge, 2007), pp. 59–60 (p. 59).
28. Richard Schechner, *Performance Theory* (Oxon: Routledge Classics, 2003), p. 186.
29. Erving Goffman quoted in Richard Schechner, *Between Theatre & Anthropology* (Philadelphia: University of Pennsylvania Press, 1985), p. 311.
30. Richard Schechner, *Between Theatre & Anthropology*, p. 308.
31. Richard Schechner, *Between Theatre & Anthropology*, p. 311.
32. Schechner makes the point also that inside the 'this is theatre' frame, every imaginable type of behaviour is presented. Depending on the type of theatre, you may find theatrical behaviour, which is interested in presenting the undramatic, (performance art, happenings) or presentations of 'real life' framed as non-theatrical (Newspapers, TV), which specialise in the dramatic. See Richard Schechner, *Between Theatre & Anthropology*, pp. 311–12.
33. Richard Schechner, *Between Theatre & Anthropology*, p. 37.
34. Richard Schechner, *Between Theatre & Anthropology*, p. 36.
35. Richard Schechner, *Between Theatre & Anthropology*, p. 35.
36. Jimmy Carr and Lucy Greeves, *The Naked Jape*, p. 129.
37. Phil Berger, *The Last Laugh: The World of Stand-up Comics* (New York: Cooper Square Press, 2000), p. 279.
38. Phil Berger, *The Last Laugh*, p. 79.
39. Alison Oddey, *Performing Women* (London: Macmillan Press, 1999), p. 21.
40. Oliver Double, *Getting the Joke*, p. 237.
41. Christina Patterson, 'Dylan Moran: I Am a Bit of a Bumbling Man As You Can Tell', *Independent*, 16 October 2009, www.independent.co.uk/arts-entertainment/interviews/dylanmoran (accessed 16 October 2009).
42. Tommy Tiernan, Unpublished Interview with the Author, 15 June 2007.
43. Jimmy Carr and Lucy Greeves, *The Naked Jape*, p. 129.
44. Oliver Double, *Getting the Joke*, pp. 244–5.
45. Oliver Double, *Getting the Joke*, p. 245.
46. Neal R. Norrick, 'On the Conversational Performance of Narrative Jokes: Toward an Account of Timing', *Humor,* 3:14 (2001), 255–73 (p. 256).
47. Jimmy Carr and Lucy Greeves, *The Naked Jape*, p. 129.
48. Rebecca Emlinger Roberts, 'Standup Comedy and the Prerogative of Art', *The Massachusetts Review* 41:2 (2000), 151–60 (p. 157).
49. Rebecca Emlinger Roberts, 'Standup Comedy and the Prerogative of Art', p. 157.
50. Brian Logan, 'Be Truthful – and Funny Will Come', *Guardian*, 9 August 2004, Arts Pages, p. 13.
51. Oliver Double, *Getting the Joke*, p. 97.
52. Tommy Tiernan, 15 June 2007.

53. Tony Allen, *Attitude: Wanna Make Something of It? The Secret of Stand-Up Comedy* (Glastonbury: Gothic Image Publications, 2002), p. 28.
54. Tony Allen, *Attitude: Wanna Make Something of It?*, p. 27.
55. Oliver Double, *Getting the Joke*, p. 100.
56. Jimmy Carr and Lucy Greeves, *The Naked Jape*, p. 131.
57. Tony Allen, *Attitude: Wanna Make Something of It?* pp. 35–6.
58. Oliver Double, *Getting the Joke*, p. 59.
59. Phil Berger, *The Last Laugh*, pp. 416–24.
60. Phil Berger, *The Last Laugh*, pp. 423–4.
61. Phil Berger, *The Last Laugh*, p. 423.
62. While comedic styles can be as various and diverse as the comedians themselves, there is some agreement within the world of stand-up that aspects of the comic's own self always inform the work, whatever the comedic style.
63. Jeremy Hardy quoted in Oliver Double, *Getting the Joke*, p. 82.
64. Tommy Tiernan, 15 June 2007.
65. Eelka Lampe, 'Rachel Rosenthal Creating Her Selves', p. 296.
66. Richard Schechner, *Between Theatre & Anthropology*, p. 37.
67. Richard Schechner, *Between Theatre & Anthropology*, p. 110.
68. Eelka Lampe, 'Rachel Rosenthal Creating Her Selves', p. 303.
69. Tony Allen, *Attitude: Wanna make something of it?* p. 35.
70. Jimmy Carr and Lucy Greeves, *The Naked Jape*, p. 115.
71. Tony Allen, *Attitude: Wanna Make Something of It?*, p. 35.
72. Oliver Double, *Getting the Joke*, p. 116.
73. Jimmy Carr and Lucy Greeves, *The Naked Jape*, pp. 129–31.
74. Richard Schechner, *Between Theatre & Anthropology*, p. 37.
75. Ciarán Benson, *The Cultural Psychology of Self*, p. 46.
76. Ciarán Benson, *The Cultural Psychology of Self*, p. 45.
77. Michel Foucault and Jay Miskowiec, 'Of Other Spaces', *Diacritics*, 16:1 (1986), 22–7 (p. 23).
78. Michel Foucault and Jay Miskowiec, 'Of Other Spaces', p. 24.
79. Michel Foucault and Jay Miskowiec, 'Of Other Spaces', p. 27.
80. Jimmy Carr and Lucy Greeves, *The Naked Jape*, p. 246.
81. Peter Crawley, 'A weekend at Kilkenny Cat Laughs', *The Irish Times*, 3 June 2009, http://www.irishtimes.com/newspaper/features/2009/0603/1224247945413.html (accessed 29 March 2010).
82. Tommy Tiernan, 15 June 2007.
83. Tommy Tiernan, 15 June 2007.
84. Keith Duggan, 'Testament According to Tommy', *The Irish Times*, 4 April 2009, http//www.irishtimes.com/newspaper/weekend/2009/0404/1224243990676.html (accessed 23 March 2010).
85. The study of play occupies a vast territory. Erving Goffman's concept of framing, through which to understand notions of play behaviour, is widely recognised. Richard Schechner's discussions on playing are far-reaching, Schechner describes the 'play net', to explicate his ideas on playing in culture and performance. Models and explorations of what constitutes playing are also prevalent in the diverse fields of anthropology, psychology, and philosophy. This is not all that play is; rather this constitutes a sample of the depth of knowledge that exists around ideas of playing in a culture. For an introduction to ideas of play, see *Performance Analysis: An Introductory Coursebook*,

ed. by Colin Counsell and Laurie Wolf (Oxon: Routledge, 2001). See also Richard Schechner, *Performance Studies: An Introduction* (London: Routledge, 2002) and Richard Schechner, *Performance Theory* (Oxon: Routledge, 2005).

86. Johan Huizinga, *Homo Ludens: A Study of the Play Element in Culture* (London: Routledge, 1980) pp. 13–20.

87. Johan Huizinga, *Homo Ludens*, p. 6.

88. Sophie Quirk 'Who's In Charge?: Negotiation, Manipulation and Comic Licence in the Work of Mark Thomas', *Comedy Studies*, 1:1 (2010), 113–24 (p. 116).

89. Schechner also takes issue with aspects of Huizinga's failure to take into account the function of play For a full discussion, see Richard Schechner, *Performance Theory*, pp. 100–1; Peter L. Berger, *Redeeming Laughter: The Comic Dimension of Human Experience* (Berlin and New York: De Gruyter, 1997), pp. 12–14; and Sophie Quirk, 'Who's In Charge?', p. 116.

90. Michel Foucault and Jay Miskowiec, 'Of Other Spaces', p. 24.

91. Sophie Quirk 'Who's In Charge?', p. 116.

92. John Morreall in Sophie Quirk, 'Who's In Charge?', p. 116. For further discussion, see Simon Critchley, *On Humour: Thinking in Action* (Oxon: Routledge, 2002), pp. 87–8; Henri Bergson, *Laughter: An Essay on the Meaning of the Comic*, trans. by Cloudesley Brereton and Fred Rothwell B.A (UK: Kessinger Publishing, [n.d.],) pp. 4–5.

93. Mary Douglas, 'Jokes', in *Implicit Meanings* (London: Routledge, 1999), pp. 150–1.

94. Mary Douglas, 'Jokes', pp. 152–9.

95. Mary Douglas, 'Jokes', p. 159.

96. Sophie Quirk, 'Who's In Charge?', p. 118.

97. Sophie Quirk, 'Who's In Charge?', p. 113.

98. Brian Boyd, 'It Was Just Unreal. All I Could Do Was Keep Gigging. And Take My Beating', *The Irish Times Weekend Review*, 27 November 2010, p. 7.

99. Brian Boyd, 'It Was Just Unreal. All I Could Do Was Keep Gigging. And Take My Beating'.

100. Sophie Quirk, 'Who's In Charge?', p. 117.

101. Oliver Double, *Getting the Joke*, pp. 150–1.

102. There is perhaps no better cautionary tale than that of Lenny Bruce. Bruce's career was all but destroyed by his breaking the rules of acceptable comedy in 1950s and 1960s America. Bruce was arrested several times for using 'obscene' material in his acts, making it increasingly difficult to secure work. The comic became embroiled in legal wrangling surrounding his arrests and had one conviction for obscenity. His final performances were filled with bitter rants about his legal struggle. He died in 1966 of a morphine overdose and 'as a final insult, police allowed photographers to take pictures of his corpse.' His conviction was quashed 18 months later. See Oliver Double, *Getting the Joke*, p. 163.

103. Tony Allen, *Attitude: Wanna Make Something of It?*, p. 36.

104. Keith Duggan, 'Testament According to Tommy', *The Irish Times*, 4 April 2009.

105. Lawrence E. Mintz, 'Standup Comedy as Social and Cultural Mediation', *American Quarterly*, 37 (1985), 71–80 (p. 75).

106. Lawrence E. Mintz, 'Standup Comedy as Social and Cultural Mediation', p. 75.

107. For a more comprehensive discussion on the trickster, see Carl Jung, *The Archetypes and the Collective Unconscious*, trans. by R.F.C. Hull, 2nd edn (London: Routledge, 2006), pp. 257–60. See also Jimmy Carr and Lucy Greeves, *The Naked Jape: Uncovering The Hidden World of Jokes* (London: Penguin, 2006), pp. 41–2.
108. Tony Allen, *Attitude: Wanna Make Something of It?*, pp. 51–3.
109. Michael Billig, *Laughter and Ridicule: Towards a Social Critique of Humour* (London: Sage Publications, 2005), p. 3.
110. Michael Billig, *Laughter and Ridicule*, p. 2.
111. Michael Billig, *Laughter and Ridicule*, p. 2.
112. Michael Billig, *Laughter and Ridicule*, p. 243.
113. Andrew Stott, *Comedy: The New Critical Idiom* (Oxon: Routledge, 2005), p. 60.
114. Richard Schechner, 'The End of Humanism', *PAJ*, 4:1/2 (1979), 9–22 (pp. 12–13).
115. Philip Auslander, 'Postmodernism and Performance', in *The Cambridge Companion to Postmodernism*, ed. by Stephen Connor (Cambridge: Cambridge University Press, 2004), pp. 97–113 (p.107).
116. Philip Auslander, 'Postmodernism and Performance', pp. 107–8.

Chapter 3: Messages

1. Tiernan has staged some theatrical set designs for his performance tours; here the set is reminiscent of a school cloakroom with a collection of dramatic and everyday oddments strewn about the stage space.
2. Tommy Tiernan, *Cracked: Live at Vicar Street* (Galway: Mabinog, 2004), 00.50–00.54.
3. As part of this performance, Tiernan builds in a piece about how he came across the 'hippity hoppety' microphone and why he is wearing it on stage.
4. Tommy Tiernan, *Jokerman: Tommy Tiernan in America* (Galway: Mabinog, 2006). Ireland's National Broadcaster, Radio Telefis Éireann (RTÉ), commissioned the documentary.
5. Tommy Tiernan, *Jokerman*, 28.55–29.28.
6. Tommy Tiernan, *Jokerman*, 30.00–30.05.
7. Tommy Tiernan, *Jokerman*, 28.38–28.54.
8. Tommy Tiernan, *Cracked*, 16:02–17:09.
9. Tommy Tiernan, *Cracked*, 51.49–52.00.
10. Tommy Tiernan, *Cracked*, 52.05–52.11.
11. *Lanigan's Ball* is a popular Irish traditional folk song. Tommy Tiernan, *Cracked*, 52.23–52.35.
12. I have entitled this particular routine *Priest for Potato Swap*; it forms part of the larger chapter entitled 'Mighty Mass' on the *Cracked* DVD.
13. Trócaire (meaning mercy in Irish) is the official overseas development agency for the Catholic Church in Ireland. The Trócaire Box is a small cardboard box with a slit in the top, so that it resembles the idea of a moneybox. The box has been distributed widely to Irish households every year for the last forty years or so. The Trócaire box is part of a Lenten campaign to raise monies for overseas development in some of the poorest nations in the world.

14. The Hothouse Flowers were an Irish fusion band popular in the 1990s.
15. Lyrics from The Hothouse Flowers debut single, *Don't Go*, taken off the album *People*, which was first released in 1988.
16. Tommy Tiernan *Cracked*, 52.58–58.41.
17. Simon Critchley, *On Humour: Thinking in Action* (Oxon: Routledge, 2002) p. 4.
18. Simon Critchley, *On Humour*, p. 4.
19. Simon Critchley, *On Humour*, p. 4.
20. Tony Allen, *Attitude: Wanna Make Something of It? The Secret of Stand-Up Comedy* (Glastonbury: Gothic Image Publications, 2002) p. 42.
21. Oliver Double, *Getting the Joke: The Inner Workings of Stand-Up Comedy* (UK: Methuen Drama, 2005), p. 207.
22. Tony Allen, *Attitude: Wanna Make Something of It?*, p. 42.
23. Oliver Double, *Getting the Joke*, p. 208.
24. Susanne Colleary, 'God's Comic,' in *Staging Thought: Essays on Irish Theatre, Scholarship and Practice*, ed. by Rhona Trench (Bern: Peter Lang, 2012), pp. 153–69 (pp. 155–6).
25. Tommy Tiernan, *Unpublished Interview with the Author*, 15 June 2007.
26. Tommy Tiernan, 15 June 2007.
27. Tommy Tiernan, 15 June 2007.
28. The theory of humour as incongruity can be traced as far back as Francis Hutcheson's *Reflections upon Laughter* in 1750. Immanuel Kant, the Earl of Shaftsbury and Arthur Schopenhauer also made significant contributions to incongruity theories. For a comprehensive treatment of the three classic theories of humour, see Michael Billig, *Laughter and Ridicule: Towards a Social Critique of Humour* (London: Sage Publications, 2005), pp. 37–110. Other works of interest are Andrew Stott, *Comedy: The New Critical Idiom* (Oxon: Routledge, 2005), pp. 127–45, and Peter L. Berger, *Redeeming Laughter: The Comic Dimension of Human Experience* (Berlin and New York: De Gruyter, 1997). See also Simon Critchley, *On Humour*, pp. 3–6.
29. Simon Critchley, *On Humour*, p. 3.
30. Cynthia True, *American Scream: The Bill Hicks Story* (London: Sidgwick & Jackson, 2002), p. 178.
31. The DVD contains footage of a version of the *Priest for Potato Swap* routine at the Gesu Centre de Créativité (Just for Laughs, the Montreal International Comedy Festival).
32. Tommy Tiernan, *Loose* (Galway: Mabinog, 2005), 1.16–1.24.
33. This running order represents the 'chapters' on the *Loose* DVD; as such, it is an amalgamation of the many live performances that make up the *Loose* tour.
34. Gemma O'Doherty, 'Dublin's Olympic Dreamers', *Irish Independent*, 9 July 2005, http://www.independent.ie/opinion/analysis/dublins-olympic-dreamers-248807.html (accessed 29 January 2011).
35. Gemma O'Doherty, 'Dublin's Olympic Dreamers.'
36. Tommy Tiernan, *Loose*, 104.27–111.48.
37. Bert O. States, *Great Reckonings in Little Rooms: On the Phenomenology of Theater* (London: University of California Press, 1985), p. 173.
38. See Susanne Colleary, 'God's Comic', pp. 162–3.
39. See Bert O. States, 'The Actors Presence: Three Phenomenal Modes', *Theatre Journal*, 35 (1983), 359–75 (p. 359). Also Bert O. States, *Great Reckonings in Little Rooms*, pp 170–82 (p. 181).

40. Bert O. States, *Great Reckonings in Little Rooms*, pp. 160–70.
41. Bert O. States, *Great Reckonings in Little Rooms*, p. 164.
42. At the Olympic Games in Athens in 2004, Cian O'Connor won an individual show jumping gold medal on the horse Waterford Crystal for Ireland. The medal was subsequently taken from O'Connor due to drug offences. After a urine sample, A, tested positive for a banned substance in Athens, a second urine sample was stolen in the UK. However, the second blood sample, B, confirmed the earlier findings. Although O'Connor has always denied any wrongdoing, he was "banned for three months for breaching medication regulations... the FEI said it was satisfied that Cian O'Connor was not involved in a deliberate attempt to influence the performance of the horse." See 'O'Connor Loses Olympic Gold Medal', *RTE News*, 27 March 2005, http://www.rté.ie/news/2005/0327/61345-oconner/.html (accessed 15 November 2013).
43. Oliver Double, *Getting the Joke*, p. 217.
44. This idea of 'instant characterisation' as Double describes has been dealt with in many other ways from within theatre, drama and performance discourse. Bert O. States's representational mode could be applied here, as could Schechner's 'restored behaviour' model as discussed, to give two examples. In addition, that sense of moving in and out of character or personification can be applied to many of Tiernan's 'snapshot characterisations', throughout all his performance works, it is a well-established aspect of the performance form of stand-up comedy and more widely in other performance disciplines. I draw particular attention to it here, as I am interested in looking at Tiernan's treatment of animal characterisation in *Drug Olympics*. See Oliver Double, *Getting the Joke*, p. 217, Richard Schechner, *Between Theatre & Anthropology*, pp. 35–8, Bert O. States, *Great Reckonings in Little Rooms*, pp. 160–97.
45. Simon Critchley, *On Humour*, p. 25.
46. Simon Critchley, *On Humour*, p. 25.
47. Briefly, Helmuth Plessner's argued that laughter confirms that humans are *eccentric* and that 'the humanity of the human' is irrevocably bound to the curse of reflection. In other words, humans have the singular ability to occupy a critical position in relation to oneself, a position that often inspires laughter at oneself or indeed others. This is a position that cannot be occupied by animals although there are those who disagree with Plessner's thinking, including among others, Simon Critchley and Mary Douglas. See Helmuth Plessner, *Laughing and Crying*, trans by James Spencer Churchill and Marjorie Grene (Illinois: Northwestern University Press, 1970), Simon Critchley, *On Humour*, pp. 25–38, Andrew Stott, *Comedy*, pp. 11–12.
48. Simon Critchley, *On Humour*, pp. 29–34.
49. Smith was never stripped of the three gold and one bronze medal that she won at the Atlanta Olympics in 1996 (rather than the Los Angeles Olympics suggested by Tiernan). Smith had passed all drugs testing during those games. However, her success was mired by consistent accusations and investigations about her alleged drug taking following her success in Atlanta. Subsequent tests were carried out and in 1998, "swimming worlds governing body banned her from competition for four years after finding

that she had manipulated a drug test by spiking her urine sample with alcohol." That ban may have effectively ended her swimming career, however, Smith has always maintained her innocence; unsurprisingly, she does not speak of her experiences and is currently practicing as a barrister at law in Ireland. See Jere Longman, 'Swimming; Olympic Swimming Star Banned; Tampering With Drug Test Cited', *New York Times*, 7 August 1998, http://www.nytimes.com/1998/08/07/sports/swimming-olympic-swimming-star-banned-tampering-with-drugs-test-cited.html (accessed 15 November 2013); Séan Fay, 'London 2012 – Where Are They Now? Michelle Smith', *Eurosport*, 29 February 2012, http://eurosport.yahoo.com/29022012/58/london-2012-michelle-smith.html (accessed 15 November 2013).

50. Simon Critchley, *On Humour*, p. 7.
51. This is a method that many comics use on a regular basis; on the other hand comics can usurp these conventions at will. Certainly, Tiernan, Moran and Higgins have done so through the performance works under discussion in these pages.
52. Russian theorist Mikhail Bakhtin introduced the theory of carnival in his book *Rabelais and His World*, written in the 1930s and published in 1965. Embodied in the free space of marketplace, although sanctioned by the hegemonic order, the laughter of carnival can be represented as ambivalence towards official culture, so we understand that 'in the carnival, dogma, hegemony and authority are dispersed through ridicule and laughter.' Within the itinerary of carnival festivities we encounter a ludic celebration of macabre humour (pregnant Death) and the grotesque body, which Bakhtin believed, contrary to Gnostic ideology, held the promise of true salvation. Bakhtin's belief in 'grotesque realism' proclaims to the world that the power of carnivalistic laughter is trans-temporal and universal, but that the carnival free space of play is the place in which the 'drama of the body' is enacted by and for the populace. Bakhtin argued for the 'The drama of birth, coitus, death, growing, eating drinking, and evacuation. This corporeal drama applies not to the private, individual body, but rather to the larger collective one of the folk.' It is within the free space and free time that is the carnival space of play that a 'myth of ambivalence' is created that denies death in and through the power of laughter. For further discussions on Bakhtin's concept of carnival see Mikhail Bakhtin, *Rabelais and his World*, trans. by Helene Iswolsky trans. By Helene Iswolsky (Bloomington: Indiana University Press, 1984). Also, see Renate Lachmann, Raoul Eshelman, and Marc Davis, 'Bakhtin and Carnival: Culture as Counter-Culture', *Cultural Critique*, 11 (1988-1989), 115-152 (pp. 124–30).
53. Bert O. States, *Great Reckonings in Little Rooms*, p. 175.
54. Peter Berger quoted in Simon Critchley, *On Humour*, p. 17.
55. Simon Critchley, *On Humour*, pp. 17–18.
56. Thomas Nagel quoted in Bob Plant, 'Absurdity, Incongruity and Laughter', *Philosophy*, 84 (2009), 111–34 (p. 131).
57. See Bob Berky and Claude Barbre, 'The Clown's Use of Empathy: An interview with Bob Berky', *Journal of Religion and Health*, 39 (2000), 239–46 (p. 245).
58. Tommy Tiernan, 15 June 2007.
59. Keith Duggan, 'Testament according to Tommy', *The Irish Times*, 4 April 2009.

60. Ken Sweeney, "'Six million? I would have got 10 or 12 million out of that'", *Sunday Tribune*, 20 September 2009, http://www.tribune.ie/article/2009/sep/20 six-million-i-would-have-got 10-or-12-million-out.html (accessed 14 February 2010).
61. Ken Sweeney, "'Six Million?'"
62. Pamela Newenham, 'Tiernan off Canadian Comedy Tour', *The Irish Times*, 10 October 2009, http:www.irishtimes.com/newspaper/breaking/2009/1009/breaking41.html (accessed 30 March 2010).
63. Pamela Newenham, 'Tiernan off Canadian Tour.'
64. Keith Duggan, 'Testament according to Tommy.'
65. Peter Crawley, 'A weekend at Kilkenny Cat Laughs', *The Irish Times*, 3 June 2009, http://www.irishtimes.com/newspaper/features/2009/0603/1224247945413.html (accessed 29 March 2010).
66. Peter Crawley, 'A Weekend at Kilkenny Cat Laughs.'
67. Peter Crawley, 'A Weekend at Kilkenny Cat Laughs.'
68. Keith Duggan, 'Testament According to Tommy.'
69. Ken Sweeney, "'Six Million?'"
70. Tommy Tiernan, 'Navan Man – Bovinity Tour', *Bovinity* (Galway: Mabinog, 2008), 16.40–18.28.
71. Gay Byrne is a veteran radio and television broadcaster in Ireland. As I mentioned above, Byrne hosted *The Late Late Show* from the show's inception in 1962 until he retired from the programme in 1999. He has continued his broadcasting career on several other radio and television programmes. He is currently the chairperson for the Road Safety Authority (RSA). Mr Byrne is something of a national treasure, and is still affectionately known as Uncle Gay, a throwback term to *The Gay Byrne Show*, (radio) which ran from 1972 to 1999. For more information on the '*Meaning of Life*' television programme and Tiernan's interview with Gay Byrne, http://see www.rte.ie/tv/meaningoflife/programmes.html (accessed 1 September 2013).
72. Jimmy Carr and Lucy Greeves, *The Naked Jape: Uncovering The Hidden World of Jokes* (London: Michael Joseph/Penguin Books, 2006), p. 258.
73. Tommy Tiernan, 15 June 2007.
74. This line refers back to an earlier part of the scenario about flying body parts.
75. Tommy Tiernan, *Filmed by the author at the Axis Centre, Ballymun, Dublin*, 6 July 2007, 08.57–11.18.
76. Tommy Tiernan, 6 July 2007, 11.29–12.24.
77. Tommy Tiernan, 6 July 2007.
78. Jimmy Carr and Lucy Greeves, *The Naked Jape*, p. 192.
79. Jimmy Carr and Lucy Greeves, *The Naked Jape*, p. 195.
80. Jimmy Carr and Lucy Greeves, *The Naked Jape*, p. 196.
81. Tommy Tiernan, 6 July 2007, 42.15–45.17.
82. Tommy Tiernan, 6 July 2007, 00.03–00.25.
83. Tiernan, 15 June, 2007.
84. Tommy Tiernan, 6 July 2007, 44.44–44.50.
85. Tommy Tiernan, 6 July 2007, 44.44–44.50.
86. Philip Auslander, *From Acting to Performance: Essays in Modernism and Postmodernism* (New York: Routledge, 1997), p. 111. Ideas of status in stand-up comedy are central to the comic-audience exchange and are operating

in one way or another through all the comedy in these pages. I draw attention here particularly because of the way in which Tiernan emphasises that game of dominance and submission in this scenario.

87. Keith Johnstone, *Impro for Storytellers: Theatresports and the Art of Making Things Happen* (London: Faber and Faber, 1999), p. 219.
88. Richard Kearney, *On Stories: Thinking in Action*, ed. by Simon Crtichley and Richard Kearney (London, Routledge, 2002), p. 4.
89. Smith and Watson cited in Catherine McLean-Hopkins, 'Performing Autologues: Citing/Siting the Self in Autobiographic Performance', in *Monologues: Theatre, Performance, Subjectivity* ed. by Clare Wallace (Czech Republic: Litteraria Pragensia, 2006), pp. 185–207 (p.194).
90. Kristin M. Langellier, 'Personal Narrative, Performance and Performativity: Two or Three Things I Know For Sure', *Text and Performance Quarterly*, 19:2 (1999), 125–44 (p. 129).
91. I borrow the term from Richard Bruner, *Making Stories: Law Literature Life* (London: Harvard University Press, 2003), p. 65.
92. The comic Ellen DeGeneres readily admits that the thought of people coming to see her time and again scares her, for her the 'whole secret of stand-up is that the audience really think it's something brand new.' Quoted in Oliver Double, *Getting the Joke*, p. 179.
93. Michel Foucault and Jay Miskowiec, 'Of Other Spaces', *Diacritics*, 16:1 (1986), 22–7 (p. 24).
94. Dee Heddon, 'Beyond the Self: Autobiography as Dialogue', in *Monologues: Theatre, Performance Subjectivity*, ed. by Clare Wallace (Czech Republic: Litteraria Pragensia, 2006), pp. 157–84 (p. 162).
95. Tommy Tiernan, *Loose* (Galway: Mabinog, 2005) 09.19–13.26.
96. Nina Witoszek and Pat Sheeran, *Talking to the Dead: A study of Irish Funerary Traditions* (Amsterdam and Atlanta, GA: Rodopi, 1998), p. 108.
97. Nina Witoszek and Pat Sheeran, *Talking to the Dead*, p. 109.
98. Leszek Kolakowski quoted in Nina Witoszek and Pat Sheeran, *Talking to the Dead*, pp. 115–16.
99. Nina Witoszek and Pat Sheeran, *Talking to the Dead*, p. 107.
100. Nina Witoszek and Pat Sheeran, *Talking to the Dead*, p. 162.
101. Nina Witoszek and Pat Sheeran, *Talking to the Dead*, p. 122.
102. Tommy Tiernan, *Loose* (Galway: Mabinog, 2005) 09.19–13.26.
103. Dee Heddon, 'Beyond the Self: Autobiography as Dialogue', p. 167.
104. Jill Dolan cited in Dee Heddon, 'Beyond the Self: Autobiography as Dialogue', p. 166.
105. Dee Heddon, 'Beyond the Self: Autobiography as Dialogue', p. 182.
106. Keith Duggan, 'Testament according to Tommy.'

Chapter 4: Everybody Knows That
The Dice Are Loaded

1. Leonard Cohen and Sharon Robinson, 'Everybody Knows', *I'm Your Man* (USA: Columbia Records, 1988).
2. Dylan Moran, 'Cartoon Gallery', *Monster: Live* (UK: Universal Pictures, 2004).
3. Dylan Moran, 'Cartoon Gallery', *Monster*, 2004.

4. Dylan Moran, *Monster*, 02.26–02.47.
5. Dylan Moran, *Monster*, 02.55–03.09.
6. Dylan Moran, *Monster*, 03.17–03.40.
7. Dylan Moran, *Monster*, 03.44– 03.49.
8. Dylan Moran, *Monster*, 04.08–04.41.
9. Stephanie Merritt, 'Ranting at the Modern World: It's That Bloody Irishman Rambling in the Bar Again...', *Guardian*, 18 April 2004, www.guardian.co.uk/ theobserver/2004/arp/18/features.review57 (accessed 03.01.2010).
10. Dylan Moran, 'Dylan Moran at Comic Aid 2005', http://www.youtube.com/ watch?V=-j3qzAUCREo (accessed 4 July 2010).
11. Veronica Lee, 'Dylan Moran, Apollo', 30 October 2009, http://www.theartsdesk. com/indes.php?option=com (accessed 1 Decmber 2010).
12. Dylan Moran, *Monster*, 05.05–06.36.
13. Dylan Moran, *Monster*, 06.39–09.39.
14. Christina Patterson, 'Dylan Moran: I Am a Bit of a Bumbling Man as You Can Tell', *Independent* , 16 October 2009, www.independent.co.uk/arts-entertainment/ interviews/dylanmoran (accessed 12 June 2010).
15. Jimmy Carr and Lucy Greeves, *The Naked Jape: Uncovering The Hidden World of Jokes* (London: Penguin, 2006) pp. 131–2.
16. Jimmy Carr and Lucy Greeves, *The Naked Jape*, p. 139.
17. Jimmy Carr and Lucy Greeves, *The Naked Jape*, p. 140.
18. Jimmy Carr and Lucy Greeves, *The Naked Jape*, p. 140.
19. Samuel Beckett, *Molloy, Malone Dies, The Unnameable* (Picador, London, 1979), p. 30, quoted in Simon Critchley, *On Humour: Thinking in Action* (Oxon: Routledge, 2002), p. 49.
20. Simon Critchley, *On Humour*, p. 49.
21. Simon Critchley, *On Humour*, p. 50.
22. Dylan Moran, 'Image Gallery', *like, totally...* (UK: Universal Studios, 2006).
23. Dylan Moran, *like, totally...*, 57.39–58.20.
24. The first line of this scenario is referring to some of Moran's previous observations in the performance.
25. Dylan Moran, *What It Is: Live* (UK: Universal Pictures, 2009), 32.08–37.10.
26. Simon Critchley, *On Humour*, pp. 11–12. At times here, Moran is emphasising a heterosexual relationship or perspective. More generally Moran's material has dealt with the subject matter of gender and sexuality and in a number of ways. In 2012, Moran played two nights at Chaplin Hall in St Petersburg, and he is apparently the first English-speaking professional comedian to do so. During those performances Moran did attempt to cover the city's controversial new laws, which ban 'homosexual propaganda,' albeit that sections of the set were lost in translation. In other parts of this performance, Moran tells the audience that too much is made of gender lines and that the aging process finally dissolves constructions of difference. Moran tells the audience that his own behaviour is becoming increasingly feminised, as he gets older. He admits that he has never spoken the language of 'hammer or pipe' and that he has urges that include smearing his wife's expensive creams on his knees just to see what happens. He blocks the bedroom door with Turkish Delight, listens to show tunes, eats chocolates and watches Jane Austen adaptations 'Oh him he's lovely, I don't like the other fella... Oh look, the lovely one's on a horse, mmm, ooh, hee hee.' Moran

tells the audience that he doesn't 'give a shit', that his urges and behaviour, as he grows older, are completely natural.

27. Jimmy Carr and Lucy Greeves, *The Naked Jape*, p. 132.
28. Jane Gullet, http://www.leftlion.co.uk/articles.cfm?id=2292 (accessed 1 December 2010).
29. Tony Allen, *Attitude: Wanna Make Something of It? The Secret of Stand-Up Comedy* (Glastonbury: Gothic Image Publications, 2002) p. 42.
30. Karl Valentin was a famous German cabaret performer, both before and during the war years in Germany, and he numbered both Bertolt Brecht and Adolf Hitler among his fans. Wilson and Double read Valentin's performance style for its subversive qualities and use of the Brechtian alienation effect. See Oliver Double and Michael Wilson, 'Karl Valentin's Illogical Subversion: Stand-up Comedy and Alienation Effect', *NTQ*, 20:3 (2004), 203–15.
31. Bertolt Brecht, cited in Oliver Double and Michael Wilson, 'Karl Valentin's Illogical Subversion' p. 214.
32. Peter L. Berger, *Redeeming Laughter: The Comic Dimension of Human Experience* (Berlin and New York: De Gruyter, 1997), p. 207. Berger also links the comic to ideas of transcendence, which is not entirely unrelated to my discussion of Tiernan in the last chapter.
33. Critchley talks of the *sensus communis* as a Roman concept that was first linked to the idea of humour by the Earl of Shaftsbury in 1709. See Simon Critchley, *On Humour*, p. 80.
34. Simon Critchley, *On Humour*, p.18.
35. I have discussed this in Chapter 2 also. See Michael Billig, *Laughter and Ridicule: Towards a Social Critique of Humour* (London: Sage Publications, 2005).
36. Simon Critchley, *On Humour*, p. 18.
37. Simon Critchley, *On Humour*, pp. 18–19, p. 90.
38. Julian Hall, 'Dylan Moran: Monster I, Wyndham's Theatre, London', *Independent*, 8 November 2004, http://www.independent.co.uk/arts-entertainment/theatre-dance/reviews/dylan-moran-monster-i-wyndhams-theatre-london-532415.html (accessed 3 January 2010).
39. Dylan Moran, 'Image Gallery', *like, totally...*
40. Dylan Moran, *What It Is*, 55.43–58.55.
41. Stephanie Merritt, 'Ranting at the Modern World.'
42. Dylan Moran, *What It Is*, 1.08.35–1.10.18.
43. Bob Monkhouse once said that an audience is 'not a community... the comic may impose a temporary bonding but it vanishes as soon as people disperse.' See Bob Monkhouse, *Over the Limit: My Secret Diaries 1993–8* (London: Century, 1998), p. 85.
44. Oliver Double, *Getting the Joke: The Inner Workings of Stand-Up Comedy* (UK: Methuen Drama, 2005) p. 146.
45. Johan Huizinga quoted in Simon Critchley, *On Humour*, p. 41.
46. Peter L. Berger, *Redeeming Laughter*, p. 209.
47. Simon Critchley, *On Humour*, pp. 42–3.
48. Simon Critchley, *On Humour*, p. 44.
49. Oliver Double, *Getting the Joke*, p. 175.
50. Dylan Moran, *What It Is*, 1.11.35–1.11.58.
51. Dylan Moran, *What It Is*, 1.16.12–1.16.20.

52. Christina Patterson, 'Dylan Moran: I Am a Bit of a Bumbling Man As You Can Tell.'

53. Tommy Tiernan, 'Interview', *Tommy Tiernan: Live* (UK: Universal, 2002), 3.03–4.12.

54. Tommy Tiernan, 'London Interview', *Cracked: Live at Vicar Street* (Galway: Mabinog, 2004).

55. Julian Hall, 'Stand-up: Dylan Moran takes on the world', *Independent*, 23 September 2008, http://www.independent.co.uk/arts-entertainment/comedy/features/938570.html (accessed 12 December 2010).

56. Stephen Armstrong, 'Comedy Trio: The Three Fellas live are bringing the house down', *Sunday Times*, 1 June, 2008, http://entertainment.timesonline.co.uk/tol/arts_and_entertainment/stage/comedy/article4025189.ece (accessed 1 December 2010).

57. Moran's comedy does navigate between a more personalised and broader observational style, which expresses his feelings, opinions, attitudes and points of view as performance. That blended style can be played near to or further away from the idea of immediate or personal experience in Moran's comedy. Understanding Moran's comedy in this way accommodates a way to speak of the self in the stand-up form as it encompasses Moran's comedic technique. In addition, I suggest that although Moran's work is more heavily observational than that of either Tiernan or Higgins, all three use observational comedy to various degrees. As discussed in detail in Chapter 2, Schechner's performance model has the capacity to accommodate the self as it plays with both personal and observational styles of stand-up comedy.

58. Elinor Ochs and Lisa Capps, 'Narrating the Self', *Annual Review of Anthropology*, 25 (1996), 19–43 (p. 19).

59. Paul Eakin cited in Catherine McLean-Hopkins, 'Performing Autologues: Citing/Siting the Self in Autobiographic Performance', in *Monologues: Theatre, Performance, Subjectivity*, ed. by Clare Wallace (Czech Republic: Litteraria Pragensia, 2006), pp. 185–207 (p. 189).

60. Franklyn Ajaye, *Comic Insights: The Art of Stand-up Comedy* (Los Angeles: Silman James Press, 2002), p. 36.

61. Oliver Double, *Getting the Joke*, pp. 73–81.

62. Even the perceived distance between character comedians and their comic creations collapses under the weight of the comedians' own opinions, with a general consensus (certainly among contemporary comedians) that aspects of themselves always inform and inhabit their characterisations.

63. Smith and Watson cited in Catherine McLean-Hopkins, 'Performing Autologues: Citing/Siting the Self in Autobiographic Performance', p. 194.

64. Lawrence E. Mintz, 'Standup Comedy as Social and Cultural Mediation', *American Quarterly*, 37 (1985), 71–80 (p. 77).

65. Trevor Griffiths, *Comedians* (London: Faber, 1976), p. 20.

66. Stephen Armstrong, 'Comedy Trio: The Three Fellas Live Are Bringing the House Down.'

67. Julian Hall, 'Stand-up: Dylan Moran Takes on the World', *Independent*, 23 September, 2008, http://www.independent.co.uk/arts-entertainment/comedy/features/938570.html (accessed 12 December 2010).

68. Stephen Armstrong, 'Comedy Trio: The Three Fellas Live Are Bringing the House Down'.
69. Northrop Frye, 'The Argument of Comedy', in *Comedy: Developments in Criticism*, ed. by D.J. Palmer (Houndmills: Macmillan, 1984), pp. 74–84 (p.76).
70. The surrealist André Breton coined the term 'humour noir' in his *Anthologie de l'humour noir*, first published in 1939. Here, Breton is quoted in Patrick O'Neill, 'The Comedy of Entropy: The Contexts of Black Humour,' *Canadian Review of Comparative Literature*, 10:2 (1983), 145–66 (p. 154).
71. Nina Witoszek and Pat Sheeran, *Talking to the Dead: A Study of Irish Funerary Traditions* (Amsterdam and Atlanta GA: Rodopi, 1998), p. 126.
72. Samuel Beckett, *Watt* (Calder, London, 1970), quoted in Simon Critchley, *On Humour*, [n.p.d.].
73. The comedian and actor Kenneth Williams recorded these final words in his diary before taking his own life.
74. Brian Logan, 'Dylan Moran: Apollo, London', *Guardian*, 1 November 2009, http://www.guardian.co.uk/stage/2009/nov/01/dylan-moran-review.html (accessed 3 January 2010).
75. Nigel Farndale, 'Have I Had Therapy? I Went to Yoga Once', *Telegraph*, 27 August 2006, http://www.telegraph.co.uk/culture/3654902.html (accessed 15 January 2010].
76. Bob Plant, 'Absurdity, Incongruity and Laughter', *Philosophy*, 84 (2009), 111–34, (p. 132).
77. Bob Plant, 'Absurdity, Incongruity and Laughter', p. 133.
78. Martin Esslin, *The Theatre of the Absurd* (New York: Vintage, 2004), pp. 23–4.
79. Albert Camus quoted in Bob Plant, 'Absurdity, Incongruity and Laughter', p. 116.
80. Della Pollock quoted in Dee Heddon, 'Beyond the Self: Autobiography as Dialogue', p. 183.
81. Richard Kearney, *On Stories: Thinking in Action*, ed. by Simon Critchley and Richard Kearney (London: Routledge, 2002), p. 3.
82. See Bert O. States, 'The Actors' Presence: Three Phenomenal Modes', *Theatre Journal*, 35 (1983), 359–75 (p. 359). Also Bert O. States, *Great Reckonings in Little Rooms*, pp 170–82 (p. 181).
83. Andrew Stott, *Comedy*, p. 61.

Chapter 5: Revenge of the Buckteeth Girl

1. Maeve Higgins, 'Comedy Gala in Auckland' (New Zealand, 2009), http//www.youtube.com/watch?u=iUwntYUxkWa (accessed 1 January 2011), 00.00–3.23.
2. Maeve Higgins, *Live at Vicar Street*, 5 April 2010, 02.58–6.06.
3. Maeve Higgins, *Unpublished Interview with the Author*, 25 March 2010.
4. Maeve Higgins, 25 March 2010.
5. Jimmy Carr and Lucy Greeves, *The Naked Jape: Uncovering The Hidden World of Jokes* (London: Penguin, 2006) p. 117.
6. Jimmy Carr and Lucy Greeves, *The Naked Jape*, pp. 137–8.

7. Tiernan is also no stranger to using local settings, times and language idioms in his work. Moran does not really inhabit that style of joke telling as much as either Higgins or Tiernan. However, other Irish comics have fully embraced ideas of the local. By way of example Pat Shortt and Jon Kenny's *D'Unbelievables* was hugely popular in Ireland in the 1990s and was very involved in comedy that referred to local place names and stock small town characters familiar to rural Ireland. From a distinctly urban perspective, the stand-up act of Brendan O'Carroll (the creator of the popular situation comedy *Mrs Brown's Boys*) was, at times, based on local stories from his childhood growing up in Dublin's north inner city.

8. Oliver Double, *Getting the Joke: The Inner Workings of Stand-Up Comedy* (UK: Methuen Drama, 2005), p. 125.

9. Oliver Double, *Getting the Joke*, p. 125.

10. Oliver Double, *Getting the Joke*, p. 125.

11. Jimmy Carr and Lucy Greeves, *The Naked Jape*, pp. 141–2.

12. Philip Auslander, 'Brought to you by Fem-Rage: Stand-up Comedy and the Politics of Gender', in *Acting Out: Feminist Performances*, ed. by Lynda Hart and Peggy Phelan (Michigan: University of Michigan Press, 1993), pp. 315–36 (p. 326).

13. Maeve Higgins, 25 March 2010.

14. Maeve Higgins, 25 March 2010.

15. Patrick Freyne, 'Freyne's World', *Sunday Tribune*, 20 September 2009, http://www.tribune.ie/arts/article/2009/sep/20/freynes-world/ (accessed 11 December 2009).

16. John Boland, 'The Gong for Worst Show Goes to...', *Irish Independent*, 19 September 2009, http://www.independent.ie/entertainment/tv-radio.html (accessed 12 December 2009).

17. Maeve Higgins, 'Girlfriends Coming for Dinner!', *Fancy Vittles*, http://www.youtube.com/watch?v=c55IjFnp8CY&feature=related (accessed 12 September 2010), 00.00–00.40.

18. Maeve Higgins, 5 April 2010, 8.08–10.22.

19. Alison Oddey, *Performing Women* (London: Macmillan Press Ltd, 1999), p. 22.

20. Alison Oddey, *Performing Women*, p. 115.

21. Danielle Russell, 'Self Deprecatory Humour and the Female Comic: Self Destruction or Comedic Construction', *Third Space: A Journal of Feminist Theory and Culture*, 2:1 (2002), http://www.thirdspace.ca/articles/druss.html.

22. Philip Auslander, 'Brought to you by Fem-Rage', p. 326.

23. Philip Auslander, 'Brought to you by Fem-Rage', p. 327.

24. Lisa Merrill, 'Feminist Humor: Rebellious and Self-affirming', in *Last Laughs: Perspectives on Women and Comedy*, ed. by Regina Barreca (New York: Gordon and Breach, 1988), pp. 271–80 (p. 279).

25. Lisa Merrill, 'Feminist Humor', p. 277.

26. Lisa Merrill, 'Feminist Humor', p. 277.

27. Alison Oddey, *Performing Women*, p. 22.

28. Alison Oddey, *Performing Women*, p. 111.

29. Maeve Higgins, 5 April 2010, 10.35–10.55.

30. O'Toole's research took place over a year's observation of slimming classes in Ireland. O'Toole notes that it is mainly women who attended slimming classes and that only two men attended the classes during her

observations. See Jackie O'Toole, '"A Danger to Yourself?" Motivational Talks in Group Slimming Classes', in *Ireland of the Illusions: A Sociological Chronicle 2007–2008*, ed. by Mary P. Corcoran and Perry Share (Dublin: IPA, 2010) p. 254.

31. Chris Shilling cited in Jackie O'Toole, '"A Danger to Yourself?"', p. 258.
32. Jackie O'Toole, '"A Danger to Yourself?"', pp. 258–61.
33. Jackie O'Toole, '"A Danger to Yourself?"', p. 268.
34. Jackie O'Toole, '"A Danger to Yourself?"', p. 261.
35. Jackie O'Toole, '"A Danger to Yourself?"', p. 265.
36. Maeve Higgins, 5 April 2010, 6.07–6.41.
37. Maeve Higgins, 5 April 2010, 41.19–43.50.
38. Lisa Merrill, 'Feminist Humor', pp. 275–6.
39. Philip Auslander, 'Brought to You by Fem-Rage', p. 323.
40. Maeve Higgins, 5 April 2010, 44.26–48.02.
41. Denise Collier and Kathleen Beckett, *Spare Ribs: Women in the Humor Biz* (New York: St Martins Press, 1980), p. 99.
42. Betsy Borns, *Comic Lives: Inside the World of American Stand-up Comedy* (New York: Simon and Schuster, 1987), p. 20.
43. Philip Auslander, 'Brought to you by Fem-Rage', p. 326.
44. For a more detailed discussion on the female comic in mediatised performance, see Philip Auslander, 'Brought to you by Fem-Rage', p. 234.
45. Philip Auslander, 'Brought to you by Fem-Rage', pp 234–5.
46. Danielle Russell, 'Self Deprecatory Humour and the Female Comic.'
47. Danielle Russell, 'Self Deprecatory Humour and the Female Comic.'
48. Danielle Russell, 'Self Deprecatory Humour and the Female Comic.'
49. Danielle Russell, 'Self Deprecatory Humour and the Female Comic.'
50. Andrew Stott, *Comedy: The New Critical Idiom* (Oxon: Routledge, 2005), p. 100.
51. Danielle Russell, 'Self Deprecatory Humour and the Female Comic.'
52. At the time of writing, the female comic and stand-up is in need of much more research. That research could include an examination of gendered power relations, bias, agency, and the comic–audience exchange. Such research would more fully inform the tensions and currents at work within the performance form in more recent years.
53. Elinor Ochs and Lisa Capps, 'Narrating the Self', *Annual Review of Anthropology*, 25 (1996), 19–43 (p. 20).
54. Franklyn Ajaye, *Comic Insights: The Art of Stand-up Comedy* (Los Angeles: Silman James Press, 2002), p. 36
55. Oliver Double, *Getting the Joke*, p. 76.
56. Oliver Double, *Getting the Joke*, p. 76.
57. Lawrence E. Mintz, 'Standup Comedy as Social and Cultural Mediation', *American Quarterly*, 37 (1985), 71–80 (p. 79).
58. Smith and Watson cited in Catherine McLean-Hopkins, 'Performing Autologues: Citing/Siting the Self in Autobiographic Performance', in *Monologues: Theatre, Performance, Subjectivity* ed. by Clare Wallace (Czech Republic: Litteraria Pragensia, 2006), pp. 185–207 (p. 194).
59. Maeve Higgins, 'Comedy Gala in Auckland', 00.00–3.23.
60. Maeve Higgins, 25 March 2010.

61. Serving up the silliness, *Irish Times*, 19 September 2009, http://www.irishtimes.com/newspaper/weekend/2009/0919/1224254847640.html (accessed 15 May 2010).
62. Ashley Davies, 'Charming Irish Stand-up', 16 August 2007, http://edinburghfestival.list.co.uk/article/4004-maeve-higgins/ (accessed 10 May 2010).
63. Alison Oddey, *Performing Women*, p. 19.
64. Danielle Russell, 'Self Deprecatory Humour and the Female Comic.'
65. Danielle Russell, 'Self Deprecatory Humour and the Female Comic.'
66. Claire Sawers, 'Maeve Higgins', 14 August 2008, www.edinburghfestival.list.co.uk/article/11632-maeve-higgins (accessed 7 December 2010).
67. Dee Heddon, 'Beyond the Self: Autobiography as Dialogue', *Monologues: Theatre, Performance Subjectivity*, ed. by Clare Wallace (Czech Republic: Litteraria Pragensia, 2006), pp. 157–84 (p. 182).
68. Dee Heddon, 'Beyond the Self: Autobiography as Dialogue', p. 170.
69. Jill Dolan, 'Utopia and the "Utopian Performative"', *Theatre Journal*, 53:3 (2001), pp. 455–79 (p. 478).
70. Jill Dolan, 'Utopia and the "Utopian Performative"', p. 478.
71. Andrew Stott, *Comedy*, p. 61.

Final Remarks

1. Elinor Ochs and Lisa Capps, 'Narrating the Self', *Annual Review of Anthropology*, 25 (1996), 19–43 (p. 21).
2. Simon Critchley, *On Humour: Thinking in Action* (Oxon: Routledge, 2002), p. 4.
3. Simon Critchley, *On Humour*, p. 49.
4. Simon Critchley, *On Humour*, p. 6.
5. Rebecca Emlinger Roberts, 'Standup Comedy and the Prerogative of Art', *Massachusetts Review*, 41:2 (2000) 151–60 (p. 157).
6. Rebecca Emlinger Roberts, 'Standup Comedy and the Prerogative of Art', p. 157.
7. Andrew Stott, *Comedy: The New Critical Idiom* (Oxon: Routledge, 2005), p. 60.
8. Echart Voigts-Virchow and Mark Schreiber, 'Will the "Wordy Body" Please Stand-up? The Crises of Male Impersonation in Monological Drama', in *Monologues: Theatre, Performance Subjectivity*, ed. by Clare Wallace (Czech Republic: Litteraria Pragensia, 2006), pp. 278–96 (p. 286).
9. Rebecca Emlinger Roberts, 'Standup Comedy and the Prerogative of Art', p. 160.

Bibliography

Books

Ajaye, Franklyn, *Comic Insights: The Art of Stand-up Comedy* (Los Angeles: Silman James Press, 2002).

Allen, Tony, *Attitude: Wanna Make Something of It? The Secret of Stand-up Comedy* (Glastonbury: Gothic Image Publications, 2002).

Auslander, Philip, *From Acting to Performance: Essays in Modernism and Postmodernism* (New York: Routledge, 1997).

Bakhtin, Mikhail, *Rabelais and his World*, trans. by Hélène Iswolsky (Bloomington: Indiana University Press, 1984).

Beckett, Samuel, *Molloy, Malone Dies, The Unnameable* (Picador, London, 1979).

_____, *Watt* (London: Calder, 1970).

Benson, Ciarán, *The Cultural Psychology of Self: Place, Morality and Art in Human Worlds* (London: Routledge, 2001).

Berger, L. Peter, *Redeeming Laughter: The Comic Dimension of Human Experience* (Berlin and New York: De Gruyter, 1997).

Berger, Phil, *The Last Laugh: The World of Stand-up Comics* (New York: Cooper Square Press, 2000).

Bergson, Henri, *Laughter: An Essay on the Meaning of the Comic*, trans. by Cloudesley Brereton and Fred Rothwell, B.A (UK: Kessinger Publishing, [n.d.]).

Billig, Michael, *Laughter and Ridicule: Towards a Social Critique of Humour* (London: Sage Publications, 2005).

Borns, Betsy, *Comic Lives: Inside the World of American Stand-up Comedy* (New York: Simon and Schuster, 1987).

Bruner, Richard, *Making Stories: Law Literature Life* (London: Harvard University Press, 2003).

Butsch, Richard, *The Making of American Audiences: From Stage to Television, 1750–1990* (New York: Cambridge University Press, 2000).

Carr, Jimmy and Lucy Greeves, *The Naked Jape: Uncovering The Hidden World of Jokes* (London: Penguin, 2006).

Collier, Denise and Kathleen Beckett, *Spare Ribs: Women in the Humor Biz* (New York: St Martins Press, 1980).

Collins, K.L and Skover, David, *The Trials of Lenny Bruce: The Fall and Rise of an American Icon* (Naperville, Illinois: Sourcebooks Inc, 2002).

Cook, William, *Ha Bloody Ha: Comedians Talking* (London: Fourth Estate, 1994).

Critchley, Simon, *On Humour: Thinking in Action*, ed. by Simon Critchley and Robert Kearney (Oxon: Routledge, 2002).

Dixon, Stephen and Falvey, Deirdre, *Gift of the Gag: The Explosion in Irish Comedy* (Belfast: Blackstaff Press Limited, 1999).

Double, Oliver, *Stand-Up: On Being a Comedian* (London: Methuen Publishing, 1997).

_____, *Getting the Joke: The Inner Workings of Stand-up Comedy* (London: Methuen Publishing, 2005).

_____, *Britain Had Talent: A History of Variety Theatre* (Basingstoke: Palgrave Macmillan, 2012).

Douglas, Mary, 'Jokes', in *Implicit Meanings* (London: Routledge, 1999).

Epstein, Lawrence J., *The Haunted Smile: The Story of Jewish Comedians in America* (New York: Perseus Books Group, 2001).

Esslin, Martin, *The Theatre of the Absurd* (New York: Vintage, 2004)

Fitz-Simon, Christopher, *The Irish Theatre* (London: Thames and Hudson, 1983).

_____, *"Buffoonery and Easy Sentiment": Popular Irish Plays in the Decade Prior to the Opening of the Abbey Theatre* (Dublin: Carysfort Press, 2011).

Huizinga, Johan, *Homo Ludens: A Study of the Play Element in Culture* (London: Routledge, 1980).

Johnstone, Keith, *Impro for Storytellers: Theatresports and the Art of Making Things Happen* (London: Faber & Faber, 1999).

Jung, Carl, *The Archetypes and the Collective Unconscious*, trans. by R.F.C. Hull, 2nd edn (London: Routledge, 2006).

Kearney, Richard, *On Stories: Thinking in Action*, ed. by Simon Critchley and Richard Kearney (London: Routledge, 2002).

Levitas, Ben, *The Theatre of Nation: Irish Drama and Cultural Nationalism 1890–1916* (New York: Oxford University Press, 2002).

Matthews, Eugene and Matthew Murtagh, *Infinite Variety: Dan Lowrey's Music Hall 1879–97* (Dublin: Gill and Macmillan, 1975).

Monkhouse, Bob, *Over the Limit: My Secret Diaries 1993–8* (London: Century, 1998).

Morash, Christopher, *A History of Irish Theatre: 1601–2000* (Cambridge: Cambridge University Press, 2002).

Oddey, Alison, *Performing Women* (London: Macmillan Press, 1999).

Pavis, Patrice, *Analysing Performance: Theater, Dance and Film*, trans. by David Williams (Michigan: The University of Michigan Press, 2003).

Performance Analysis: An Introductory Coursebook, ed. by Colin Counsell and Laurie Wolf (Oxon: Routledge, 2001).

Plessner, Helmuth, *Laughing and Crying: A Study of The Limits of Human Behaviour*, trans by James Spencer Churchill and Marjorie Grene (Evanston, IL: Northwestern University Press, 1970).

Ryan, Philip B., *The Lost Theatres of Dublin* (Wiltshire: Badger Press, 1998).

_____, *Jimmy O'Dea: The Pride of the Coombe* (Dublin: Poolbeg, 1990).

Schechner, Richard, *Between Theatre & Anthropology* (Philadelphia: University of Pennsylvania Press, 1985).

_____, *Performance Studies: An Introduction* (London: Routledge, 2002).

_____, *Performance Theory* (Oxon: Routledge Classics, 2003).

Skinner, Frank, *Frank Skinner* (London: Century, 2001).

States, Bert O., *Great Reckonings in Little Rooms: On the Phenomenology of Theater* (London: University of California Press, 1985).

Stott, Andrew, *Comedy: The New Critical Idiom* (Oxon: Routledge, 2005).

True, Cynthia, *American Scream: The Bill Hicks Story* (London: Sidgwick & Jackson, 2002).

Wilmut, Roger, *Kindly Leave the Stage: The Story of Variety 1919–1960* (London: Methuen, 1985).

Wilmut, Roger and Peter Rosengard, *Didn't You Kill My Mother in Law? The Story of Alternative Comedy in Britain from The Comedy Store to Saturday Live* (London: Methuen, 1989).
Witoszek, Nina and Pat Sheeran, *Talking to the Dead: A Study of Irish Funerary Traditions* (Amsterdam and Atlanta, GA: Rodopi, 1998).

Chapters in books

Auslander, Philip, 'Comedy about the Failure of Comedy: Stand-up Comedy and Postmodernism', in *Critical Theory and Performance*, ed. by Janelle G. Reinelt and Joseph R. Roach (Michigan: University of Michigan Press, 1992), pp. 196–207.
——————, 'Brought to You by Fem-Rage: Stand-up Comedy and the Politics of Gender', in *Acting Out: Feminist Performances*, ed. by Lynda Hart and Peggy Phelan (Michigan: University of Michigan Press, 1993), pp. 315–36.
——————, 'Liveness: Performance and the Anxiety of Simulation', in *Performance and Cultural Politics*, ed. by Elin Diamond (London: Routledge, 1996), pp. 196–213.
——————, 'Postmodernism and Performance', in *The Cambridge Companion to Postmodernism*, ed. by Stephen Connor (Cambridge: Cambridge University Press, 2004), pp. 97–113.
Bial, Henry, 'What is Performance', in *The Performance Studies Reader: Second Edition*, ed. by Henry Bial (Oxon: Routledge, 2007), pp. 59–60.
Colleary, Susanne, 'God's Comic', in *Staging Thought: Essays on Irish Theatre, Scholarship and Practice*, ed. by Rhona Trench (Bern: Peter Lang, 2012), pp. 153–69.
——————, 'Eating Tiny Cakes in the Dark: Maeve Higgins and the Politics of Self-Deprecation', in *Performing Feminisms in Contemporary Ireland*, ed. by Lisa Fitzpatrick (Dublin: Carysfort Press, 2013), pp. 17–39.
Frye, Northrop, 'The Argument of Comedy' in *Comedy: Developments in Criticism*, ed. by D.J. Palmer (Basingstoke: Macmillan, 1984) pp. 74–84.
Heddon, Dee, 'Beyond the Self: Autobiography as Dialogue', in *Monologues: Theatre, Performance, Subjectivity*, ed. by Clare Wallace (Czech Republic: Litteraria Pragensia, 2006), pp. 278–96.
Lampe, Eelka, 'Rachel Rosenthal Creating Her Selves', in *Acting (Re)Considered: A Theoretical and Practical Guide*, 2nd edn, ed. by Phillip B. Zarrilli (Oxon: Routledge, 2002), pp. 291–304.
McLean-Hopkins, Catherine, 'Performing Autologues: Citing/Siting the Self in Autobiographic Performance', in *Monologues: Theatre, Performance, Subjectivity*, ed. by Clare Wallace (Czech Republic: Litteraria Pragensia, 2006), pp. 185–207.
Merrill, Lisa, 'Feminist Humor: Rebellious and Self-affirming', in *Last Laughs: Perspectives on Women and Comedy*, ed. by Regina Barreca (New York: Gordon and Breach, 1988), pp. 271–80.
O'Toole, Jacqueline, '"A Danger to Yourself?" Motivational Talks in Group Slimming Classes', in *Ireland of the Illusions: A Sociological Chronicle 2007–2008*, ed. by Mary P. Corcoran and Perry Share (Dublin: IPA, 2010), pp. 253–70.
Ricoeur, Paul, 'Life In Quest Of Narrative', in *On Paul Ricoeur: Narrative and Interpretation*, ed. by David Wood (London: Routledge, 1991), pp. 20–34.

Voigts-Virchow, Echart and Mark Schreiber, 'Will the "Wordy Body" Please Stand-up? The Crises of Male Impersonation in Monological Drama', in *Monologues: Theatre, Performance, Subjectivity*, ed. by Clare Wallace (Czech Republic: Litteraria Pragensia, 2006), pp. 278–97.

Weitz, Eric, 'Who's Laughing Now? Comic Currents for a New Irish Audience', in *Crossroads: Performance Studies and Irish Culture*, ed. by Sara Brady and Fintan Walsh (Basingstoke: Palgrave Macmillan, 2009), pp. 225–36.

Articles in journals

Auslander, Philip, 'Going with the Flow: Performance Art and Mass Culture', *TDR*, 33:2 (1989), pp. 119–36.

Berky, Bob and Claude Barbre, 'The Clown's Use of Empathy: An Interview with Bob Berky', *Journal of Religion and Health*, 39:3 (2000), pp. 239–46.

Byrne, F. Patrick, 'Fifty Years of Gaiety: Dublin's Gaiety Theatre 1871–1921', *Dublin Historical Record*, 38:1 (1984), pp. 37–44.

Devitt, David, 'The Theatre Royal: A Place of Cine-Variety', *History Ireland* (Dublin: History Publications Ltd, 2013).

Dolan, Jill, 'Utopia and the "Utopian Performative"', *Theatre Journal*, 53:3 (2001), pp. 455–79.

Double, Oliver and Michael Wilson, 'Karl Valentin's Illogical Subversion: Stand-up Comedy and Alienation Effect', *NTQ*, 20:3 (2004), pp. 203–15.

Foucault, Michel and Jay Miskowiec, 'Of Other Spaces', *Diacritics*, 16:1 (1986), pp. 22–7.

Jackson, Bruce, 'The Stories People Tell', *The Antioch Review*, 55:3 (1997), pp. 261–76.

_____, 'The Fate of Stories', *The Antioch Review*, 60:1 (2002), pp. 9–27.

Lachmann, Renate, Raoul Eshelman and Marc Davis, 'Bakhtin and Carnival: Culture as Counter-Culture', *Cultural Critique*, 11 (1988–9), pp. 115–52.

Langellier, M. Kristin, 'Personal Narrative, Performance and Performativity: Two or Three Things I Know For Sure', *Text and Performance Quarterly*, 19:2 (1999), pp. 125–44.

Mintz, E, Lawrence, 'Standup Comedy as Social and Cultural Mediation', *American Quarterly*, 37 (1985), pp. 71–80.

Norrick, R. Neal, 'On the Conversational Performance of Narrative Jokes: Toward an Account of Timing', *Humor*, 3:14 (2001), pp. 255–73.

Ochs, Elinor and Lisa Capps, 'Narrating the Self', *Annual Review of Anthropology*, 25 (1996), pp. 19–43.

O'Neill, Patrick, 'The Comedy of Entropy: The Contexts of Black Humour', *Canadian Review of Comparative Literature*, 10:2 (1983), pp.145–66.

Plant, Bob, 'Absurdity, Incongruity and Laughter', *Philosophy*, 84 (2009), pp. 111–34.

Quirk, Sophie, 'Who's In Charge? Negotiation, Manipulation and Comic Licence in the Work of Mark Thomas', *Comedy Studies*, 1:1 (2010), pp. 113–24.

Roberts, Emlinger, Rebecca, 'Standup Comedy and the Prerogative of Art', *The Massachusetts Review* 41:2 (2000), pp. 151–60.

Russell, Danielle, 'Self Deprecatory Humour and the Female Comic: Self Destruction or Comedic Construction', *Third Space: A Journal of Feminist*

Theory and Culture, 2:1 (2002), http://www.thirdspace.ca/articles/druss.html (43 Paragraphs).

Schechner, Richard, 'The End of Humanism', *PAJ*, 4:1/2 (1979), pp. 9–22.

States, Bert O., 'The Actor's Presence: Three Phenomenal Modes', *Theatre Journal*, 35 (1983), pp. 359–75.

Plays

Griffiths, Trevor, *Comedians* (London: Faber, 1976).

Internet sources

Articles

Armstrong, Stephen, 'Comedy Trio: The Three Fellas Live are Bringing the House Down', *Sunday Times*, 1 June 2008, http://entertainment.timesonline.co.uk/tol/arts_and_entertainment/stage/comedy/article4025189.ece.

Boland, John, 'The Gong for Worst Show Goes to...', *Irish Independent*, 19 September 2009, http://www.independent.ie/entertainment/tv-radio.html.

Boyd, Brian, 'The Tiers of Ireland's Clowns', *Irish Times*, 9 August 2010, http://irishtimes.com/newspaper/features/2010/0809/1224276415315.html.

Brown, Georgia, 'Five Top Comedy Festivals Around The World', *Guardian*, 16 March 2007, http://www.guardian.co.uk/travel/2007/mar/16/scotland.canada.australia.html.

Caesar, Ed, 'Dylan Moran: Sourpuss Supreme', *Independent*, 25 April 2006, http://www.independent.co.uk/news/people/profiles/dylan-moran-sourpuss-supreme-475554.html.

Custance, Dee, 'Profile of a Serial Kidder', *The Skinny*, 8 September 2007, http://www.the skinny.co.uk/40232-profile-of-a-serial-kidder.

Duggan, Keith, 'Testament According to Tommy', *The Irish Times*, 4 April 2009, http//www.irishtimes.com/newspaper/weekend/2009/0404/1224243990676.html.

Farndale, Nigel, 'Have I had therapy? I went to yoga once', *Telegraph*, 27 August 2006, http://www.telegraph.co.uk/culture/3654902.html.

Fay, Séan, 'London 2012 – Where Are They Now? Michelle Smith', *Eurosport*, 29 February 2012, http://eurosport.yahoo.com/29022012/58/london-2012-michelle-smith.html.

Freyne, Patrick, 'Freyne's World', *Tribune*, 20 September 2009, http://www.tribune.ie/arts/article/2009/sep/20/freynes-world.

Gullet, Jane, http://www.leftlion.co.uk/articles.cfm?id=2292.

Hall, Julian, 'Dylan Moran: Monster I, Wyndham's Theatre, London', *Independent*, 8 November, 2004, http://www.independent.co.uk/arts-entertainment/theatre-dance/reviews/dylan-moran-monster-i-wyndhams-theatre-london-532415.html.

_____, 'Stand-up: Dylan Moran Takes on the World', *Independent*, 23 September 2008, http://www.independent.co.uk/artsentertainment/comedy/features/938570.html.

Holmquist, Kate, 'The Comedy Don', *Irish Times*, 1 January 2010, http://www.irishtimes.com/newspaper/newsfeatures/2010/0102/1224261521677.html.

Lee, Veronica, 'Dylan Moran, Apollo', 30 October 2009, http://www.theartsdesk.com/indes.php?option=com.

Longman, Jere, 'Swimming; Olympic Swimming Star Banned; Tampering With Drug Test Cited', *New York Times*, 7 August 1998, http://www.nytimes.com/1998/08/07/sports/swimming-olympic-swimming-star-banned-tampering-with-drugs-test-cited.html.

Newenham, Pamela, 'Tiernan off Canadian Comedy Tour', *The Irish Times*, 10 October 2009, http:www.irishtimes.com/newspaper/breaking/2009/1009/breaking41.html.

'O'Connor Loses Olympic Gold Medal', *RTE News*, 27 March 2005, http://www.rté.ie/news/2005/0327/61345-oconner/.html.

O'Doherty, Gemma, 'Dublin's Olympic Dreamers', *Irish Independent*, 9 July 2005, http://www.independent.ie/opinion/analysis/dublins-olympic-dreamers-248807.html.

Patterson, Christina, 'Dylan Moran: I am a bit of a bumbling man as you can tell', *Independent*, 16 October 2009, www.independent.co.uk/arts-entertainment/interviews/dylanmoran/1803279.html.

'Serving Up the Silliness', *Irish Times*, 19 September 2009, http://www.irishtimes.com/newspaper/weekend/2009/0919/1224254847640.html.

Sweeney, Ken, '"Six Million? I Would Have Got 10 or 12 Million Out of That. No F**kng Problem! F**k Them. Two at a Time, They Would Have Gone. Hold Hands, Get in There! Leave Us Your Teeth and Your Glasses'", *Sunday Tribune*, 20 September 2009, http://www.tribune.ie/article/2009/sep/20 six-million-i-would-have-got 10-or-12-million-out.html.

Whittington, Paul, 'Just for Laughs', *Irish Independent*, 12 September 2009, http://www.independent.ie/entertainment/tv-radio/just-for-laughs-1884916.html.

Reviews

Chambers, Julian, 'Maeve Higgins: My News', *Chortle*, 2007, http://www.chortle.co.uk/shows/edinburgh_fringe_2007/m/15765/maeve_higgins%3A-my-news.

Crawley, Peter, 'A Weekend at Kilkenny Cat Laughs', *The Irish Times*, 3 June 2009, http://www.irishtimes.com/newspaper/features/2009/0603/1224247945413.html.

Davies, Ashley, 'Charming Irish Stand-up', 16 August 2007, http://edinburghfestival.list.co.uk/article/4004-maeve-higgins/.

Hunkin, Joanna, 'Review: Maeve Higgins at Basement Theatre', 14 May 2009, http://www.nzherald.co.nz/entertainment/news/article/cfm?_id+1501119&objectid=10572098.

http://www.rte.ie/inthenameofthefada.

Logan, Brian, 'Dylan Moran: Apollo, London', *Guardian*, 1 November 2009, http://www.guardian.co.uk/stage/2009/nov/01/dylan-moran-review.

Merritt, Stephanie, 'Ranting at the Modern World: It's That Bloody Irishman Rambling in the Bar Again...', *Guardian*, 18 April 2004, www.guardian.co.uk/theobserver/2004/arp/18/features.review57.

Sawers, Claire, 'Maeve Higgins', 14 August 2008, www.edinburghfestival. list.co.uk/article/11632-maeve-higgins.

Tracer, Jake, 'Tommy Tiernan – Loose Macgowan Little Theater Los Angeles', *Daily Bruin*, 17 March 2006, www.TommyTiernan.com/reviews.

Articles in newspapers

Boyd, Brian, 'It Was Just Unreal. All I Could Do Was Keep Gigging. And Take My Beating', *The Irish Times Weekend Review*, 27 November 2010.
Logan, Brian, 'Be Truthful – and Funny Will Come. To Mark This Year's Inaugural Richard Pryor Award for Comedy, We Asked a Group of Comics to Put a Question to the Great Stand-Up. Brian Logan introduces the Results', *Guardian*, 9 August 2004.

Interviews

Higgins, Maeve, *Unpublished Interview with the Author*, 25 March 2010.
Tiernan, Tommy, *Unpublished Interview with the Author*, 15 June 2007
_____, *Meaning of Life*,' http://www.rte.ie/tv/meaningoflife/programmes. html.

VHS

Sayle, Alexei, *Alexei Sayle Live at the Comic Strip* (MCI: Spoken Word, 1988).

DVDs

Moran, Dylan, *Monster: Live* (UK: Universal Pictures, 2004).
_____, *Aim Low* (UK: Universal, 2010).
_____, *like, totally... Dylan Moran Live* (UK: Universal Studios, 2006).
_____, *What It Is: Live* (UK: Universal Pictures, 2009).
Tiernan, Tommy, *Cracked: Live at Vicar Street* (Galway: Mabinog, 2004).
_____, 'Navan Man – Bovinity Tour', *Bovinity* (Galway: Mabinog, 2008).
_____, *Jokerman: Tommy Tiernan in America* (Galway: Mabinog, 2006).
_____, *Loose* (Galway: Mabinog, 2005).
_____, *Tommy Tiernan: Live* (UK: Universal, 2002).

CDs

Cohen, Leonard and Sharon Robinson, 'Everybody Knows', *I'm Your Man* (USA: Columbia Records, 1988).

Live shows

Higgins, Maeve, 'Comedy Gala in Auckland' (New Zealand, 2009), http//www.youtube.com/watch?u=iUwntYUxkWa.
_____, *Live at Vicar Street* (filmed by the author, March 2010).

Moran, Dylan, *'Dylan Moran at Comic Aid'* (2005) http://www.youtube.com/watch?V=-j3qzAUCREo.

Tiernan, Tommy, *House of Fun* (filmed by the author, Dublin, July 2007).

Television

Higgins, Maeve, 'Girlfriends Coming for Dinner!', *Fancy Vittles*, http://www.youtube.com/watch?v=c55IjFnp8CY&feature=related.

Index

Printed and bound by CPI Group (UK) Ltd, Croydon, CR0 4YY